How We Do It

How We Do It

Black Writers on Craft, Practice, and Skill

EDITED BY JERICHO BROWN

PRESENTED BY THE

AMISTAD

An Imprint of HarperCollinsPublishers

The credits on pages 337–41 constitute a continuation of this copyright page.

Every effort has been made to obtain permissions for pieces quoted or adapted in this work. If any required acknowledgments have been omitted, or any rights overlooked, it is unintentional. Please notify the publishers of any omission, and it will be rectified in future editions.

HOW WE DO IT. Copyright © 2023 by Hurston/Wright Foundation. All rights reserved. Printed in the United States of America. No part of this book may be used or reproduced in any manner whatsoever without written permission except in the case of brief quotations embodied in critical articles and reviews. For information, address HarperCollins Publishers, 195 Broadway, New York, NY 10007.

HarperCollins books may be purchased for educational, business, or sales promotional use. For information, please email the Special Markets Department at SPsales@harpercollins.com.

FIRST EDITION

Designed by Kyle O'Brien

Library of Congress Cataloging-in-Publication Data is available upon request.

ISBN 978-0-06-327818-9
ISBN 978-0-06-327819-6 (Library Edition)

23 24 25 26 27 LBC 6 5 4 3 2

To the memory of Zora Neale Hurston and

Richard Wright, and for the storytellers

in the Hurston/Wright workshops

Contents

Going Back

Introduction

How We Do It is not a conventional anthology of craft essays. Our request of the writers in these pages was a statement quite literally explaining how they go about making what they make. What happens to move things from a blank page to a beautiful book? So this is a book of answers—answers to questions new writers ask every day about how to produce writing that proves their very identity as a practitioner. In other words, this is a book for anyone who is a student of the craft. More particularly, though, this is a book for younger and newer Black writers in undergraduate and graduate workshops and in absolutely no workshop at all. We hope teachers find these words useful for their students, and we hope students who have yet to find their teachers learn from these thirty-two pieces born out of absolute generosity and hope for the future of Black writing.

We have arranged this volume in a way that we hope defies supposed boundaries set by genre. I am certain there is news for the poet in the essay on vernacular by Daniel Omotosho Black. I believe the poet Evie Shockley is indeed in conversation with the filmmaker Barry Jenkins. That certainty and that belief come from how much I learned about my own work and my own attempts at work from the process of reading and organizing these essays. This is a book I wish existed twenty years ago. I would have led an easier life if it had.

How We Do It is divided into eight sections, with a range of essays in each: "Who Your People?," "What You Got?," "Where You At?," "How You Living?," "What It Look Like?," "Who You With?," "How to Read," and "Going Back." The titles here are intended to communicate the fact that these sections could not be narrowed down to the kind of jargon with which writers are accustomed. We weren't going to name the sections "voice," "tone," "setting," "character," or "good advice" because every essay here gets at more than any single topic. "Who Your People?," for instance, includes meditations on characterization and speech. It has bare-bones, real-time directives from Crystal Wilkinson, like "when you begin to talk about your characters as if they are members of your family, then you've got it right," and an exhaustive list of questions any writer may want to answer when envisioning the full, human life of someone imagined. "What You Got?" is a section on the uses of personal and communal experiences in writing, no matter how traumatic or dire those experiences may be. Here, Hurston/Wright Foundation founder and writer Marita Golden advises, "To write your story well, you must fully understand and be willing to stand up for its significance and necessity."

The next section, "Where You At?," elucidates the possibilities for place, environment, and region in our literature. It is also the section where it becomes clear that these writers do not always agree and very often seem to be talking to one another directly. W. Ralph Eubanks discusses how a poem by the former poet laureate Natasha Trethewey continues to teach him how to make Mississippi itself tantamount to the role of a character in his essays. This is followed by an essay by Trethewey herself, in which she recalls:

My mother had come of age in Mississippi during the era of Jim Crow and at the height of the Civil Rights Movement. She had

grown up steeped in the metaphors that comprised the mind of the South—the white South—and thus had not missed the paradox of my birth on Confederate Memorial Day: a child of miscegenation, a word that entered the American lexicon during the Civil War in a pamphlet. It had been conceived as a hoax by a couple of journalists to drum up opposition to Lincoln's re-election through the threat of amalgamation and mongrelization. When I was born, my parents' marriage was illegal in Mississippi and as many as twenty other states in the nation, rendering me illegitimate in the eyes of the law, persona non grata. My father was traveling out of town for work, so she made the short trip from my grandmother's house to Gulfport Memorial Hospital, as planned, without him. On her way to the segregated ward, she could not help but take in the tenor of the day, witnessing the barrage of rebel flags lining the streets, flanking the Confederate monument: private citizens, lawmakers, Klansmen hoisting them in Gulfport and small towns all across Mississippi . . .

Sequestered on the *Colored* floor, my mother knew the nation was changing, but slowly. She knew . . . I would have to journey toward an understanding of myself, my place in the world, with the invisible burdens of history, borne on the back of metaphor, the language that sought to name and thus constrain me. I would be both bound to and propelled by it. She knew that if I could not parse the metaphorical thinking of the time and place into which I'd entered, I could be defeated by it.

And yes, it was important for us to include previously published work from some of our greatest writers so that we were always contextualizing our contributors in a long tradition and a widely vast current moment. For instance, a 1979 interview with Ernest J. Gaines (and *Callaloo* editor Charles H. Rowell) also appears in this section. Gaines is clear about his need "to be with the land—not

only with the people but to be with the land. I come back not as an
objective observer, but as someone who must come back in order
to write about Louisiana." And beyond that need, he discusses how
he decides on point of view and his appreciation for adaptation. Of
course, I have questions about what Gaines means when he associ-
ates "bad" writing with "too many" Black Arts Movement writers
(as if excellence is characteristic of more writers from any other
movement).

Our "How You Living?" section shows writers' habits and ways
of moving through the world such that their lives are open to in-
spiration and play. Here, Camille T. Dungy quips, "The first thing
a writer needs to do is to learn how to pay attention." Our "What
It Look Like?" section follows with actual writing exercises from
Tony Medina and Afaa Michael Weaver, and a full discussion on
the uses of form in any genre from Tiphanie Yanique. I'm prob-
ably proudest of gathering the "Who You With?" section, which
is ultimately about empathy and collaboration. How do we write
those who are supposedly and obviously different from ourselves?
How do we maintain creative partnerships with those who audi-
ences might not expect? Is it possible to speak for the community
through our work?

The final two sections are meant to help move writers toward
making use of well-known advice I am not sure everyone under-
stands. In public forums since the dawn of Q&As, writers have been
asked their advice for those interested in learning the craft. Quite
often and no matter who is asked, the answer is "read." Read more.
Read widely. "How to Read" begins to get at what to do with
all that reading and how to translate it into well-wrought writing.
Angela Flournoy discusses how reading frees us to write grief and
tragedy as we feel it and not as if there is some prescribed way to do
it right. Terrance Hayes's journals show us how to live in the world

of tradition, how to ingest as much of the past literature as we can, as if it is air. Carl Phillips's long essay provides example after example of what syntax is and how to employ it given one's reading of it in other work.

In our final section, "Going Back," Elizabeth Nunez discusses how literature (and Shakespeare in particular) taught her to write and how to write plot. Her essay offers a series of litmus tests for anyone who is wondering if what they made actually works with sentences like "Plot is the arrangement of events in a story to achieve a desired effect" and "Plot is not simply about the clever arrangement of events in a story. It is about how these events affect the character. It is about the character's journey through these events." She is joined by Mitchell S. Jackson and Charles Johnson, who write about going back with the freshest of eyes to revise our work.

In all, *How We Do It* is a kind of selfish gift. I want you to have what I always wanted. Here is an anthology that gives us modes to try on the way we might wear and change clothing. And these wonderful writers are proof that nothing ever beat a failure but a try.

Jericho Brown
Atlanta, Georgia

Who Your People?

—

Characterization and Vernacular

Rhythm in Writing

DANIEL OMOTOSHO BLACK

I've always loved the rhythm of Black vernacular. It's in the preacher's hoop, Black women's talk at kitchen tables, Black men's guttural laughter in barbershops, the sway and clapping of the Black church choir. We are a people who move and have our being in metered time. That's no secret. Writers and scholars have documented this phenomenon since the 1960s. What *is* elusive is how to capture this pace, this cadence on paper. It's not simply an issue of writing in Ebonics. Rather, it's the ability to seize the reader's consciousness and move it in musical time. That, my friend, is a literary craft, a stylistic device, that is hell to master.

But it's not impossible. Some Black writers are known for it. Morrison comes to mind as do John Edgar Wideman and Sonia Sanchez. Indeed, the 1960s Black Arts writers germinated in a time and space where the aesthetic emphasis centered around Black pathos. In other words, these writers meant to translate the beauty of Black idiomatic expression into literary artistic production. And this is the creative achievement contemporary Black writers inherit. However, mimicking it is another story.

It seems the first secret is in the consciousness of word choice. Check out this sentence.

> After sunset, Willie Joe and Bessie went to the bedroom and made love.

This sentence is okay, but it doesn't carry the rhythm of Black existence. It doesn't show or celebrate the way in which Black folks had to make space for love when the entirety of their existence was subsumed in survival. But this sentence does:

> After the sun went down, Willie Joe and Bessie made their way to the bedroom and did what they could do.

The difference here is several things. First, "sunset" is what the sun does every day; there is nothing particular about it. The sun "going down," however, is Black people's hope for a moment of rest. It's the time of day when they get to breathe for a minute. Then exchanging "went to the bedroom" for "made their way" makes all the difference in terms of the rhythm of movement. "Made their way" implies struggle and difficulty, but it also implies desire and intentionality. It means they wouldn't be denied. And finally, "did what they could do" does all the work to demonstrate the beauty of Black intimacy within the limitations of bondage and restraint. Writers are often taught (and rightly so) the craft of language economy—the use of as few words as possible to convey a point. And, generally, this makes for a smoother style and less laborious text. However, sometimes, in order to establish a Black rhythmic pulse in written discourse, one needs *more* words, more instruments with which to play the symphonic complexity of Black life.

Another way to establish rhythm in Black narrative is via the

manipulation of punctuation. Of course, all creative writers use grammar to their advantage, forcing commas, for instance, to do what normally only periods do. Yet there are other punctuation marks that offer a conscious Black writer many options of how best to say a thing that represents the rhythmic nature of who we are. For instance,

> Old Mr. John, that crazy-ass, half-blind, snuff-dippin' man, told us a story—that's all he did all day!—about the time he met a snake face to face. That's right: face to face. Upright. Both of them.

I love this sentence for so many reasons. First, the use of hyphenated adjectives is, as Zora Neale Hurston explains in *The Sanctified Church,* a cornerstone of Black rhythmic expression. We tend to love the musicality of bump-bump, bump-bump, bump-bump phrases. They disturb and excite an otherwise lazy, common 4/4 time structure. In other words, a good grammarian knows how to write polyrhythmically. The use of various punctuation marks turns a sentence into a jazz moment where words and ideas get their own solo but also function to create one whole set. Listen to this:

> They said Ethel Bell went to hell when she died. I don't know. But I know this: she was one mean heffa, you betta hear what I'm sayin'.

Again, many would delete "when she died" because one has to die to get to hell. But I wouldn't. That phrase means something a little different in Black cultural spaces. Put simply, it returns the reader to the day, the moment she died as a significant time signature in that community.

The moment of her death signaled a change, perhaps, among a people who had tolerated her existence a long time. It also means

she was *somebody*, because folks keep thinking and talking about her after she's gone. The use of a colon after "But I know this" is classic Black vernacular cadence. It announces that one is *about* to say something that folks ought to pay attention to. Some literary critics would posit, frustratingly, that one shouldn't announce that you're going to say a thing then say it. Just say it, damn it! But, again, I disagree. The announcement is the "call." The colon holds space for readers to get ready. Then, what is said afterwards is the "response." So "she was one mean heffa" is the point being made. Yet the statement after the comma—"You betta hear what I'm sayin'"—adds emphasis and humor that causes the reader to wonder just who this woman was. In some ways, it makes folks want to know her—although the whole point has been that you might not enjoy her. This intentional vernacular contradiction is the work of Black literary pastiche: the ability to *sing* a discourse instead of simply saying it.

One other trick Black writers use to establish rhythmic expression is what I call "repeated dialogue." I remember seeing it first in Toni Morrison's *The Bluest Eye*. This whole book mesmerizes, of course, but it is the dialogue at the end between the women who speak of Pecola's "condition" that arrests my consciousness. They say,

"Did you hear about that girl?"
"What? Pregnant?"
"Yas. But guess who?"
"Who? I don't know all these little old boys."

When the receiver repeats the words of the inquirer, then answers the question, the question itself becomes more potent.

This stylistic device creates a kind of back-and-forth rhythmic banter that sounds almost like a duet of dialogue. They continue:

> "That's just it. Ain't no little old boy. They say it's Cholly."
> "Cholly? Her daddy?"
> "Uh-huh."
> "Well, they ought to take her out of school."
> "Ought to. She carry some of the blame."

These repetitive phrases force readers to discover that words often mean different things, depending upon who says them. The repetition also makes readers contemplate the levels of depth of what the author might be trying to convey without spelling it out. Of course, here, the horror of an eleven-year-old girl pregnant by her father is far too appalling to glide over. So, Morrison turns the dialogue into a rhythmic exploration of trauma. This is the Black speech I grew up loving:

> "Chile, I went to the store, and milk was almost three dollars a gallon!"
> "Was?"
> "Yes ma'am it was! And I put it right back."
> "Did you put it back, Stine?"
> "You better believe I did!"

As a child, I'd stand near grown folks as they spoke this way, smiling and laughing as their discourse shaped my literary sensibility. Now I get it: This musical rhetoric is my literary inheritance. My job is to assure it never dies, to make sure my characters sound

like my people in all their beauty and complexity. Yet having been taught the English language by teachers who don't know my linguistic legacy, I've had to break rules and resist conventions that promise to drown out voices I know so well.

Well, I pray I have done it well.

Asking Questions and Excavating Memory

Creating Complex Fictional Characters

CRYSTAL WILKINSON

> The responsibility of a writer is to excavate the
> experiences of the people who produced him.
>
> —James Baldwin

In the same way a member of your family might say "Aww. That's Uncle Marlon being Uncle Marlon," characters in fiction are folks just being themselves. Folks in a specific physical place, doing something specific, navigating their experiences, wanting something (often something they can't have) and these folks come with a lifetime of psychological history and reasons why they can't have the things they desire or deserve. It is our jobs as writers to give them meaningful, full lives on the page, to tell their absolute truths without flinching.

It is the writer's job to know as much about the people we create as we can, even though, if we're wise, most of what we discover

doesn't have to end up in the pages of our final drafts. In fact, there is great power in leaving out particular things about a character's life and leaving room for the reader to guess, to reach, to intuit a few things on their own. I guess I'm hinting at Hemingway's Iceberg Theory from *Death in the Afternoon*, in which he says, "If a writer of prose knows enough about what he is writing about, he may omit things that he knows and the reader, if the writer is writing truly enough, will have a feeling of those things as strongly as though the writer had stated them. The dignity of movement of an iceberg is due to only one-eighth of it being above water." There's a bit more to Hemingway's theory and you can easily find it on the Internet if you're interested, but it's this knowing on the writer's part that enables us to inhabit a life that feels true to our characters and their worlds, to ourselves, and by extension, to the reader.

We are walking, breathing people who carry copious amounts of experiences, haunts, faults, contradictions within one body. Your characters should too. I'd say the difference is how these things affect the NOW of the story you're writing. You can't dump everything you know in your story, but I believe you should know things, whether they appear in the story or not.

When I teach fiction, I warn students of Flat Rita on a page. When engaged in characterization, immediately the writer might know what Rita's complexion is, whether she has box braids, locs, or a Jheri curl, and even the clothes she is wearing down to her platform shoes and bright red toenails. The writer might even know what her voice sounds like, but none of these things make Rita a living, breathing person—the ways in which she navigates her experiences make her a real person.

Often the writer doesn't know how Rita's feeling, what being good in Rita's family meant when she was a girl, what she ate for breakfast, what she values, who her mama and daddy are, or what

she dreams about at night. They don't know Rita grew up with a grandmother who directly experienced Jim Crow. That she went to church every Sunday, that she was molested by the next-door neighbor, that bucktoothed Johnny was the boy she fell in love with in third grade.

This kind of character deepening and excavation of a life comes from walking around your characters with curiosity and wonder until they become grown and full—vulnerable, flawed folks who have done things and lived through things and overcome things. And all of these things affect and inform who they are now at this moment that you are writing them and their world and their specific circumstances and this specific moment that they are living in now.

But how do you do that? How do you turn Flat Rita into a dynamic unique individual on the page?

I tell my writing students that when you begin to talk about your characters as if they are members of your family, then you've got it right. I often give the example of how old folks in my family (including my grandfather who was a farmer) would sit around and talk about characters on soap operas like they were real people. "That woman ain't gon never stay married with all that devilment she does." They would suck their teeth and cross their arms and shake their heads at these TV folks and be caught up in their TV lives. I sometimes eavesdropped on my grandparents, thinking they were talking about real people, but they were talking about the fictional characters who populated their television stories.

There are many ways to create characters, and there are a plethora of craft books and writing exercises that are designed to help you create characters. Janet Burroway in her book *Imaginative Writing: The Elements of Craft* presents five possible methods of presenting a character to a reader: directly through thought, action, speech, and appearance, and indirectly through the interpretation by the author

(telling). These certainly give you a foundation, but I propose there is a deeper layer, the layer where memories and secrets and a psychological history lies.

The following questions are designed to help excavate some vital information to help you find out who your folks are. I suggest you answer these questions as quickly as you can and try to unearth new information about a character that you are already working with. Of course, there can be many, many variations on these questions and these questions are not the end-all to beat all, but the goal is to find out something new that deepens your understanding of who your character is.

1. What relationships are important to your character? Describe them.
2. What relationships are problematic to your character? Describe them.
3. Who does your character confide in?
4. What does your character believe in?
5. What is your character most afraid of?
6. What makes your character happy?
7. What's your character's favorite thing to do for pleasure?
8. What did your character eat for breakfast?
9. What did being good mean in their family?
10. What is an object your character cherishes?

Now, try these from your character's point of view:

1. When I was five, _____
2. What I think about God: _____
3. My father always_____
4. I miss the smell of _____

5. What I said was_____, but what I meant was _____

6. Last night I dreamt about _____

7. My mother always said _____

8. While the family gathered at the _____, I would _____

9. I wish I could remember _____, but all I remember is _____

10. Sunlight hitting the floor from the window made me remember _____

Memory is essential. Memory isn't history, but it may be the most compelling way in which a character works through historical events. Of course, the folks you create won't recall the details of a remembered thing exactly the way other folks in their lives will. There is power and importance in this too.

Some of our greatest writers rely on memory to invent and investigate the lives of their characters. Consider Ursa in Gayl Jones's *Corregidora*, who not only grapples with her own memories but those ancestral memories and stories passed from her mother to Grandmama and Great Gram. Or consider Sethe, Paul D, and Denver in Toni Morrison's *Beloved* and how what's remembered and what's secreted or forgotten are integral to the complexity of the lives of these characters and how Morrison's narrative strategy is weighted by memory or rememory, as Sethe calls it. *Rememory* is a term Morrison gives to Sethe, which describes memories affected by not only an individual but also by others. In this way, rememory-ing is communal as well as individual, as are so many of our memories. What is remembered or rememorized can seep into the emotional history of a family, a people, a community for generations.

Consider your character's individual memories as well as collec-

tive memories. What are they haunted by? Consider the haunts of your characters and what memories recur and have great effect. Use as many as you need to deepen and complicate. Consider the power of what's remembered, what's forgotten, what's avoided, what enters when they least expect it. What do these things say about the emotional landscape of your characters? The core of your story?

Here are a few to consider, but come up with your own list. Don't flinch. Dig deep.

1. A birthday celebration that they were present for. Could be their own or someone else's. Who was there?
2. A religious experience that took place in your character's childhood, real or imagined. How did they react? Where did it take place?
3. A time when they felt ashamed. What happened before the incident? What happened after?
4. Their experience of a national or regional tragedy.
5. Their experience of their culture.
6. A memorable Saturday or Sunday morning.
7. A day someone they loved disappointed them.
8. A place they go to for solitude or pleasure.
9. A strange interaction with a neighbor.
10. A time when they were hurt. Emotionally? Physically?
11. A memorable meal in your character's life. A regular meal, a holiday, a celebration outside the house, etc. Describe both the food and the people that populate the scene.
12. An interaction with a wild animal or a swarm of insects. How does this moment relate to your character's situation now?
13. The day someone died. Or the days before or after the death.
14. A day when they experienced injustice.

15. Something they lost and could never get back.
16. Something they found.
17. A secret they've held for too long.

Look over your list and expand the things that carry the most potential into a full scene and see how it informs your character, story, or chapter. And remember, there is no magic outside of yourself for discovering who your characters are. This, too, is part of the process. But circling around them and finding out new things about who they are and what makes them *them* will guarantee a deeper level of understanding.

When a Character Returns

RION AMILCAR SCOTT

Woodrow and Rita Cunningham's fifteen-year-old daughter Elaine left home after arguing with her father about the boys she entertained in the house while her parents were away. I turned the pages of "A New Man," from Edward P. Jones's collection *Lost in the City,* betting on a return. She's gone for twenty-four hours and then forty-eight. Soon Jones writes that it's "a little more than a year and a half after their daughter disappeared." Finally, it becomes "nearly seven years after Elaine Cunningham disappeared." The pages dwindled, and long before the last sentence, I knew we'd never see Elaine again.

I began reading Jones by dipping in and out of his second collection, *All Aunt Hagar's Children.* I read the title story and felt a swirling in my brain as if new parts of it were being brought to life. Since then, I've read through his work, chasing that feeling. His expansive sentences give the impression of a world alive, a world in motion. I've turned to Jones's sentences from time to time in an attempt to establish that feeling in my work.

Maybe because it was late at night the first time I read "A New Man," but the story left me unusually shaken. To be moved is one of the reasons why I read. Some of the Cunninghams' despair ra-

diated off the page and into me. I didn't want to turn off the lights and lie in darkness, wondering how that poor girl had fared alone in a world as brutal as ours. In an interview on the Politics & Prose website, Jones said, "The new stories [*All Aunt Hagar's Children*] go back to many characters who lived in the first book . . . If I do a third book of stories, I hope to do southern ones and the people in them will be connected with those in the first two books of stories. All the people I create in DC should, in small and large ways, be connected with all the others."

I'd been shaken by the disappearance of a young girl in a story before. When a teenager goes off with some shady young men in Danielle Evans's "Virgins" and does not return by the story's end, all I could do was imagine the million horrible things that could have happened to her. There is not (yet) a follow-up story to assuage my fears.

With "A New Man," there is a story to follow up with. Perhaps, I thought, in this next installment, the grieving Cunninghams find the closure they seek after all. I stayed up later than I should have as I read "A Rich Man," the story in *All Aunt Hagar's Children* that corresponds with *Lost in the City*'s "A New Man." I met Elaine again, older and harder, changed through difficult living ten years after running away. She comes back with little fanfare, introduced as a new character rather than one the author has been dreaming about since first inventing her.

Here, she is the main focus rather than offstage as she is for most of "A New Man." Jones offers up Elaine's missing decade in shards, allowing space for readers to continue to construct her absence for themselves. Instead of feeling comfort in Elaine's return, my heart broke in an entirely different way. I also learned that if you read both of Jones's collections together, it's as if you've discovered a new genre, neither novel nor story, but something unnamed, otherworldly, and three-dimensional.

A story, it is often said, is the most challenging moment—or at least the most interesting moment—in a character's life. As Aristotle notes in *Poetics,* "In composing the Odyssey, [Homer] did not include all the adventures of Odysseus." What we build toward is the moment of change. Begin your story too far from this moment and your story will collapse. Oftentimes, I ask my students to rethink where their story starts and ends. Don't give me a guy in a room thinking about the glory days—give me the glory days.

But what about when a character returns and keeps returning, often altered? Whole stories have happened between the last time we've seen them. Like a friend you haven't seen in a while who has gained or lost weight, or changed their hairstyle and manner of dress, suggesting a story has been going on in your absence. My characters often seem to keep coming back, dancing from one story to the next, the main focus of the camera in one story, deep in the background of the next. And it can be a tricky proposition bringing a character back. If their story has been told, what is this character doing in another story? A recurring character must bring something new to the page each time they show up. Some characters come back because the force of their personalities are needed. Some have more story to tell. Each time though, the weight of what's been written about them previously is there on the page whether it's addressed openly or is implied by the movements of the character.

A character took hold of me years ago just as Elaine Cunningham had; this time she was my own character, an eleven-year-old girl enamored with chess and her father. At the time I was a twenty-six-year-old man struggling to figure out how to connect with characters that seemed to sit lifeless and flat on the page, particularly when assigned attributes associated with women. I would ignore my girl and women characters or give them little to do—perhaps a wooden piece of dialogue here, a crying fit there. But the story that even-

tually became "202 Checkmates" from my story collection *Insurrections* was something different. Writing it was a state of grace that often leads writers to believe a story is writing itself, that characters are speaking, and words are falling from heaven. Stories don't write themselves. Characters on the page never wrench themselves starkly to life; they are objects in an elaborate daydream.

As I wrote, the sickness I had—the aversion and fear and inability to write female characters—was eventually healed. How did I get this girl to turn to flesh on the page? I had to figure out what she wanted, which were the same things I wanted at eleven: a close connection to her father (which I had, and like the girl and father in the story, my dad and I angled, endlessly and sometimes awkwardly, to foster a closer connection), and some understanding of the often cloudy motivations of the adults around her.

When I called this family back into service for another story, there were no sentences falling on my head like snow over Joyce's Ireland. I wrote a few sentences and stopped. And then I wrote some more and stopped until a structure began to cohere. The follow-up story, "Confirmation," I imagined, would be set many years later. The family would have to move differently, reacting to things both unmentioned and hinted at that had happened in the years since. In addition to being older, in between stories the family moved out of poverty, achieving a tenuous foothold in the middle class. I asked myself how that might change the way they would act toward one another. How might this family react to gaining a hold of things they thought they wanted, of landing in a sort of happily-ever-after. Bobby and his mother—she goes unnamed in both stories—minor characters in "202 Checkmates" whom I loved, could now take center stage and be explored in greater depth.

In many ways, "Confirmation" is the opposite of "202 Checkmates." In that first story, I set myself aside mostly, creating the

surface details entirely from imagination. For "Confirmation," I pulled in things I knew: experiences long gone by, childhood crushes unrealized, hurts I knew well because when I poked at them they were still raw and tender.

The father, last seen in "202 Checkmates" in the grips of self-destructiveness, is more heard than seen in the follow-up story. In "Confirmation" it made sense to bring him to the stage to show his change, all the little reactions to the unseen stories he's lived. In this case, the hinted story is the end of his self-destructiveness. Unlike his daughter, whose story has been told, for Robert, there is a question still lingering, a story yet to be related, even if it's not the main narrative. This new placidness Robert has achieved, this calmness, can it possibly last?

There are limits to this sort of cameoing and returning, though. One must remember that each story should stand on its own, rather than reading like an extension of a previous adventure. If the writer has done their job, the cameo is a bonus for the close reader and not an impediment for everyone else. "I wanted more and more of the characters in *Lost* to roam in and out of stories," Jones says of his first book. "I ran out of time and inspiration." Like Jones, I wanted more of my characters to wander in and out of the stories in *Insurrections*, though I don't blame time or inspiration. Sometimes there was no reason for so-and-so to be there or a story had to be cut for the good of the overall book. But every once in a while, it's nice to pick up a story or a novel and see a character we once knew, passing on by like the cat coming back, an old friend returned to say "hi."

What Do You Want from Me

JACQUELINE WOODSON

Here's the thing: everybody wants something. Inside the narrative and out. We want to be loved, we want to be seen, we want to be happy, fed, healthy, housed, needed. Did I say loved? Can I say *loved* enough? And if we're being true to ourselves and the characters we're creating, they want what we want. Hence, the question to ask as a writer is *What do our characters want and how are they going to get it?* Always. Why? Because it's the question we've been asking ourselves our whole lives.

I don't teach, so crafting an essay about some particular area of writing is a challenge. I believe in leading by example and on the next page or two, that's exactly what I'm gonna do.

In the early nineties, I began writing a book that I'd later title *I Hadn't Meant to Tell You This*. When I bent over the page to begin it, it was because I had a voice in my head. The voice was raspy. The girl who belonged to the voice was obviously white. And young. Somehow, I knew that she was poor. She said, *"Black, white, it don't make no difference; we all just people here."* I didn't know why this character who had just suddenly shown up in my brain was saying this, but I knew someone had to respond, had to be at once in conversation and in conflict with the character I named Lena—because

I like the name. Marie, an upper-middle-class Black girl, came out of my thinking about conflict. What did it mean to put two people from different economic backgrounds into conversation? So now I had some characters and a statement. And a whole lot of blank pages in front of me. But I had conflict and people longing to tell their stories. I didn't know yet what was important about their stories and why *right now* was when their stories needed to be told. But I knew my characters had something to say. And having written many books before this one, I knew they had to be more than mouthpieces. They had to have flaws and brilliance. They had to have a deep fragility while remaining unbreakable.

I think there are some writers who believe they have it all figured out, that they know the machinations of their stories early on, from beginning to end. Maybe they're not lying, but I stay doubtful. There is so much that is unknown when we begin telling our stories. I've never been afraid of that unknown. Because in the unknowing comes discovery—of both character and self. With Lena in *I Hadn't Meant to Tell You This*, I wanted to know what she wanted. Why was she in my head? Why now? Was I supposed to be telling her story? What did I know about whiteness? Poverty? The rural Midwest? What did what she was saying—*Black, white, it don't make no difference; we all just people here*—mean? To me? To the narrative? To the greater good? But more than all of this, I kept coming back to the question of what does Lena want? I didn't know. How was she going to get it? No idea.

Here's what I knew back then—that Audre Lorde's *The Cancer Journals* was a big part of my reading. I was using her words in the lectures I was giving to talk about the state of race in this country. I was thinking about the ways to weave her teachings into the books I was writing for young people. Already, she had appeared in two other books of mine: *From the Notebooks of Melanin Sun* and

If You Come Softly. I had put her words into the mouths of young people. Years later, I would write in my adult novel *Red at the Bone* that "if a body's to be remembered, someone has to live to tell its story." Lorde had only recently become an ancestor, and I wanted her remembered the way I wanted Baldwin and Grimké, Haley and Hurston remembered. I couldn't drag all of those figures into one novel, but I could center the work of one and let it be the touchstone for a character or two. Let it be the voice that spoke truth to power. Let it be its own character inside the story. In centering *The Cancer Journals* between Lena and Marie, I began to figure out so much about economic class structure in the novel, about parenting, about loss, about depression and survival. In the early nineties, not a lot of people were doing this in young people's literature. I chose to embrace the fact that what I was trying to write didn't exist yet, knowing that if the characters had the depth and empathy needed to make a reader *feel*, the rest would come.

What did Lena want: to be loved, to be seen, to be safe. What did Marie want: the same. How were they going to get it: by first seeing the depth in each other, the impact the outside world had on them, and their own power. And Lorde's work, I would later understand, was in the narrative to paint a road. "For to survive in the mouth of this dragon we call america, we must learn the first and most important lesson," Lorde wrote, "that we were never meant to survive."

With young people, "You can't" becomes a bit in their mouths that they will pull and bite against until it kills them—or they break free of it. For a long time, I didn't know what my characters wanted. And then I did because I knew what I wanted. To love and be loved. To break free . . . and live to tell the story.

What You Got?

—

The Uses of Memory and Experience

The "Natives of My Person" or Blood Is Not Enough

A Meditation on Literary Kinships

CURDELLA FORBES

In this essay I want to offer a meditation on what writing means for beginning Black writers, and in the process draw out some thoughts towards craft. My focus is on kinship as the motive and subject of writing.[*]

Not so long ago, I had a conversation with a talented young man with dreams not merely of being famous but, to his credit, of being great. The story he showed me was very well written, but I was curious as to how he came to write about the people and places in his story. As far as I knew, he had never lived in the US South (or any part of the USA, for that matter), had not participated in or witnessed the kinds of activities his story described, and unlike the seemingly closely observed characters in his story, he was Black, not white. I want to make this clear: Nowhere in the story were

[*] The title for this chapter comes from the 1971 novel by Caribbean writer George Lamming.

the characters described as white, but it was clear that they were. In answer to my question, he said he had been reading William Faulkner, had become a deep admirer, and felt that if he could write like that, he would attain his dream of greatness. I love Faulkner, so naturally, I was impressed with this young writer's taste. And I could not but be moved by the fact that he had discovered so enabling a kinship—that is, one that made it possible for him to write. (This was a story he hoped to publish; it was not a story he regarded as simply "trying his hand," but as a product of his authentic voice, trained by Faulkner).

You probably see at once that his story and his response involve some troubling issues about power, about the origin of ourselves, and about affect—the kinds of attachments, and perhaps commitments, out of which one writes. But the scenarios in this anecdote are not unusual—quite the contrary.

As writers, we all begin with imitation—it is not simply "the sincerest form of flattery" but the only way we know to begin—we learn to write from what we have read, and perhaps the best creative writing school is an intense apprenticeship with a great writer. From that perspective, there was every reason to applaud the young writer who had committed to close, intense study of William Faulkner's worlds and done it so effectively that had he been a forger, it might have been hard to distinguish his work from the original.

I can hear some of you objecting that it is all well and good to imitate a technique, but why imitate a world that is not his? Why not use (variations on) the techniques to paint a world that is his or at least contiguous to the one he knows—a world to which he is in relation?

What is our reason for such questions? Is the young man's writing a sign of an affective disorder, an alienation from his own culture,

or a lack of conviction that it was interesting enough for fiction? Or is he performing an encroachment, the political (and ethical) egregiousness of which is most clearly seen if the page is flipped and a white person writes intimately about Black people he has never lived amongst or known? Or is it a logical impossibility, this attempt to go against the grain of creative writing advice, "Write what you know"? (If the answer to the last is yes, would your qualms be assuaged if the young man had lived among white people in the US South and made them the chief subject of his work, as did the Black writers Alexandre Dumas in nineteenth-century France, Alexander Pushkin in nineteenth-century Russia, and Frank Yerby in twentieth-century USA?)

To all of these questions, what is the purchase of a response that refuses any form of censorship of the imagination? One could say, without even mentioning science fiction or alternative realities, imagination is an unbounded place, not a country. There is no passport required in this territory where we live to create. Or one could point out that there is no rule that Black people should write only Black characters (or should only "write Black"—a different kettle of fish altogether). Would these be acceptable responses?

Across the Black world, an attraction to white worlds is not uncommon. Growing up many years ago in a new Caribbean country barely emerging from British colonial rule, I was exposed mainly to literature by (mostly dead) white men and women. My childhood models, therefore, were white. Toni Morrison showed us how alive the Black affiliation to whiteness was in 1970s America, with her portrayal of Pecola in *The Bluest Eye*. In her famous TED talk "The Danger of a Single Story," Nigerian writer Chimamanda Adichie, growing up in the 1980s and '90s, tells of her own childhood forays into writing fiction in which all her characters "were blue-eyed . . . played in the snow . . . and ate apples" though none of these "facts"

were Nigerian. Decades later, my Black creative writing students often feel driven to describe protagonists with long brown hair and green or blue eyes (when peers, discomforted, inquire if the character is white, invariably they are told the character is Black. Invariably also, an explanation is offered: Lots of Black people have brown hair and green or blue eyes).

Interestingly, I have never had a male student offer such descriptions; physical appearance in this regard seems to have larger significance for female writers. An intriguing corollary is that I seldom receive descriptions of physical features that identify the character as Black. I muse on two possibilities: Either my students, based on the kinds of literature to which they have been exposed, find it difficult to *imagine* "Black"-looking characters in fiction, or they imagine Black so closely, so much a part of themselves, that there is no felt need to describe "Black" in that way. It's a bit like experiencing oneself in a dream: You know you are there, but you never actually see yourself. Your dreamself is so closely aligned to your deepself that you know, blindfolded, that you are there. If this latter suggestion is right, perhaps the brown-haired/green-eyed protagonist is not quite Black after all, or perhaps such protagonists, who never look like their creators, belong in the realm of desire: to be desirable is to attain a form of Blackness that is closer to white. This particular inhabitance of the color line speaks to a female anguish that, while writing, my young students might learn to excavate.

The issue of why the affinity to whiteness persists will have different answers for different individuals in different parts of the Black world, depending on how the situated legacies of history have played out. But my main interest in this meditation is to flip the direction of our gaze from the Black/white relation and to turn it towards "kin." There are many kinds of kinship, and if kinship is felt in the heart, writing brings the state of health of our heart into

question. Writers such as Chimamanda Adichie, Toni Morrison, and myself questioned the imaginative kinships imposed on us as children. (My marvelous salvation was that I grew up in the rural Jamaican countryside where I was also exposed to a robust oral-storytelling tradition imbued in indigenous orature, and investigating these and other Caribbean forms was major in my journey to my identity as a writer.) But the writers we read have influenced our writing in richer, deeper ways—they remain, we may say, part of our writerly genealogy. Could we say then that they are close enough to be called natives of our person?

Who really is our kin? The answer that each of us makes will to a large extent decide what, whom, how, and why we write. At one level, perhaps for all of us, kin is simply the human collective. But experience is concrete, and we encounter in our daily lives not all of humanity but the communities and groups in which we live and with whom we have experienced together. Our sense of kinship and other forms of affect tend to be with such groups and communities, which include familial, ethnic, national, and racial affiliations. Certainly, in North America, we often think of kin as our close kind in racial terms—what we might call racial family, a community of blood. For many, the African diasporan community writ large is a major dynamic of kinship. But here kin is an extremely complex idea. Even in one immediate family (for example), kin may cross over more than one world diaspora, more than one nationality or race and over several ethnicities, and so, writing kin as we have experienced it is not a straightforward proposition. And when we begin to talk about the diaspora, we may find that we really know very little about each other, sometimes nothing at all, and so the issue of whether we need passports in the territory of the imagination becomes rather messy.

In the end, the kinship choices we make in shaping our creative

worlds will depend on what I call our moral passion—that is to say, what we want to bear witness to, what kinds of lives matter to us enough to make us expend our perpetual struggle with words on showing forth such lives and what we see as their meanings. How we represent "others" will depend equally on our sense of what it means to be human.

I offer three considerations.

1. Kin, like the quotidian, is one of the greatest challenges of writing. In other words, writing the "familiar" is every writer's treasure house. Creative writing, like science, is a form of investigation. To watch the sun appear to move through the heavens—and to discover that, in fact, it doesn't—requires a certain curiosity, a skepticism about what we know; indeed, a conviction that the everyday surface of things, in this case our knowledge of kin, though important, is really not a sufficient truth after all. A work of fiction that is memorable comes to us with the shock of recognition. This is an oxymoron, because we remember this writing for the way it raises fresh wonder, fresh questions about things/people we already knew or thought we knew. If the reader comes to this discovery, it must be because the writer takes nothing for granted.

2. Not taking kin for granted means we understand that we must *learn* kin. That everything we thought we knew about kin is under suspicion. There are always layers that we do not know. Every act of writing brings a new creation into being—things "become" in and through the act of writing. This every writer knows. But before the writing also comes the prior investigation. This can involve many kinds of research. For me as a woman writer, it might mean

listening anew to how men (as opposed to women) talk in order to write a male character. As a writer seeking to authentically represent diasporan "others," I might need to do some reading research, or some interviews, to find out where in Nigeria people say "step down from the bus" instead of "exit the bus" (do all Nigerians talk the same?). As a writer seeking to use hip-hop as a cultural idiom to shape my novel, I might spend a lot more time investigating what energizes hip-hop. As a beginning writer, I might study how writers before me have done this.

In other words, "write what you know" invites us to know more, and more fully and more deeply, as an act of responsibility to our craft and the communities we might use it to represent. That level of authenticity can only come through the keenest and most dedicated observation, bringing all our senses to bear. Sometimes this requires participant observation—deliberate self-immersion in a situation, event, or place. We must become students of our own culture. (This remains true even if one is writing speculatively. The best speculative fictions are based on acute observation of the life-world we inhabit—the only one we know and therefore the only one in whose image our fictive worlds are created.)

3. I believe that to be a good writer, one has to begin with an idea of kinship as encompassing the whole human collective (I do not want to say "race" since "race" might defeat my point). If our writing is to illuminate something of what it means to be human, it probably cannot deal in stereotypes or ideal characters. Even a character written as an enemy partakes of the messy asymmetry of the human. A racist killer may love his biracial children (What is his history?).

A preteen deeply attached to her mother may be ashamed of her mother because her mother cannot read or write. A character can hate the person they love without this being an irony.

In insisting on concrete observation/experience/research and the messy consistency of the human, I highlight the authenticity that strikes the reader and lays a responsibility upon us. One strives to be a good writer, not a Black one. When that happens, my reader, whoever they might be, will know that I am Black and will meet, with the shock of recognition, my human story.

Sweet, Bittersweet, and Joyful Memories

JEWELL PARKER RHODES

MY BEST ADVICE

Memoirs are less about the chronology of events and more about the spiritual and emotional quality of life. As with real memories, emotional images dominate. The emphasis is not on logical truths but on interior needs, dreams, and desires.

Images—word pictures—aren't exclusive to memoir. In fact, most fine writing relies not only on concrete descriptions but on more evocative, imagistic renderings as well. Both Patrice Gaines's autobiography *Laughing in the Dark* and Rosemary L. Bray's autobiography *Unafraid of the Dark* use the color of darkness as an image of something to be overcome. Nightmares, demons, fears, lack of social- and self-awareness (as in "being in the dark") suggest women's struggle to overcome barriers toward selfhood. Because the color of darkness is also associated with Blackness in racial divisions, both women emphatically celebrate their ethnicity while deploring racist connotations.

For Lorene Cary in her novel *Black Ice*, the image of "black ice" becomes a powerful image of growth. "I have never skated on black ice, but perhaps my children will." Ice—slippery, dangerous, frozen, and cold—can become a triumph, a state of grace. And ice can uniquely reflect the blackness of an ancient earth. In *I Know Why the Caged Bird Sings*, Maya Angelou, too, plays on the way racism inhibits growth with her image of the "caged bird." But this image also evokes limits of gender, geography, experiences, and much, much more. Angelou the young child, once silenced, learns to sing songs of herself despite societal limitations; in doing so, she becomes internally and eternally free.

Well-formed images capture the essence of memories, the essence of interior feelings and yearnings. Each of us, I believe, is swayed by powerful images that shape us at least as much as, if not more than, actual events. For example, anyone can report, "In 1985, I was fired from my job." But if someone asks, "What do you remember of the day you were fired?," chances are the response would be in "word pictures," images of bleakness on a bright, sun-filled day. Perhaps you pictured yourself growing smaller and smaller as giant-sized guards cleaned out your desk and escorted you out the door. Images may have flitted through your mind—pictures of a mouth clamped shut when you wanted to scream, hands shut tight when you want to flail and hit. You may even have fantasized about hitting a smirking coworker.

What images shape your most potent memories? Darkness? Silence? Music? Jail? A euphoric high? A nurturing touch?

What images shape your most potent dreams? Sometimes what we dream is a reflection of our conscious life. Dreams of an ancestor visiting from the dead, an endless walk toward the horizon, even a dream of hitting a "lucky seven" can signify the tenor of our waking life and of our past memories.

Images—word pictures—are reflective of your theme. *Theme is what your story means*, what you're trying to express as an author, what you're trying to say to readers.

In African American autobiography, the thematic message is often a testament to survival. As in the song "We Shall Overcome," autobiographers tend to write about the social, economic, and cultural barriers they've broken to succeed. Memoir, too, may cover this terrain, but the writer has greater freedom in selecting which portions of his or her life to reveal. Henry Louis Gates, Jr., in his memoir, *Colored People*, speaks lovingly of a community that nurtured its children. Veronica Chambers, in her award-winning *Mama's Girl*, focuses on her bittersweet relationship with her mother. Bebe Moore Campbell, in *Sweet Summer: Growing Up With and Without My Dad*, focuses on the summer months she went South to live with her father.

Writing a memoir offers a multitude of advantages primarily because, as an author, you have a range of choices regarding what to tell or not to tell. Autobiography demands explanations of how a life journeyed from point A to point B. A memoir may focus on only one significant summer spent backpacking after you finished college. Or you may write about the year you spent training for the New York marathon or attending culinary school or preparing for an amateur piano competition. You may even want to write about your role as caregiver to aging parents or your quest to adopt a child.

Memoir's scope can be narrower and deeper than autobiography. But even though you're writing more selectively, don't sacrifice the sense that you're sharing a special story with significance for you and perhaps for others. As with autobiography, the reader wants to feel pulled into the essence of your life.

Before beginning a memoir, you should ask yourself:

- What unifies your memoir? Is there a particular image associated with a special time of your life? An overwhelming event, such as new parenthood, midlife renewal, or living in a foreign land?
- What is important about your memories? What do you hope to communicate about them? How do you think they will be useful, entertaining, meaningful to others?
- Are you intellectually and emotionally ready to confront the totality of your memories—the pleasant as well as not-so-pleasant aspects? Are you ready to recognize the complexity of events, time, space, and distance that influenced experiences as they were then, as well as the experience of recovering memories now?
- Do you recognize how remembering is an act of recovery, of retrieving vital information about your life and your survival?

History and memory are intertwined. When choosing a subject to write about, you should let your passions be your guide. Write only about those memories that are most essential to who you are, your quality of living, and being in this world. Memories are the essence of the self.

Originally published in *The African American Guide to Writing and Publishing Nonfiction*, 2002.

How to Write a Memoir or Take Me to the River

MARITA GOLDEN

I launched my career with a memoir, *Migrations of the Heart*, published when I was thirty-three years old. Carol Mann, a Manhattan literary agent, had read a draft of my first attempt at a novel. In a meeting in her Lower East Side office, she was encouraging, and then she asked me about my life. When I told her that I was visiting from Lagos, Nigeria, where I lived with my Nigerian husband, her eyes brightened with interest. When I told her that I had come of age as a Black Power activist in college, was a feminist, a freelance journalist, and now lived in the capital city of Africa's most populous nation as a member of a large Yoruba family, she smiled in surprise. When I shared stories of my struggle to maintain my back-to-the-motherland idealism in a society that was deeply patriarchal and tribalistic, and did not recognize me as returning kin, and that despite all that I felt more comfortable in my skin living there than I ever had in America, she asked me if I had ever considered writing a book about all of that. My answer was no. A year later, as my marriage dissolved, and I contemplated and planned a return to the US, the answer became yes.

Migrations of the Heart was published in 1983, and over the next several years as women and people of color nudged their stories into the center of discourse, it became a widely read book on college campuses and with book clubs. It remains in print today. Memoirs now rival novels in popularity, are studied, critiqued by scholars, make the bestseller list, and at their best are a form of literature and art. In between novels and anthologies, I followed *Migrations of the Heart* with two "communal memoirs" (my term), *Saving Our Sons: Raising Black Children in a Turbulent World,* where I wrote about raising my son against the backdrop of the urban violence of the 1990s and wove into that narrative the stories of other families, and *Don't Play in the Sun: One Woman's Journey Through the Color Complex,* the story of my journey as a brown-skinned woman in a color-conscious world that included powerful stories of men and women of all shades who had experienced colorism.

The memoir is, in my view, cousin to the novel. I advise memoirists to read novels to learn how to create a unique, resonant world—a place and space that is irresistible and that becomes reflective, a mirror in which the reader sees themselves. I advise novelists to read memoirs to absorb that authentic, vulnerable, yearning *voice of story* that becomes testimony and witness. Voice makes memoir memorable. Who is telling their story? Does their voice force me to care?

———

A memoir is the story of a portion of your life, a period of transition, change, growth. Maya Angelou's *I Know Why the Caged Bird Sings* is the story of a young girl growing up in the 1930s Deep South as a victim of rape and racism, but it is mostly the story of

how Maya was saved by the love of her grandmother and her love of literature, how she gained a spirit that would lead her to soar throughout her life.

The childhood years are formative, where we are shaped by the imprint of parents, family, community, and by what we are given and denied. Our childhoods are a repository of clues to our future and where the seeds of our dreams are embedded in soil that, whether rich or rocky, is our inheritance. In *Migrations of the Heart*, I wrote about coming of age, getting Black and proud, falling in love, becoming a mother, finding my writer's voice against the backdrop of a decade that saw walls that had blocked Black progress come tumbling down. I lost my parents, a child, a marriage, but made peace with my dual African and American identities and defined myself as a citizen of the world.

What portion of your life and experience is calling for you to examine and re-create it? I believe that we write memoirs not because we want to, but because we must. To find our way through our lives and show the way to others. Memoir is art and literature, and it can be therapy. How did your childhood, the loss of a loved one, surviving trauma, achieving a goal, make you bolder? Memoir captures the essence of the experiences that you turned from obstacles into lessons. Your life is a story, and you are its hero.

Why would anyone care, you may wonder? A compelling story told in language that is beautiful and honest and true turns any story into a balm. Beautiful language fearlessly tells a story in all its colors and feelings. Beautiful writing does not shrink from memory or revelation because it has been defined as taboo or shameful. Beautiful writing rushes in toward those stories, armed with a mission.

Focus on that slice of your life that haunts and inspires you. That is the material of your memoir. Where to begin? I remember feeling

overwhelmed by stories, anecdotes, memories, as I tried to decide how to begin my memoir. I finally chose to open by telling the reader about my parents. Parents who had both died years earlier. Parents who I would search for and try to reconnect with in all my writing. *"My father was the first man I ever loved."* That is the first sentence.

That sentence precisely captures the significance of my father in my life, as well as how my Nigerian husband was in many ways an echo of his character, and how important were the stories of Africa that my father raised me on in shaping my destiny. That single sentence is the result of many hours of remembering how much I loved my father and what that meant for the memoir I was struggling to compose. I dove into the hard places of our often-difficult love as the gift of hindsight revealed the resilience of that love. I began my memoir with my father not because I loved him more, but because our love had involved more convulsions, more storms than my love of my mother. *"My father was the first man I ever loved."* The sentence is a confession and an invitation, one that roots the loves of my womanhood to the love I felt as a child. That sentence is in some ways an outline of the book.

Who from your childhood impacted you this deeply? Can you capture in a sentence or paragraph what they gave you and what that gift meant?

——

Writing a memoir forces you to take ownership of the story of your life. Ownership means claiming your life and all its false starts and final reckonings. There are no half measures, no second guessing in a memorable memoir. *This is who I was. This is who I am. These are the emotions I felt. This is my mother. This is my father. This is me.*

Writing a memoir means being prepared to evaluate your life and to uncover its terror and grace. To discover all that and shape it into a story. Memoir has allowed me to understand how much I loved my parents, how much they loved me, my strength and resilience, and the ways that my life is a reflection of the lives that all of us live.

You must be willing to tell your story. Driven by the desire to write about your life, you approach the endeavor with curiosity and passion, with a desire to answer questions that have shadowed and molded you. Actively curious about your life, you become writer and truth seeker. You remember and re-create your family, your childhood, and your seminal experiences as part of a process that is creative, inevitably therapeutic, and artistic. You are writing a memoir because you want to. Maybe because you need to.

There is no unimportant or insignificant life. Memoir reveals the monumental and the momentous in the mundane. Individual choices, dreams, challenges are all we have, and what they reveal about us can inspire and sometimes save the souls of readers. *Black Boy* by Richard Wright, the memoir of his childhood and youth in the segregated 1930s South, is an important American text because Wright knew that his story mattered and deserved to be told. Wright portrayed the complex humanity of his family, the grandeur of his quest for literacy, opportunity, and agency in the wider world. He knew that his story, the story of millions of Black boys, was a story the South had attempted to strangle, abort, and censor. It was a story bigger than him, a story that had to be told. Your story is bigger than you. To write your story well, you must fully understand and be willing to stand up for its significance and necessity.

I "owned" my story in *Migrations of the Heart* by documenting in vivid detail coming of age in an era of assassinations (John F. Kennedy, Malcolm X, Martin Luther King Jr., Robert F. Kennedy), political upheaval and change (the civil rights, women's, and Black

Power movements), and transformation of identity (the Afro, from Black to Negro, Black Pride). I became an adult during one of the most dramatic historic moments and so recreated the tenor and tone of that time and how it imprinted me.

Owning the ways in which I was unfair to my father, I revealed vulnerability and stubborn pride. Every reader has yearned for parental approval, been willful, and has loved badly. Every twist and turn of your heart affirm for the reader that you are writing an authentic story and that they can trust you as narrator of your life. Critics of memoir often write off the form as a genre stuck in the mud of trauma and pain and little more. But we are all damaged in some way and how we prevail and triumph and become so much more is the material of all human story, from the oldest myths to contemporary literature.

Kathryn Harrison's memoir *The Kiss* recounts a childhood growing up isolated from a father who came back into her life when she was a young adult and manipulated her hunger, need, and love for him. The result was a toxic reunion that found expression in an incestuous affair. Harrison spent years masking her story in novels about women who were silenced and abused. When she became a mother, she decided that her daughter needed to know how she had survived this history to become the strong, creative writer, woman, wife, and mother who found a final peace, one without shame and guilt.

What must you own in order to write your memoir? You must be prepared to pay the price and reap the rewards of all that owning your story will require.

One is never afraid of the unknown; one is afraid of the known coming to an end.

—Jiddu Krishnamurti

Where You At?

—

Place, Environment, Regionalism, and Setting

Looking for a Place Called Home

W. RALPH EUBANKS

To become intimate with the place you are from is to realize how much one place affects every part of your life, including the way you see the world. Although I grew up in Mississippi, as soon as I possibly could I left the South, first to wander through England and Ireland and then to live in the North, first in Michigan and for nearly forty years in Washington, DC. If someone were to ask me what stands at the center of my writing, I would have to say it is the search for home. And there is no need to go looking for a place to call home unless you are lost.

Although I have lived an unbelievably lucky and happy life, I have been lost in ways that no map could ever assist me. In the years after I left Mississippi, when I thought I had shed my Southern skin, I felt the place tugging at me on city streets, asking me to come back. It was not until well into middle age that I answered that siren call to return. In the moment that I sat down on the same patch of ground where I came from—on the exact spot where the house I grew up in had been flattened by a tornado years before—I came to realize that both the place I had run to and the place I had run from were both home. One was a place I had constructed for myself to feel at ease in the world, and the other was my true spiritual home,

even though the place still puzzled me. Both the North and the South are a part of me, but Mississippi left its mark on me, affecting what I saw in the world as well as how I felt about what I saw. In time I learned Mississippi can never be escaped; it leaves an invisible tattoo on your soul that can never be removed.

Now I have returned to the South—at least for part of the year—to teach writing and literature. As I have learned since my return, there can never be a full repatriation to the place you once called home after you have left. A divided sense of self becomes a part of your identity. Part of returning home is accepting a feeling of exile amidst the familiar. One of the ways I have found to cope with my feelings of displacement is to reconnect with Mississippi the place: its geography, its literature, and its history. Seeking to understand the place where I am from has become a spiritual necessity. Writing about the South as a place—and specifically Mississippi—has made me feel less lost. I am certain there are other writers who feel the same way about the places where they are from, but the South is different because Southerners feel the need to explain the place they are from.

Writing with a sense of place is often seen as the domain of Southern writers, particularly white Southern writers, because of that need to explain. Unfortunately, the literary world often conflates *Southernness* with whiteness. But place and the search for home have long stood at the core of much of African American writing. Black people are shaped just as much by the places they are from as by the cultural forces that shape Blackness. Whether you are writing about the urban North or the rural South, it is important to give readers a sense of where they are and where you come from.

To write about place, first, you must understand the nuances of the place you are writing about and seek to live in that place as thoughtfully as you possibly can. Describe its geography, tell about

the people who live there, and capture the unique voices of those people. Create your own archive of the place—more about that later—whether these are notes and impressions you collect in a notebook or voices you capture in an interview.

Next, imprint a visual image of the place on the mind of your reader. Describe as many details as you possibly can. For example, what I remember most about the first time I visited Mississippi's Parchman prison was the color of the sky: It was the same color as a bruise. At the time, there was a rash of violent activity at the prison, and I came to associate that sky with that violence, leading me to describe that sky as "bruise colored" and the land itself as "a wound on the landscape of the Delta."

Then, bear in mind that place has an ongoing and lasting impact on human experience, including how you see the world. Explain to your reader how one place in particular place helps you understand other places. Tell how that place has changed and evolved over time, trying as hard as you can not to wander off into the land of nostalgia. Yes, there is always a tendency to wax nostalgic when writing about memory, but it can be avoided by asking yourself honest questions about a memory. I always say that a good memoirist should never trust their memory. Ask yourself hard questions about those memories and seek to expose the truth that time simply allows memories to be polished up and varnished. And very often those questions can be answered by thinking long and hard about a place and other things that happened there, not just the ones that you choose to remember fondly. And that is the power of using place as an archive. If you dig deep, just as you would in a physical archive, the truth is often revealed.

I think of archives as the source that can help us make and create narrative connections that push us toward truth. But it was while working on my book *A Place Like Mississippi* that I began to think

about place as an archive. This took me beyond print records and ephemera that I might find in dusty archive boxes and onto the roads of Mississippi to engage with the cultural memory this state's writers have layered over the landscape. If one begins to think about the land, its geography, and its provenance, it becomes an actual source rather than simply a narrative setting. When I learned to use place as an archival source, I came to realize that while researching place, with your insights and observations you are creating your own archive: What you see becomes layered over what others have seen imprinted on the same landscape.

———

In fact, I owe the narrative structure of *A Place Like Mississippi* to both a place and a poem about that place.

Traditionally, the story of Mississippi literature begins in the Delta. Breaking with tradition, I decided to begin the story in a place most Mississippians view as the end of the state: the Gulf Coast. Mississippi Highway 49 runs across the expanse of the Delta, along the edge of Hill Country, directly through the Piney Woods, and ends at a pier in the coastal town of Gulfport. Yet the highway's terminus at the Gulf of Mexico actually marks the beginning of Mississippi rather than the end. Of course, the main reason many think of the coast as the end of the state is because it is a place associated with the names of two powerful storms that felt like an ending: Camille and Katrina. In the popular imagination, the Mississippi Delta looms larger than life since it also hugs the shores of the state's mighty river and inspired the musical art form known as the blues. But it is because of those life-altering storms on the Gulf Coast that we see how Mississippi can be remade, reshaped, and transformed. Natasha Trethewey's "Theories of Time and Space" made me real-

ize that I needed to begin the story of Mississippi's literary landscape on the Gulf Coast. As Trethewey notes in her poem:

> You can get there from here, though
> there's no going home.
>
> Everywhere you go will be somewhere
> you've never been. Try this:
>
> head south on Mississippi 49, one-
> by-one mile markers ticking off
>
> another minute of your life. Follow this
> to its natural conclusion—dead end
>
> at the coast, the pier at Gulfport where
> riggings of shrimp boats are loose stitches
>
> in a sky threatening rain.

This is another example of how place served as an archive—I went to that spot on the coast when I began the book—with the inspiration for narrative structure coming from the drive I took through the state: through Natchez and Vicksburg, the Piney Woods, Jackson, the Eastern Hills, Hill Country, and finally, the Delta. "Theories of Time and Space" was echoing through my head as I made that trip, and I feel I owe a great deal to that poem for letting me know that there was a specific place I should travel to and write about. What I saw on that spot came to be layered on what Trethewey saw and felt on that spot, giving me a new source for writing about a particular place. For a book about Mississippi

writers and their relationship to the landscape, I learned that I needed to follow the instincts of individual writers about the places that shaped them. That meant traveling to those places and spaces to see how the real and imagined sometimes blend together. These places became my archival sources.

Each time I enter an archive, I can't wait to get the boxes and to start to read through the folders and see what I find. Working in archives stirs up the detective and sleuth inside me, since I never know what I might stumble upon in a folder or what connection I will make that will help me figure out a piece of the puzzle that I am exploring in my writing. But thinking about place and the Southern landscape as an archive now stirs up the same sense of discovery and anticipation.

Although I am a writer who leans on archival sources, I have come to enjoy creating my own archive by exploring place. A place can sometimes help you see how the historical and lived experience intersect as much as a physical document, since a place forces you to be descriptive as well as to provide historical background. But perhaps most important, using place as an archival source forces you as a writer to paint the picture on the page of what you see as much as what you are thinking. And it is in that picture on the page that perhaps both the reader and the writer can begin to seek out a place that feels like home.

On Abiding Metaphors and Finding a Calling

NATASHA TRETHEWEY

"I ask: what's been left out of the historical record of my South and my nation? What is the danger in not knowing?"

1. Abiding Metaphors

When I was three years old, I nearly drowned in a hotel pool in Mexico. My earliest memory is of what seemed a long moment, as if I were suspended there, looking up through a ceiling of water, the high sun barely visible overhead. I do not recall being afraid as I sank, only that I was enthralled by what I could see through that strange and wavering lens: my mother, who could not swim, leaning over the edge—arms outstretched—reaching for me. She was in the line of the sun and what she did not block radiated around her head, her face like an annular eclipse, dark and ringed with light.

It was 1969, a trip with my parents—my Black mother, my white father. Looking back now I can see this is where it begins, what Robert Frost insisted was a necessary education, a *proper poetical education in the metaphor*, and the establishment in my consciousness of the abiding metaphors by which my work as a poet is always influenced. Beyond my vivid memory of nearly drowning—an image to

which I'll later return—only one other image of the trip remains: a photograph. In it, I am alone, there are mountains in the distance behind me, and I am sitting on a mule.

———

In his essay "Education by Poetry," Robert Frost wrote: "What I am pointing out is that unless you are at home in the metaphor, unless you have had your proper poetical education in the metaphor, you are not safe anywhere. Because you are not at ease with figurative values: you don't know the metaphor in its strength and its weakness. You don't know how far you may expect to ride it and when it may break down with you. You are not safe in science; you are not safe in history."

Like Frost, my father believed in the necessity of a thorough grasp of figurative values. He was a poet and had begun my education in metaphor as early as I can remember. It was his idea to place me on the back of the mule—a linguistic joke within a visual metaphor: the sight gag of a mixed-race child riding her namesake, animal origin of the word *mulatto*. It was my father, too, who—perhaps oblivious to his own metaphors of animal husbandry—referred to me as a *crossbreed* in one of his poems, who taught me the phrase *Heinz 57*, a term for someone racially mixed. "All mixed up," he'd said. Of the many photographs from my early childhood, only this one suggests what I'd come to understand that each of my parents wanted me to know.

The picture represents my father's desire to show me the power of metaphor: how imagery and figurative language can make the mind leap to a new apprehension of things; that we might harness, as with the yoke of form, both delight and the conveyance of meaning; that language is a kind of play with something vital at stake.

In my work I turn often to photographs and other documentary and archival evidence, seeking to describe not only the "luminous details" of history, to borrow Pound's phrase, but also to focus in on what Roland Barthes referred to as the "punctum"—the thing that pricks you, wounding you into recognition. If there is a luminous detail, a punctum, in the photograph I described, it is not the fringe of lace on my sock, like an eyelash around my ankle, nor the delicate smocking on the bodice of my dress, but the way—simultaneously, it seems—that the mule and I have turned our heads to face the camera. This is what takes me out of the frame to contemplate the circumjacent conditions of the historical moment, of law, of received knowledge and knowledge production, and of science.

My mother had come of age in Mississippi during the era of Jim Crow and at the height of the Civil Rights Movement. She had grown up steeped in the metaphors that comprised the mind of the South—the white South—and thus had not missed the paradox of my birth on Confederate Memorial Day: a child of miscegenation, a word that entered the American lexicon during the Civil War in a pamphlet. It had been conceived as a hoax by a couple of journalists to drum up opposition to Lincoln's re-election through the threat of amalgamation and mongrelization. When I was born, my parents' marriage was illegal in Mississippi and as many as twenty other states in the nation, rendering me illegitimate in the eyes of the law, persona non grata. My father was traveling out of town for work, so she made the short trip from my grandmother's house to Gulfport Memorial Hospital, as planned, without him. On her way to the segregated ward, she could not help but take in the tenor of the day, witnessing the barrage of rebel flags lining the streets, flanking the Confederate monument: private citizens, lawmakers, Klansmen hoisting them in Gulfport and small towns all

across Mississippi. The twenty-sixth of April that year marked the hundredth anniversary of Mississippi's celebration of Confederate Memorial Day—a holiday glorifying the Lost Cause, the Old South, and white supremacy—and much of the fervor was also a display in opposition to recent advancements in the Civil Rights Movement, namely, the Civil Rights and Voting Rights Acts of 1964 and '65.

Sequestered on the *Colored* floor, my mother knew the nation was changing, but slowly. She knew, as the figurative level of the photograph suggests, that I would have to journey toward an understanding of myself, my place in the world, with the invisible burdens of history, borne on the back of metaphor, the language that sought to name and thus constrain me. I would be both bound to and propelled by it. She knew that if I could not parse the metaphorical thinking of the time and place into which I'd entered, I could be defeated by it. *You are not safe in science; you are not safe in history.*

2. You Are Not Safe in History

Growing up in the Deep South, I witnessed everywhere around me the metaphors meant to maintain a collective narrative about its people and history—defining social place and hierarchy through a matrix of selective memory, willed forgetting, and racial determinism. With the defeat of the Confederacy, wrote Robert Penn Warren, "the Solid South was born"—a "City of the Soul" rendered guiltless by the forces of history. "By the Great Alibi," he continues, "the South explains, condones and transmutes everything . . . any common lyncher becomes a defender of the Southern tradition. . . . pellagra, hookworm, and illiteracy are all explained, or explained away. . . . By the Great Alibi the Southerner makes his Big Medi-

cine. He turns defeat into victory, defects into virtues. . . . And the most painful and costly consequences of the Great Alibi are found, of course, in connection with race."

Because it was a society based on the myths of innate racial difference, a hierarchy based on notions of supremacy—white superiority and its conjoined twin Black inferiority—the language used to articulate that thinking was rooted in the unique experience of white Southerners. The role of metaphor is not only to describe our experience of reality; metaphor also shapes how we perceive reality. Thus, in the century following the war, the South—in the white mind of the South—became deeply entrenched in the idea of a noble and romantic past. It was moonlight and magnolias, chivalry and paternalism. The Blacks living within her borders, when they were good, were "children" to be guided, looked after, protected from their own folly, "mules" of the earth, "darkies" with the "light of service" in their hearts. When they stepped out of line, they were "bad niggers" from whom white women—carriers of the pure bloodline—needed to be protected; they were animals to be husbanded into a prison system modeled on the plantation system—or worse, *strange fruit hanging from the poplar trees.* On the monumental landscape, in textbooks, they were unstoried but for the stories told about them. In my twelfth-grade history book they were "singing and happy in the quarters," "better off under a master's care." According to my teacher, they were "passive recipients of white benevolence" who'd "never fought for their own freedom"—even as nearly two hundred thousand fought in the Civil War.

And when they seemed exceptional in the mind of the South, they were magical: *You're smart for a Black girl, pretty for a Black girl, articulate—not like the rest of them . . .*

Through the misuses of history, the creation of "hallowed" falsehoods, as historian John Hope Franklin pointed out, the white

South found "the intellectual justification for its determination not to yield on many important points, especially in its treatment of the Negro."

———

"Geography is fate," wrote Ralph Ellison, adapting Heraclitus's axiom to the idea of place rather than character. In Georgia, a hulk of bald granite called Stone Mountain serves as a lasting metaphor for the white mind of the South. The nation's largest monument to the Confederacy, it rises out of the ground like the head of a submerged giant—the nostalgic dream of Southern heroism and gallantry emblazoned on its brow: in bas-relief, the enormous figures of Stonewall Jackson, Robert E. Lee, and Jefferson Davis. I grew up near the base of the mountain, in its shadow, dividing my time between Georgia and Mississippi. In both geographies, public monuments and the associated rituals of memory and memorialization provided the nascent framework for my interest in the intersections and contentions between personal and public memory, the creation of cultural memory and collective history with its absences, its erasures and omissions, and notions of voice and authority in the making and documenting. "Those who can create the dominant historical narrative," wrote historian David Blight, "will achieve political and cultural power." I ask: what's been left out of the historical record of my South and my nation? What is the danger in not knowing? How does historical amnesia shape our perception of the world, our interactions with others? How am I complicit in wielding the tools of silence and oblivion?

In my collection *Native Guard*, these questions guided my research—the scholarly investigation that led to the act of discovery that poetry engenders. As poet Mark Doty wrote: "Our metaphors

go on ahead of us." I began researching and writing *Native Guard* with an interest in exploring the history of Black Civil War soldiers on the Mississippi Gulf Coast to whom no monuments had been erected. As historian Eric Foner points out, of the hundreds of Civil War monuments North and South, only a handful make any mention of Black participation in the war. In my hometown, and even in the National Military Park in Vicksburg, they had been erased from the monumental landscape and from our cultural memory as well. At the spine of the collection is the title poem, a sonnet sequence that illuminates the life of an imagined soldier, a member of the second regiment stationed off the coast of Gulfport at the fort on Ship Island. I'd grown up going out to that island every year on the Fourth of July, taking the tour of the fort, and never once learning from the park ranger anything about the Black Union soldiers who'd been stationed there, guarding Confederate prisoners. That certain facts are often left out of local historical narratives and (perhaps until most recently) were likely to be given only a small part in larger histories suggests something about the way Americans remember the Civil War and its aftermath, how we construct public memory with its omissions and embellishments.

The South of my childhood was a landscape overwritten with a dominant narrative, burying almost completely any others. But for the streets named for Martin Luther King Jr., the monuments were mostly to Confederate soldiers, staunch segregationists, governors, and Klansmen, often one and the same. The textbooks I read glorified the institution of slavery, devoted little time to Reconstruction and the horrors inflicted upon African Americans in the aftermath of Reconstruction, the Jim Crow era, and the Civil Rights Movement. I felt both erased and then penciled in again as the descendant of a caricature—the raggedy Black minstrel who'd given his name to the whole race. I felt profoundly E. O. Wilson's

words: *Homo sapiens is the only species to suffer psychological exile*. I was an outsider in my own homeland: my Mississippi—with its myriad contradictions—home to "the most Southern place on earth," so named for its brutal history of injustice, racial oppression, violence, and lynching; my Mississippi, birthplace of the blues, a literary tradition rich and fertile as Delta soil, one of the poorest states in the nation; my Mississippi, with its terrible beauty—to borrow from William Butler Yeats—borne on the backs of slaves and through the resistance of their descendants, the astonishing resilience of African Americans in the face of Jim Crow: a terrible beauty born in spite of it. As in W. H. Auden's memorial to Yeats—*Mad Ireland hurt you into poetry*—Mississippi inflicted my first wound.

Writing *Native Guard* was a way to talk back to authoritative histories, to confront the misapprehensions therein, to restore what had been erased. According to historian C. Vann Woodward, during the last two decades of the nineteenth century and the first two of the twentieth, by commissioning the writing of textbooks, the erecting of monuments, the naming of roads and bridges, it was "white ladies . . . who bore primary responsibility for the myths glorifying the old order, the Lost Cause, and white supremacy." Woodward was referring, specifically, to the United Daughters of the Confederacy, the Daughters of the American Revolution, Daughters of Pilgrims, and Daughters of Colonial Governors; they were considered "guardians of the past." "Non-daughters," he writes, "were excluded."

In Southern poetry, this kind of public memory making is rooted in the Fugitive-Agrarian stance that, according to the editors of the anthology of twentieth-century Southern poetry *Invited Guest*, "supplied the central discursive structures from which African Americans and women would compose in antithetical fashion, that is, a thesis giving rise to an antithesis." I see my work, however, not

merely as antithesis, but as synthesis, and the agrarian sidestepping of race as an unfortunate, though integral, omission. As in a photograph in which someone has been cut out—the empty space, a hole letting the light shine through—the absence becomes as palpable as the former presence. My work to fill in the blanks, the absences and omissions, is not, then, antithetical; the narratives I seek to restore have been there all along. Thus, in positioning myself as a native daughter, a *native guardian* of Mississippi's past, I sought to write myself into the history of my symbolic geography on my own terms and to challenge certain notions about the canon of Southern literature.

In a larger sense, the title *Native Guard* held for me not only literal but also figurative possibilities, and in writing it I discovered what lay beneath the surface of my scholarly inquiry. "We make of the quarrel with others, rhetoric," wrote Yeats, "but of the quarrel with ourselves, poetry." I had begun with the quarrel I had with my state, region, and nation over historical amnesia—willed forgetting of the role of African American soldiers in the Civil War and selective remembering about the aftermath. By the time I was finished I had discovered the argument with myself: all those years after my mother's death I had never put a monument on her grave. She lay in the ground unmarked, not properly memorialized by the one whose native duty it was to remember. Like those Black soldiers, she had been erased from the monumental landscape. My metaphor had gone on ahead of me; the work of research is what allowed me to catch up to it.

Though in my work I move frequently between free and fixed forms, *Native Guard* is my most formal collection. In it, traditional forms become not only a container for grief but also—as with the repetition of the blues—a way to transform it. I see also in the attempt to re-inscribe narratives that have been erased the need for

repetition. It is necessary not only to say a thing, but to say it again; thus, I make the most use of received forms that are rooted in repetition and refrain: the crown of sonnets, the villanelle, pantoum, ghazal, palindrome. These forms, too, are monumental.

Audre Lorde wrote, "The master's tools will never dismantle the master's house." I know, of course, that she was referring to the myriad tools of oppression, from laws to custom, all rooted in the thinking—powerfully metaphorical—that shapes our perception of others, the social reality we create in which to live. But when I read her words, I can't help but think of the received forms of poetry I learned in school—sonnets, for example—and how I have turned to such forms to contain the subject matter necessary to challenge the master narrative. In that way, I believe the traditional forms—the masters' tools—can help in the dismantling of a monolithic narrative based on racial hierarchy, willed amnesia, and selective remembering.

3. You Are Not Safe in Science

And by science I mean, in the largest sense, *knowledge*—philosophy, the science of thought. This is where the danger of which Frost warned is for me most piercing. Thus far, I have been speaking of the mind of the white South—the received knowledge of the region, seemingly discrete, informed by the inhabitants' perceptions of their lived experience, and yet not: a knowledge whose roots stretch back centuries and across space as well as time. Consider again the mule, the mulatto, what Immanuel Kant—in his racial classification—referred to as *Mittelschlag*. Indeed, it is through the knowledge production of Enlightenment scientists such as Linnaeus and philosophers such as Kant and Hume that we can chart the codification of racial difference and hierarchy, the roots of nineteenth-

century scientific racism, and the bedrock of ongoing, deeply ingrained, and often unexamined contemporary notions of racial difference—received knowledge becomes synonymous with truth. Thus, in my collection *Thrall*, I was interested in examining empire and the intersections between the sciences and production of ideas of racial difference across the age of reason.

In the introduction to his fifteenth-century book of Castilian grammar, Antonio de Nebrija wrote, "Language has always been the perfect instrument of empire." I found my way to the title *Thrall* by considering the word *native* in its relationship to empire and colonization. The etymology is rooted in slavery: the word's primary definition, *someone born in bondage, a thrall.* My exploration of the language of empire focused on the lexicon used to define mixed-blood people and metaphors to maintain ideas of innate difference and inferiority: for example, what was codified as the *taint* of Blackness—the eighteenth-century mythology that, even if hidden from plain view, not evident in skin color, it could be identified by the presence of a dark spot on the genitals of anyone with African blood.

The sequence of poems that is the foundation of the collection takes as its starting point the eighteenth-century Mexican casta paintings that depict the various mixed-blood unions taking place in the colony, the children of those unions, and their social status and perceived place in a society growing increasingly racialized. In colonial Mexico, the designation of *casta* relegated those with mixed blood to various levels of the social strata, beneath the pureblood Spaniards. The casta paintings, in their depiction of these mixed-blood offspring of natives and slaves and conquerors, present a captivating taxonomy as well—words on each canvas that name the racial makeup of the figures. The paintings were done in series of sixteen, beginning with the white Spaniard

father. The ideas suggested by the paintings, echoing the knowl-
edge production of the period, have stayed with us, embedded
as latent cultural beliefs: for example, that through a few gener-
ations of mixing, indigenous blood could be purified to white-
ness, but that the taint of African blood, as with the one-drop
rule, is irreversible. In colonial Mexico, the resulting taxonomies
included *mulatto-returning-backwards, hold-yourself-in-mid-air,* and *I-
don't-understand-you.*

Whereas paintings in the earlier part of the century are relatively
neutral in their representations of the various types, the images of
the latter part are evidence of a troubling history of thought about
the character of the people represented. For example, when a Black
woman appeared as part of an interracial union in the late century,
she was frequently shown lunging to stab or strike the white father
as their mulatto child tries to restrain her—scenes, according to art
historian Ilona Katzew, that meant to suggest "domestic degener-
acy," the depravity of Black women—that they were intrinsically
violent. "The message is clear," she writes. "Certain mixtures—
particularly those of Spaniards or Indians with Blacks—can only
lead to debased sentiments, immoral proclivities, and extreme sus-
ceptibility to an uncivilized state. The incorporation of this type of
scene in a number of casta sets serves to highlight the positive traits
associated with mixtures that excluded Blacks, which bore the
promise of a return to a pure racial pole." Such images undergirded
attempts at social control as they were intended to relegate people to
their designated places in the supposed natural order of things. The
paintings seem to suggest a darker, predetermined interpretation of
Heraclitus's axiom "Character is fate," as if it were something innate
and immutable.

The legacy of such knowledge production is deeply ingrained,
manifest in contemporary culture and even in the intimate relations

within families, as with my white father. To be a historical being is to be caught up in the web of history, and I see the necessity of an engagement with history as a way to look outward, beyond the inward-turning lens of self-reflection to contemplate one's place in the world and to illuminate aspects of personal experience through a much larger lens of shared experience across time and space. Ekphrasis is a useful tool in this endeavor as I look to the images in art not only to provide insight into the historical moment but also to provide a means by which to unlock the psychological landscapes that shape the way I see figures, objects, and their juxtapositions in the contemporary moment.

"Poetry," wrote Wallace Stevens, "is the scholar's art." Because a poem is in itself theoretical, pursuing insight into the nature of things, advancing ideas about language and meaning, as well as being in conversation with other discourses and forms of art, I include here a couple of poems that articulate my thinking, illustrating the intersections between public and personal history.

Taxonomy

After a series of casta paintings by Juan
Rodríguez Juárez, c. 1715
1. De Español Y De India Produce Mestiso

The canvas is a leaden sky
 behind them, heavy
with words, gold letters inscribing
 an equation of blood—

this plus this equals this—as if
 a contract with nature, or
a museum label,
 ethnographic, precise. See

how the father's hand, beneath
 its crown of lace,
curls around his daughter's head;
 she's nearly fair

as he is—calidad. See it
 in the brooch at her collar,
the lace framing her face.
 An infant, she is borne

over the servant's left shoulder,
 bound to him
by a sling, the plain blue cloth
 knotted at his throat.

If the father, his hand
 on her skull, divines—
as the physiognomist does—
 the mysteries

of her character, discursive,
 legible on her light flesh,
in the soft curl of her hair,
 we cannot know it: so gentle

the eye he turns toward her.
 The mother, glancing
sideways toward him—
 the scarf on her head

white as his face,
 his powdered wig—gestures
with one hand a shape
 like the letter C. See,

she seems to say,
 what we have made.
The servant, still a child, cranes
 his neck, turns his face

up toward all of them. He is dark
 as history, origin of the word
native: *the weight of blood,*
 a pale mistress on his back,

heavier every year.

 2. De Español Y Negra Produce Mulato
Still, the centuries have not dulled
the sullenness of the child's expression.

If there is light inside him, it does not shine
through the paint that holds his face

in profile—his domed forehead, eyes
nearly closed beneath a heavy brow.

Though inside, the boy's father stands
in his cloak and hat. It's as if he's just come in,

or that he's leaving. We see him
transient, rolling a cigarette, myopic—

his eyelids drawn against the child
passing before him. At the stove,

the boy's mother contorts, watchful,
her neck twisting on its spine, red beads

yoked at her throat like a necklace of blood,
her face so black she nearly disappears

into the canvas, the dark wall upon which
we see the words that name them.

What should we make of any of this?
Remove the words above their heads,

put something else in place of the child—
a table, perhaps, upon which the man might set

his hat, or a dog upon which to bestow
the blessing of his touch—and the story

changes. The boy is a palimpsest of paint—
layers of color, history rendering him

that precise shade of in-between.
Before this he was nothing: blank

canvas—*before image or word, before*
a last brush stroke fixed him in his place.

3. De Español Y Mestiza Produce Castiza

How not to see
 in this gesture

the mind
 of the colony?

In the mother's arms,
 the child, hinged

at her womb—
 dark cradle

of mixed blood
 (call it Mexico)—

turns toward the father,
 reaching to him

as if back to Spain,
 to the promise of blood

alchemy—three easy steps
 to purity:

from a Spaniard and an Indian,
 a mestizo;

from a mestizo and a Spaniard,
 a castizo;

from a castizo and a Spaniard,
 a Spaniard.

We see her here—
 one generation away—

nearly slipping
 her mother's careful grip.

 4. The Book of Castas
Call it the catalog
 of mixed bloods, or

 the book of naught:
 not Spaniard, not white, but

mulatto-returning-backwards *(or*
 hold-yourself-in-midair) *and*

 the morisca, *the* lobo, *the* chino,
 sambo, albino, *and*

the no-te-entiendo—*the*
 I don't understand you.

 Guidebook to the colony,
 record of each crossed birth,

it is the typology of taint,
 of stain: blemish: sullying spot:

that which can be purified,
 that which cannot—Canaan's

black fate. How like a dirty joke
 it seems: What do you call

 that space between
 the dark geographies of sex?

Call it the taint—*as in*
 T'aint one and t'aint the other—

illicit and yet naming still
 what is between. Between

her parents, the child,
 mulatto-returning-backwards,

 cannot slip their hold,
 the triptych their bodies make

in paint, in blood: her name
 written down in the Book

 of Castas—*all her kind*
 in thrall to a word.

Enlightenment

In the portrait of Jefferson that hangs
 at Monticello, he is rendered two-toned:
his forehead white with illumination—

a lit bulb—the rest of his face in shadow,
 darkened as if the artist meant to contrast
his bright knowledge, its dark subtext.

By 1805, when Jefferson sat for the portrait,
 he was already linked to an affair
with his slave. Against a backdrop, blue

and ethereal, a wash of paint that seems
 to hold him in relief, Jefferson gazes out
across the centuries, his lips fixed as if

he's just uttered some final word.
 The first time I saw the painting, I listened
as my father explained the contradictions:

how Jefferson hated slavery, though—out
 of necessity, my father said—had to own
slaves; that his moral philosophy meant

he could not have fathered those children:
 would have been impossible, my father said.
For years we debated the distance between

word and deed. I'd follow my father from book
* to book, gathering citations, listen*
as he named—like a field guide to Virginia—

each flower and tree and bird as if to prove
* a man's pursuit of knowledge is greater*
than his shortcomings, the limits of his vision.

I did not know then the subtext
* of our story, that my father could imagine*
Jefferson's words made flesh in my flesh—

the improvement of the blacks in body
 and mind, in the first instance of their mixture
with the whites—*or that my father could believe*

he'd made me better. *When I think of this now,*
* I see how the past holds us captive,*
its beautiful ruin etched on the mind's eye:

my young father, a rough outline of the old man
* he's become, needing to show me*
the better measure of his heart, an equation

writ large at Monticello. That was years ago.
* Now, we take in how much has changed:*
talk of Sally Hemings, someone asking,

How white was she?—*parsing the fractions*
* as if to name what made her worthy*
of Jefferson's attentions: a near-white,

quadroon mistress, not a plain black slave.

Imagine stepping back into the past,
our guide tells us then—and I can't resist

whispering to my father: This is where
we split up. I'll head around to the back.
When he laughs, I know he's grateful

I've made a joke of it, this history
that links us—white father, black daughter—
even as it renders us other to each other.

4. Calling

Some selected image of the past is always being delivered to our senses.

—Adrienne Rich

The wound is the place where the light enters you.

—Rumi

Over the years, my mind has turned again and again to that earliest memory of my near drowning, the image of my mother above me, arms outstretched, a corona of light around her face. Did I know then that it reflected an iconic image of sainthood? The mind works such that we see and perceive new things always through the lens of what we have already seen. What came first then—the vision of my mother as I was sinking deeper into the pool or religious paintings and altarpieces depicting the saints in much the same way? What matters is the transformative power

of metaphor and the stories we tell ourselves about the arc and meaning of our lives. Since that day decades ago, the imagery of the memory has remained the same, I think, because I have rehearsed it, telling the story of my near drowning again and again. What has changed is how I've understood what I saw, how I've come to interpret the metaphors inherent in my way of recalling the events. Scientists tell us there are different ways that the brain records and stores memory, that trauma is inscribed differently than other types of events.

To survive trauma, one must be able to tell a story about it. If the story I began to tell myself after the seemingly small trauma of almost drowning was that my mother had been there, that I was in no real danger, that she was somehow ethereal, a light-ringed saint to whom I might send up my prayers for salvation, the story evolved over the years to create a narrative of self that could contain yet another trauma and give it meaning. Near the end of my freshman year in college, my mother was murdered—gunned down in a parking lot by her then ex-husband, a troubled Vietnam veteran with a history of mental illness, a man who had been my stepfather for ten difficult years.

Not long after her death I dreamt of her, and it has taken me nearly forty years to understand the connection the images were making in my subconscious. In the dream, I knew that she was dead, and it seemed as if I had journeyed somewhere to meet her. We were walking side by side and only once did she speak, turning to ask me a final question: *Do you know what it means to have a wound that never heals?*

Articulation

After Miguel Cabrera's Portrait of Saint
Gertrude, 1763

In the legend, Saint Gertrude is called to write
after seeing, in a vision, the sacred heart of Christ.

Cabrera paints her among the instruments
of her faith: quill, inkwell, an open book,

rings on her fingers like Christ's many wounds—
the heart emblazoned on her chest, the holy

infant nestled there as if sunk deep in a wound.
Against the dark backdrop, her face is a wafer

of light. How not to see, in the saint's image,
my mother's last portrait: the dark backdrop,

her dress black as a habit, the bright edge
of her afro ringing her face with light? And how

not to recall her many wounds: ring finger
shattered, her ex-husband's bullet finding

her temple, lodging where her last thought lodged?
Three weeks gone, my mother came to me

in a dream, her body whole again but for
one perfect wound, the singular articulation

of all of them: a hole, center of her forehead,
the size of a wafer—light pouring from it.

How, then, could I not answer her life
with mine, she who saved me with hers?

And how could I not—bathed in the light
of her wound—find my calling there?

We know, of course, that dreams are metaphorical. And in the moment of waking from it, my mother's voice ringing in my head, I was transformed. The world as I knew it and myself in it were not the same. I had acknowledged the undeniable presence of my deepest wound, and something of the past was delivering to me again a familiar scene but in the negative—a reversal of light and dark that transformed my mother's face into pure light ringed in darkness. The light all-consuming and piercing.

Over the years, as I applied the dream again and again to the ongoing narrative of my life, I began to see it as a bookend to my earliest memory—as if indeed my earliest memory had provided the discursive framework of the dream. Being pulled from the water into my mother's arms was akin to a baptism. I had witnessed something strange, not unlike the visions reported by the faithful which set them on a path of devotion, of meaningfulness and purpose: my mother, through the wavering lens of water, seemed distant and not fully embodied—an apparition, the dead woman she was to become, but with the light surrounding her as if she had already undergone her hagiography.

In the narrative of my life, which is, of course, the look backward rather than forward into the unknown and unstoried future, I emerged from the pool as from a baptismal font—changed, reborn—as if I had been shown what would be my calling even then. Years later, the dream would answer that early vision, would provide me

the abiding metaphor by which I have come to live. My writing life began not long after that, and I have been trying to answer my mother's last question to me—*Do you know what it means to have a wound that never heals?*—ever since.

Originally published in *Southern Cultures*, Spring 2020.

How They Must Have Felt—Imaginary Tulsa

Empathy and Writing Historical Fiction

BREENA CLARKE

They say that hundreds of bodies were shoved into mass graves, dumped in the Arkansas River, or loaded onto trains—victims of the Tulsa Race Massacre of June 1921. These events were formerly known as the "Tulsa Race Riot," this country's largest. A massacre is defined as an indiscriminate and brutal slaughter of people. A riot is defined as a violent disturbance of the peace by a crowd. Most people agree that the events of June 1921 in Tulsa, Oklahoma, are best defined as a massacre.

My maternal grandmother often spoke of Tulsa, Oklahoma, and always with delight, in glowing terms. She traveled to Oklahoma as a three-year-old when her father and mother moved parts of their family to Tecumseh from North Carolina. Throughout her subsequent adult life in segregated, constricted Washington, DC, she kept a child's awe and admiration for Tulsa and the Black incorporated towns of Oklahoma. She didn't mention the massacre of 1921.

My grandmother didn't share any specific stories about Tulsa that

I can recall. She just spoke glowingly. Her children never shared any stories forward, and I can no longer check with them. When I reach back and scratch around in my memory, I have no recollection that they spoke of the massacre or any trouble.

However, growing up in the Washington, DC, area, we were aware of "White" menace. We have always been aware that we had violent enemies in nearby Maryland and Virginia. I remember that well. As an author of historical fiction, I have often engaged in plumbing the depths of African American trauma and joy.

———

I've imagined Tulsa several times in fiction; that is, I have included an imagined Tulsa in several fictional narratives I've created. It doesn't matter that I haven't seen the town because the part I've memorialized doesn't exist anymore. Even if nothing dire or trans-formational happens in a place, it changes. One aspect of the imagi-native work I like to do is archival. I attempt to preserve a snapshot of the days of a place based on firsthand reports if I can find them and pictures I build from interior interrogation. What must they have been thinking, smelling, feeling in summer, fall, spring? So, for a story surrounding the events following the Tulsa Massacre of 1921, I weave the known experience of my grandmother with what my text needs. For whatever reason, these two are rarely the same. I don't write autofiction or family memoir. I won't tell you how it was actually. I think you want to know how I interpret the world. And now, at this most critical time in our country, who can say that they know the full story, the whole truth of any event as long as the white mainstream perspective is taken as universal truth.

I want to talk about "How They Must Have Felt" in creating a fictional landscape for the Tulsa Massacre of 1921. "They" are

the African American people who lived in Tulsa, Oklahoma, in May/June 1921. Over the years, I've maintained an interest in the events of this little-known racial genocide. As we approach the one-hundredth anniversary of the massacre, a possible mass grave is being examined, and much attention is being paid to the events. As each development comes to light, I draw a direct connection between my childhood perception of my grandmother's narrative and how I will construct my imaginary Tulsa. How will I plumb my feelings of connection to mine the event for my story and my characters?

In my debut novel, *River, Cross My Heart*, I depict Tulsa in the same ways that my grandmother described it. It was a place of pride and excitement, and my grandmother was enormously proud of her association with Tulsa. She wore it as a badge. She was a young adult when she returned to North Carolina, some years before the massacre. I know very little of this period of her life except that she attended Langston College, now University, an HBCU in Langston, Oklahoma. Founded in 1890 by Edwin McCabe, Langston City had a population of six hundred and had twenty-five retail businesses by 1892, the year in which a common school was built and opened with an enrollment of 135. There's a photo of Pearl Miller in a long skirt, leaning against a clapboard building, with a hat and a straightforward, determined look. No date or location on the photo. It must have been 1910 or so. I like to believe that photographs can hold on to the essence of their subject, and so I take this young woman to heart and applaud her perceived self-confidence and can't decide if I am more like her or if my sister is or if it matters. As a youngster, I didn't appreciate my grandmother's attachment to this pride in Tulsa, but I felt it, absorbed it when I began writing *River, Cross My Heart*. I wrote to attach to that feeling that there was a kind of magic to the town, that it had a large,

prosperous African American population. This picture is the image of Tulsa that stayed in my grandmother's mind and is the depiction that has passed to me. I developed the character of Pearl Miller, who becomes a friend to my protagonist as a vessel to explore the feelings my grandmother must have experienced in Oklahoma. I don't always use the actual names of my family. However, I feel that African American individuals do not get enough recorded mentions in newspapers and public records. So, I make a point of mentioning names and creating them, and it is an essential part of how I write fiction. Another way for me to include the specifics about people I know when I write is to enshrine their vernacular expressions in the text. I try to make my novel a portmanteau for oral traditions that might otherwise fade. I think this is one of the chief functions of historical fiction that I find most rewarding.

———

Though slavery reenactments give me a queasy feeling, a recent *New Yorker* magazine story on them caused me to ponder this discussion. What we do in literary historical fiction is embellish the imaginary potential of history and expand and cultivate empathy for our characters and, by inference, for other human beings. Often this includes empathy or understanding for antagonists as well. To what degree is depicting enslavement informative, transformative, or exploitative? Is it not too easy to empathize with the perceived agony of slavery? I'm not sure how other authors will answer, but I'm never entirely certain I can trust in my understanding of the condition of slavery. Radical empathy aside, it may not be possible to know the depths of this horrible condition. I do understand most major human events. I understand physical and emotional pain, and I understand grief. Grief, being suddenly, tragically bereft. In *River,*

Cross My Heart, there is the sudden death of a child and the death of hope in imaginary Tulsa. In Tulsa 1921, a project I'm currently working on, the characters are suddenly bereft of their home and business. My understanding of the emotional trauma of grief that attends to these events gets me in the door of my fiction, so I get a good perspective on the ways my characters will feel, will react.

I conceived the imaginary outsider town of Russell's Knob, New Jersey, in my novel, *Angels Make Their Hope Here*, because I had a model of Tulsa's success and pride in a cohesive, productive Black community. I was helped in constructing my town because of what my grandmother had done for me. She enshrined a "before" picture of Tulsa, a vibrant, thriving colored town, a source of pride and aspiration, a hopeful place. That town, the Greenwood neighborhood of Tulsa, was utterly destroyed in the Massacre of 1921. The key motivating factor in my writing about it is the opportunity to present the image, the picture of how it was, and how the people of Tulsa felt. I feel an obligation to inform and to vindicate my grandmother's depiction of the town by recreating it in my fiction.

There is an extension to this inquiry. Reimagining our historical past by creating the human beings as they likely were, is for me a vital contribution to the work of archiving our disputed American past. Absent the documentary evidence afforded white Americans in the historical record, African American fiction writers can deploy factual history and imaginative cultural history to fill in the empty landscape.

This Louisiana Thing That Drives Me

An Interview with Ernest J. Gaines

CHARLES H. ROWELL WITH ERNEST J. GAINES

The following interview was originally taped in Baton Rouge, Louisiana, on March 6, 1976, a few days following Ernest Gaines's YWCA reading. During the summer of 1978, I, with Gaines's assistance, edited this interview extensively. In fact, Gaines himself retaped most of the interview, which I edited further. As presented below, the interview is, among other things, the product of a genial collaboration by telephone and mail.

Charles H. Rowell (CR): Ernie, you were born here in Louisiana on a plantation near New Roads. For the past few years I have observed that you return here ever so often to give readings and visit your family. Do you also return here for a spiritual renewal with the people and the land?

Ernest J. Gaines (EG): I have brothers here. Aunts, uncles, and different relatives, friends whom I'd come to visit. I also come back here to be with the land—not only with the people, but to be with

the land. I come back not as an objective observer, but as someone who must come back in order to write about Louisiana. I must come back to be with the land in different seasons, to travel the land, to go into the fields, to go into the small towns, to go into the bars, to eat the food, to listen to the language. As I said, I don't come back as a scientist, strictly as an observer; I come back to absorb things.

CR: You said you must "absorb things." Does that mean you have not absorbed California, or does it merely mean that Louisiana interests you as a place to write about?

EG: Well, Charles, I'm not one of those intellectuals who can explain the creative mind, but I do feel that the early impressions on the artist are the most lasting. I'm thinking of such writers as James Joyce who left Ireland but who could not write about anything except Ireland. I'm thinking about the Russian writers who were exiled but who could not write about anything except Russia. About California—I have written several books about California. I suppose I have written four or five novels about California, but they are not very good books. They have not been published. They will not be published during my lifetime, if I have anything to do with it. Maybe sometime in the future I will write a good book, or publish a good book, about California. But I doubt that I will be able to do it until I have gotten rid of this Louisiana thing that drives me, yet I hope I never will get rid of that Louisiana thing. I hope I'm able to write about Louisiana for the rest of my life.

CR: In your reading last week, you mentioned that *In My Father's House* will deal with relationships between father and son. What specifically about that relationship do you deal with in the novel?

EG: Charles, a pet theme I deal with in so much of my fiction (and I just think I took it a little bit farther in this particular book) is that Blacks were taken out of Africa and separated traditionally and then physically here in this country. We know that on the slave block

in New Orleans, or Washington, DC, or Baltimore, or wherever the slave ships docked, families were separated. Mothers were separated from their children, husbands from their wives, fathers from their sons, mothers from their daughters. And I feel that because of that separation they still have not, philosophically speaking, reached each other again. I don't know what it will take to bring them together again. I don't know that the Christian religion will bring fathers and sons together again. I don't know that the father will ever be in a position—a political position or any position of authority—from which he can reach out and bring his son back to him again. I don't know where that thing which is needed will come from. That is something I suppose some other writer will have to deal with. Anyway, that is the main theme that is running through the new novel *In My Father's House*, the novel I'm working on.

CR: At your reading, you also talked about point of view of *In My Father's House*. You said it is different from that in your other works.

EG: *In My Father's House* is told from the omniscient point of view. Everything I have done, except *Catherine Carmier*, is told from the first-person point of view. That is the only difference.

CR: You mentioned some difficulty you've had in writing in the omniscient point of view.

EG: In the first-person point of view, it seems that my characters take over very early in the book—or I should say that when I start a book in the first-person point of view my characters take over very soon and then carry the story themselves. From the omniscient point of view, it is harder for me (for the characters to take over), because it seems that I'm always interrupting them. I seem to think it is necessary to add things that they might not. Sometimes I feel that they don't see enough or that they don't know enough. I'm constantly adding things, and adding things sometimes gets in the way of the novel. It slows the novel down too much; it impedes the

progress, the movement. Quite often it throws things out of the line in which it travels; form gets in the way of development. This is where the problem lies. I had the same kind of problem when I was writing my first novel, *Catherine Carmier*, my only other book in the omniscient point of view. It was a very small book, but still it gave me trouble developing the character as well as putting some form in the book. I usually don't have problems when writing dialogue—whether I'm writing it in the omniscient point of view or the first person. But the other things like descriptive passages or exposition or development of theme—things like that—have given me a lot of trouble when I'm involved in a book dealing with the omniscient point of view. Usually I think of myself as a storyteller. I would like for readers to look at a person telling the story from the first-person point of view as someone actually telling them a story at the time. But when you are dealing with the omniscient point of view, you are not being told a story; you are reading a story, I feel. Now maybe what I need to do is sit in a chair on a stage and just tell people stories rather than try to write them. I wish I could do that. I wish I could be paid just to sit around and tell stories, and forget the writing stuff. But, unfortunately, I am a writer, and I must communicate with the written word. And, of course, certain books require that you write not from the first person but from the omniscient point of view. *In My Father's House* is just such a book. You cannot tell that story from the minister's point of view because the minister keeps too much inside him. He does not reveal it—he won't reveal it to anybody. It would be totally impossible to tell this story from anyone else's point of view—or should I say, have anyone else tell the story. So the story has to be told from that omniscient point of view. That is, I, the author, must tell the story rather than let a character tell it for me.

CR: In your interview with John O'Brien, you spoke of your

characters, Tee Bob and Jackson, as victims of the past, and you also talked about their efforts to escape the past. Is it really possible for anyone to escape the past? That is to say, the past is, in my opinion, always present and shaping the future.

EG: I think Faulkner says something like the past ain't dead; it ain't even passed. And I agree with you all the way. I don't know that you can escape the past. If it were possible, I would have escaped it myself, because Louisiana is definitely not only my past but my present also. I believe I, myself, and my writing are good examples to support that observation that you can't escape your past. There is a difference between living in the past and trying to escape it. If you do nothing but worship the past you are quite dead, I believe. But if you start running and trying to get away from the past, you will, I think, eventually run yourself out of whatever it does to you. It will run you mad, or kill you in some way or the other. So you really don't get away. It's there, and you live it. That is especially true with the artist.

CR: You also said that *Catherine Carmier* could not exist outside the South. Why?

EG: Just as so many other people cannot exist outside the South.

CR: What is there in her character that would prevent her?

EG: Her family, the problem of her family. And you must remember that Catherine is nearly white. Her family is nearly white—her father and sister. But they are not white, so there is the problem between her family and Blacks. And the problem between her family and whites. Her family does not fit with the whites or Blacks. But Catherine is the strength of the family. The family could never exist without her. She is the conscience. She is the one who communicates with the family because of the problem they have had in their past. That is the thing that would prevent her from staying away. Oh, she could leave, she could go for a while, but she would

have to come back because they could not exist without her. That is the reason so many people stay in an area. They are trapped for one reason or another. Catherine is trapped because of the family conflict. She is trapped because of the color of her skin and the color of her parents.

CR: Why did you call your second novel *Of Love and Dust*?

EG: Because dust is the absence of love. Dust is the absence of life. Man goes back to dust when he dies. There is a little line of dialogue in the original draft of *Of Love and Dust* where Louise, the little white girl, tells Marcus, my hero, that without love everything is dust, or something like that. Then, of course, the whole story takes place in the dust. When Jim meets Marcus for the first time, he sees the dust coming toward him, even before he sees Marcus in the truck. When the truck stops in front of Jim's house, Marcus walks away from it while the dust drifts all over the plantation. Each time Marshall Hebert, the man who owns the plantation, goes by the house in his car you will notice how much dust is flying all over the place. Because in the end it will be this man, Marshall Hebert, who will bring death. So this is the meaning of the story. There are two love stories in the book: the story of Marcus and Louise, and the story of Sidney Bonbon and Pauline. Because they are Black and white, they cannot love as they would want to. Eventually, death does separate—separates them all. I think even when Marcus falls dead, he falls dead in dust. Dust is the absence of love, the absence of life. These people wanted to love, but because of the way the system is set up, it was impossible to love. Dust.

CR: I want to go back to the subject of influence, because certain critics keep writing about your influences. And in the interview I mentioned earlier, you are compared to William Faulkner. You also said that both Ernest Hemingway and William Faulkner influenced you.

EG: Faulkner has influenced me, as I think he has influenced most Southern writers. But I'd like to make this clear: Faulkner has influenced me in style only, not in philosophy. His philosophy is a completely different thing. Faulkner can write, and he has an ear for dialect, like few writers have for Southern dialect. You might not agree with his philosophy, but he can capture that Southern dialect, both the white and the Black, like no one else I know can. He shows you a lot about rhythm in sentences, the long sentences as well as the shorter ones. His capturing of time can be compared to parts of a great symphony. He can really capture a moment, put everything into the moment. He knows how to stop time and make you see how long a second can be. I've told this to many students in high school as well as college who've asked me how can a white man influence me. You know, in the 1960s you had to go through this all the time if a student in the classroom didn't know what to ask you. He would ask if you were a writer or a Black writer? And he wanted you to give him a definite yes or no, whether you were just a writer or a Black writer. If you were a writer, he had very little interest in whatever you were talking about. I tried to tell them that I consider myself a writer and tried to show them how a person like Hemingway could influence me. I would say when Hemingway, whose major theme was grace under pressure, was writing he was saying as much about the Black man as he was about the white man, although very seldom were his Black characters given any kind of sympathetic roles. Still, his writings of that grace under pressure, his writing about the white characters, made me see my own Black people. For example, who had more pressure on him than Jackie Robinson when he was playing baseball, or when he first broke into baseball with the Brooklyn Dodgers? Who had more pressure on him than Joe Louis? No man has had more pressure on him than Martin Luther King. But

look how gracefully these men stood. These are the things I tell a young writer he can learn from reading Hemingway's stories. Hemingway's characters are white, that's true, but we can learn how to write about our own Black characters by reading what he has to say about his white characters—because, as I said, the theme that Hemingway uses is more related to our own condition than that of white Americans. Good examples of Hemingway's themes of grace under pressure can be found in "Fifty Grand," the story about a boxer, and in *The Old Man and the Sea*, where the character fights sharks and is defeated—physically defeated, but not spiritually defeated—when he loses his great fish. There is the story, "The Undefeated," which is about an old bullfighter who is just about washed up but goes for one more try. Our people go back for one more try all the time. We get up day after day after day and try again. With all the pressures on us, we, some kind of way, force ourselves to try again. We have survived by trying over and over and over. A writer like Hemingway can show you how to write the story about your own people. But there were influences on me when I was in college other than Hemingway and Faulkner. Sherwood Anderson was an influence because I had to study his *Winesburg, Ohio*. James Joyce was an influence, his *Dubliners*. I also learned from Anton Chekhov. I learned from the great nineteenth-century Russian stylist, Ivan Turgenev. His *Fathers and Sons* was a great influence on my first novel, *Catherine Carmier*; I used his novel as a Bible when I was writing *Catherine Carmier*. These men and many, many more were influences in those early years when I was trying to be a writer.

CR: Much good came out of the Black Arts Movement of the '60s and early '70s. But I think that too many of the advocates of the Black Aesthetic de-emphasized the importance of craft. That is, at the expense of good writing, too many critics and creative writers

argued for politics as if how you said what you said were not of equal importance. Do you agree with my charge?

EG: Yes. And I think it's too bad they did that. But you can understand why. At that time the point was to get something over. Too many of the writers did not realize that you don't get it over with bad writing. To be a writer, one ought to strive to write well. If you want what you say to last, you should write it as well as you possibly can. Now I have been criticized like hell in certain magazines, whose names I don't want to mention here, because I insist on writing well. I've never insisted on not criticizing. I've never insisted on not writing protest. All I've said was write whatever you are going to write as well as you can. I don't know any other Black writer who has written a scene which showed the brutality of the system any more than I expressed in the violence of the massacre scene in *The Autobiography of Miss Jane Pittman*. But I was after writing the scene as well as I possibly could. The violence is there. No one can deny that. But still accuracy was the thing I had to try to achieve. I had to rewrite and rewrite that scene in order to get it the way I wanted it. I suppose you know what scene I'm talking about. It's the scene in which the Blacks, after they hear of their emancipation, try to leave the South. They try to leave that particular plantation where they have been slaves, and on the second day of their journey a group of Klansmen and defeated Confederate soldiers find them in the swamp and murder all of them, except Jane and the little boy Ned. I don't know of any other writer who has done a more violent scene than that. At the same time, my aim was to write well. My aim was to get the dialogue that was going on at that time, as well as the swinging of the clubs, as well as the noises made in the bush, in the shrub, in the trees, and among the leaves. I wanted to get the sun coming down through the trees, on the ground where the men lay dead, and a woman dying with a child clutched in her arms. This

is what I mean by doing it well no matter what you're doing—no matter what the politics or what the violence is. You must write it well. Write it over and over until you do it well. I don't think there is any more respected Black man in this world today than Muhammad Ali. I think we all love him; we worship him. But when he gets into the ring he's a fighter. He's as graceful as anybody we've ever seen. He's talking, but he's fighting. His punches and his jabs know exactly. He punches and jabs like nobody has ever done. He's directing them where they will have the greatest effect. Each one is calculated. Now we worship that in him. We respect that in him. That's the kind of thing I would like to see in writing. If you are going to use words, put them where they are going to have the greatest and most lasting effect. I've always felt that the white man out there would rather we did not use the proper language. He would rather that all we did was scream and make noises. He would prefer that our aim was not perfection. My aim in writing will always be at perfecting a sentence, just as the aim of the great fighter (or any other athlete) is perfecting his style, making the right move at the right time.

CR: A few years ago, when you spoke at Southern University (Baton Rouge), someone asked you what do you advise Black writers to study to help develop their writing. I think you said they should listen to music. Why?

EG: Well, I feel we have expressed ourselves better in our music traditionally than we have done in our writing. The music (blues, jazz, and spirituals, for example) is much better than our prose or poetry. I think that we have excelled in music because it is more oral. We are traditionally orally oriented. What I'd like to see in our writing is the presence of our music.

CR: I not only see Black music as being important in your work, but it seems as if a lot of things—more than in any other piece of

your fiction—went into the making of *The Autobiography of Miss Jane Pittman*. I hear, for example, the voice of the slave narrative. I also hear the voice of the tellers of folk history. Will you talk about the kind of research that went into the making of *Miss Jane Pittman*?

EG: When I wrote *Miss Jane Pittman*, my Bible was *Lay My Burden Down*, a collection of short WPA [Works Progress Administration] interviews with forty-seven ex-slaves recorded during the '30s. I used that book to get the rhythm of speech and an idea of how the ex-slaves would talk about themselves. Remember, I wanted a folk autobiography. *Miss Jane Pittman* is a folk autobiography. Miss Jane must tell things from memory. Miss Jane has not gone to school or done any research work. What she does is talk about the things she can remember and what others have said year after year after year. Of course, I had to do a lot of research, especially a lot on slavery. I also did a lot of research on the Reconstruction Period—I read book after book: books by Black historians, books by white historians, books by Northern historians, books by Southern historians. I had access to the Archives at Louisiana State University. I went to the State Library uptown and to the Southern University Library. After I went back to San Francisco I could write back to these libraries and ask for additional information. While I was here I would go out into the fields and talk to the people, talk about Huey Long, talk about the flood, talk about Angola State Prison, talk about Jackson Mental Institution. We talked about everything. I remember just before I began writing *The Autobiography of Miss Jane Pittman* I went up to talk to Al Aubert. He was living up on East Boulevard at the time. While we were sitting in his living room, I asked him to discuss some things. I said, "Let's talk about twelve things that could have happened nationally that a woman who lived to be 110 years old might be able to recall." I wanted twelve things that could [have] happened statewide that a

110-year-old woman might be able to recall. I remember we began by talking about things like, of course, the Civil War. We talked about the Reconstruction Period. We talked about the Depression. We talked about Abraham Lincoln. We talked about Huey Long, of course. We talked about Jack Johnson, Jackie Robinson, and Joe Louis. We talked about the Dodgers and the Yankees. We talked about many, many, many other things. For example, we talked about Roosevelt. We talked about the floods of both 1912 and 1927. We talked about the Civil Rights Movement. We had to talk about Martin Luther King. We talked about all the younger people who were caught up in the Civil Rights Movement that a lady who was 110 years old would know something about. After Al and I had discussed this, I then had to do the research work to give Miss Jane this information, to get accurate data on this kind of information. Although she could distort the information, I had to be aware of its accuracy. For example, when dealing with the Joe Louis–Schmeling fight, which she would talk about, I had to know exactly what round Louis lost the first fight and what round he won the second fight. So this is the kind of research I had to do. Of course, after I went back to San Francisco I had people here in Baton Rouge to xerox that kind of information and send it on to me. I had to put this information into the mind of someone who was illiterate, who was very intelligent, of course, but who was illiterate because Miss Jane had had no formal education. After doing the research work (knowing exactly what she should know), I then had to find a voice for her to give that information in her autobiography. That is how the *Lay My Burden Down* interviews were so valuable to me. After reading so many of them (I forget how many I read, maybe a hundred), I got a rhythm, a speech, a dialogue, and a vocabulary that an ex-slave would have had. Miss Jane, as you know, was an ex-slave.

CR: At your reading last week, you talked about the importance of love in *Miss Jane Pittman*.

EG: At that reading, Charles, someone asked me why was Miss Jane important. I said anyone who had lived 110 years in a country like this, under the conditions she lived, and could love God, could still love baseball and ice cream, was worth writing about. I went on to say that, if she could come out as a whole human being after living 110 years with the kind of life she had to live, she is worth writing about. Survival with sanity and love and a sense of responsibility, and getting up and trying all over again not only for one's self but for mankind—those achievements I find worth writing about. Miss Jane, not generals who had killed thousands of people . . . Miss Jane, who loved humankind so much she did not have to kill one person to continue life. . . . So when I mentioned the love in *Miss Jane Pittman*, this is the kind of thing I quite possibly could have been talking about.

CR: What do you think of the TV filming of the novel? I know everybody has asked you that question.

EG: I like the film. I liked what they did with the two hours that they had. Remember this book covers one hundred years in time. The film covers 110 minutes of time, giving us about a minute to a year. So the film could not depict the book as it was. No film ever can, and this one definitely did not. But I think the two hours did give us an idea of what the book was about. If we had had more time (say three hours or four hours or five hours), we would have had a much better film. I'm not saying we did not have a good film, but we would have had a much better film. Even when we were shooting the film here around Baton Rouge, the aim was toward shooting a bigger film, more than a two-hour film. I wish the viewers could see all the good footage that was done which had to be edited out in Hollywood. So what you have in the film now is

peaks—a lot of peaks. But you don't have the valleys and slopes as you would have had, had the film been longer. But the film as it is, I think, is quite good. I want to go back to what I was trying to say a moment ago about peaks and the difference in peaks and valleys and slopes. For example, in the film after the Cajun Albert Cluveau kills the professor, you never see Cluveau ever again. (The professor is Miss Jane's adopted son, and Miss Jane, as you recall, is Cluveau's closest friend.) In my book, after Cluveau has killed the son of his closest friend, he gradually goes mad. In the film, before it was edited, you see him going mad after he had killed the professor. The actor, Will Hare, who plays the part of Albert Cluveau, does his best acting in the mad scene. But, of course, when the footage went back to Hollywood all this was edited out. So what we get is the assassination and nothing about Cluveau's madness. The assassination is a peak, but the gradual madness is a slope and a valley. And that is what I think is missing in the film. I am not saying that the film is not a good film. But the slopes and valleys are missing.

CR: I want to go back to the late '60s and early '70s, when we heard so many Black writers and critics arguing that Black writing should be politically functional—that is, to aid in the liberation of Black people. And many critics argued that Black writers should write to the Black community. Looking back at that time and looking back at that position, will you comment on the period?

EG: I have always felt that the writer, regardless of what he writes about, should write it well, and that's final.

CR: When you write, do you have an audience in mind?

EG: I never write for any particular group. I try to write well enough so that anyone can pick up my book and say "I like this." A Black child in this country can pick the book up and say "I like it." The same I hope of a Chinese child, or a Russian child, or a Russian teacher. I never think of any particular audience. But I think

of writing as well as I can—writing cleanly, clearly, truthfully, and making it simple enough so that anyone might be able to pick it up and read it. I've been asked what people would I rather have read a story of mine. And I've answered that if I had to write for one group, then I would want that group to be the Black youth of the South. If I had to write for two groups, I would like for those groups to be the Blacks and the whites of the South. Of course, I want the world to read my work. But I don't write with the world in mind. Writing to me is tough enough. It's hard work, but I try to write clearly about my experiences, whether direct or vicarious. Other people who have had that same kind of experience might be able to recognize themselves in the work. But I never write for any particular group, surely never with critics in mind. They are the last people I think of when I'm trying to create a book, a story, or a novel.

CR: Ernie, one final question. If you were asked to give advice to Black writers, what would you tell them to do in the 1970s?

EG: I don't know what to tell a writer to do. One of the things I believe in is that the writer should be free to do whatever the hell he wishes to do. I only hope that he writes about the human condition. If he is Black, he should write about the Black condition. I don't know how in the hell he can avoid writing about white conditions if he is an American. If he is a Black Southern writer, how can he avoid writing about the Southern condition? If he is a Northerner, how can he avoid writing about Northern conditions? As long as he writes truthfully about Northern conditions? As long as he writes truthfully about the human condition, his experiences, whether these experiences are direct or vicarious, I'm pleased. I don't know what else you can tell a writer to do. But I would give this same advice to a young man who wanted to play football, who came out and asked my advice. I'd say, play the game as well as you can possi-

bly play it. Or if you are studying to be a dentist, I would say study as hard as you can to be a damn good dentist. Or if you are going into law, read as much as you can; know law, know the Constitution, know everything there is that you can possibly know about your subject. Sacrifice time; put a lot of time into your work. In order to do it well you are going to have to sacrifice; you are going to have to put a lot of time in. If you are a writer, read good writers, whether they are white or Black, Chinese or Japanese, or Russian, or writers from Mars or wherever. Read the best to see how they do things, because any writer can help you—any good writer can help you. I don't give a damn who he is or who you are. If he is good, he can help you. Faulkner can help you. Hemingway can help you. Joyce can help you. The great Russian writers (Tolstoy, Turgenev, and Chekov) can help you. The great French writers, Flaubert and de Maupassant, can help you. So study hard, and spend a lot of time at the desk. You sure can't become a good writer unless you spend time at the desk. I don't know of any writers who have written anything worthwhile unless they read. You must read, and you must write. The same thing goes for a fighter. A fighter watches films, a fighter works, and a fighter listens to his manager, no matter whether that manager is white or Black or green or gray. It takes a lot of work, a lot of discipline, and a lot of studying in order to accomplish anything that you want to go into. So, I'd say the same thing to a young writer of the 1970s as I would to anyone else.

Originally published in *Callaloo*, May 1978.

How You Living?

—

The Daily Life and Intentions of a Writer

Seven Brides for Seven Mothers

RITA DOVE

I do not like how-to-write manuals. Throughout my entire professional life, I have shied away from proposing poetics methodology. Barring a few narrowly defined exceptions, I have declined invitations to deliver craft talks, although I've attended such lectures given by poets whose work I admire and whose opinions on the writing of poetry I respect. I've turned down multiple opportunities to publish my own such reflections, though I have observed student poets discuss and implement techniques expounded by my colleagues and contemporaries. In my writing workshops, I prefer to issue an off-the-wall writing assignment called "The Wild Card" instead, an individually tailored prompt designed to upset that particular student's notions of prosody and poetic vision: If they write lyrics, their assignment will usually demand some sort of narrative; for someone heavily into history, the prompt will be stripped of historical context. Additional requirements might include incorporating randomly plucked words, creating a collage using postcards and gum wrappers, walking into a field at dusk, eating a fruit while writing, scribbling a psalm directly onto a soda bottle; all are designed to get the creative juices flowing in apprentice poets without providing a standardized rubric they might feel obliged to adopt.

This caution comes from bitter experience. As a young poet in my twenties, I labored under an old-school indoctrination which promoted a few "proven" approaches for producing a good poem: Write first thing in the morning, before the business of the day crashes in! Focus your energy on one poem until it's finished! When revising, cut off the opening lines (and sometimes the last ones)!

These are not bad suggestions per se: Morning people will welcome the rise-and-shine directive, and lopping off the edges can crack a draft open—but not all the time, and not for all folks. The orthodoxy of the writing rulebook had me shackled to the cliff face, slowly hewing poems by dawn's early light, until I realized there was no risk-free rock climbing in poetry and that instead of listening to others, I should first lend an ear to my own likes and dislikes, quirks, and habits—even my biorhythms. As I learned to embrace my proclivities—I'm a joyous multitasker and an *extreme* night owl—my writing practice evolved into the peculiar routine I follow to this day: I'll work on several pieces simultaneously, accumulating fragments as I hop from draft to draft; the drafts are stored in colored folders, my only organizational tool; I'll enter my study thinking, "I feel like a red (or blue, or yellow) poem today," leaf through the contents of the appropriately hued file, and begin writing. What this means is that quite a few poems are in suspension until . . . well, magic occurs and I find myself tending to various drafts at once, pages fanned across the desk in a glorious, evolving mess. Like a detective novel—where a bunch of seemingly disparate details slowly connect and become clues revealing the dramatic (but in hindsight, inevitable) conclusion—each draft gathers its unique energy, each epiphany ignites the next, until the clustered explosions link into a chain reaction of endgames: an extended orgasm. Pretty fun, that!

So why, if I'm opposed to writing guidelines, did I agree to this

venture? Two reasons: One, I like the concept of a craft *anthology*, the idea of a variety of voices offering advice without knowledge of the other contributions. This strategy subverts the dangerous temptation for a writer to posit their own method as the One True Way simply because it works for them by gathering a bouquet of possibilities. (The etymological root of *anthology* is *garland*, by the way.)

The second reason requires a bit of foregrounding. Years ago, Cave Canem asked me to lead a workshop during their summer in-person conference. I agreed on the condition that my group would convene at 10 p.m., thus breaking with their traditional schedule of morning workshops, afternoon panels, and early evening readings. Because I'm at my best at night—because I come *alive* at night—I saw no reason to try to talk about poetry in a semi-catatonic state. By stipulating a late-night get-together, I wanted to call attention to the benefits of linking body to mind and spirit when writing. How well I remember the faces of those who attended that night! All were psyched, and some a little tired, but here and there I could see my fellow night owls brightening to attention, spots of joyous energy— for once validated, temporarily liberated from majority dictate.

Here's the handout I distributed to the members of that 2006 nighttime seminar at Cave Canem:

Seven Statements

1. *No excuses.*

 Being Black is no justification for poor writing, for unclarity or anger. Being female, or male, is no excuse for opacity. Being young, old, poor, rich, middle-class (no traumas for material)—nothing excuses bad writing. You should write as if you were the last human on earth, as if centuries from now a stranger might come across the poem and be moved, even if not all the allusions are clear.

2. *Notebooks, not Journals.*

A notebook can contain phrases, scraps of descriptions, images, recipes—anything at all, however fragmentary and non-literary. A journal has already begun the process of sorting, judging, commenting; language and what Wallace Stevens called "the music of what happens" are already subsidiaries. A journalist is not a poet.

3. *Every roadblock is an opportunity to explore the neighborhood.*

4. *It don't mean a thing if it ain't got that swing—but if swing is all it's got, you might as well join a band and take it on the road.*

Rap may be poetry sometimes, but I doubt it. Too much is sacrificed for timing and speed—which means excess language, words that do one thing only (e.g., mark time or thrill through rhyme) with no deeper dimensions.

Performance poetry is mostly performance; it seeks the audience and tailors its expressions to that end. That's more theater than poetry, and I'm here to find the poem, not the speech. The Page can go to the Stage, but the Stage can rarely go to the Page.

5. *While you're writing, never think of your audience. They will find you.*

6. *Each word is a living, breathing thing.*

Like the human beings who created it, a word contains multitudes—it has feelings, it can be devious and hide its true self, it can bloom with contradictions. Each word has a history; community and society can shape that history. Each word has a musical signature and a corporeal insistence; its shape will fill your mouth. Respect it.

7. *Silence is the shadow of the word.*

It is always present—in the white space surrounding the

poem, in the hesitation after a comma, the pause after a period, the deliberation of a semicolon, the gasp of a dash. Sometimes finding the Right Word is actually finding the proper fit of silence around the word(s).

———

That was fifteen years ago. Although I still believe every single claim made that night, I cringe a little whenever I see those seven statements pop up on Facebook or Twitter. Taken out of context, they sound so negative. But on that singular evening, everyone chuckled at my shout-out to the Ten Commandments as I laid down the law like a scolding grandmother, all in the spirit of Tough Love. Like warning signs along the interstate, the statements were meant to avert disaster rather than discourage from making the trip. I was there to explain, answer questions, praise the participants' efforts and gently nudge them back onto the tarmac. Hence my second reason for saying yes to this enterprise: It was an opportunity to show the flip side and extol the passion that drives the writing—indeed, the sheer joy of work—by providing positive riffs for each of the original seven statements. Here we go:

1. *Ultimately, excuses are a disservice to yourself.*

 If you're looking for pity or leniency, excuses will do just fine. But if you want soaring, illuminating comprehension, if you want to be heard, to be seen, there's no more rewarding path than to strive for nothing less than greatness. Stop at the first hurdle you knock over, or walk around it, and you'll never gain the confidence to clear the obstacles ahead.

2. *The sky's the limit? No—not when there are stars and galaxies beyond.*

The imagination is a labyrinth, a tangle of paths composed of twists, U-turns, dead ends, the occasional clearing surrounded by thickets. Overlaying this web is a palimpsest of impressions—snatches of memory and current events, fragments of dreams and conversations, the taste of that last cappuccino, the metallic smell of the lawn after the season's first rain. Don't be afraid of these threads getting snarled; write it down as quickly as it comes—unfiltered, messy, alive. You can sort it out later.

3. *Tangential discoveries.*

A roadblock is a sign to stop and reconsider; it challenges the easy path but also suggests a detour. Sometimes the goal you're so confidently headed toward is precisely where everyone expects you to go; the journey is scripted, the route safe and predictable. A stumbling block can be a blessing in disguise. Try something new: Cast the poem in tercets or couplets; put your page in landscape mode to encourage longer lines; pour a thick passage into an impossibly narrow silhouette. You can even start again from the ending you were writing toward. (I mean it: Erase everything you've written, up to your last line—then put that line at the top of the blank page and start from there.) If you save your drafts, nothing will get lost, so strike out for the territories and see what happens.

4. *Know your medium.*

Language is your clay. Every nuance you can squeeze out of it, from syllabic stress to syncopated syntax, should serve your story and your emotional progression. So work with it. Beneath the surface lies the sheet music that will

guide our physical interaction with the text. Each comma, dash, period, and colon can tell us when to pause and when to move on, while the length of a line will influence how much time the line takes to read. Must you rush to fit all the words in before the punctuation or white space allows you to breathe, or can you savor each syllable? And don't get me started on the physical shapes governing the production of language—that a word can embody its meaning because basic emotions can be reinforced by the facial contortions used for vocal production. (For example, to articulate the long *e* found in "eek" and "shriek," the lips stretch back along a tightened jawline, retracting into an actual grimace of dread or fear.) All of these elements can be employed to orchestrate the pulse and trajectory of the written word, creating an invisible musical notation that directs how we feel while reading the poem on the page.

So that's the swing. But if you've got that music in your bones, if you're attuned to prosody's spell on all these levels, then the rest—the heart, the meat, the raison d'être of the piece—will be there, too. "The music of what happens" occurs when you're not able to separate the swing from the heart.

How does one achieve this amalgamation? There are 1,001 paths to glory; I can't begin to give directions! I often find myself bouncing around, from narrative trajectories to prosody to image to vowel shape. One minute I'm researching the life cycle of a frog, the next I'm rearranging semicolons and enjambments. I'll keep up the juggling act until hopefully the poem takes over and falls into place.

As for spoken word: The advantage of a great page poem over a great stage poem is its durability: The page poem

can be read anywhere by anyone, silently or aloud, and still elicit the same emotional empathy. The page poem is scored to make the reader's breath catch and heartbeat accelerate exactly when the writer intends for it to happen.

5. *Howlin' Wolf!*

Your audience doesn't know who they are until the poem calls them, so how can the poem call before it's finished? Stop thinking about satisfying others. Just write, write, write as if no one is present, not even you—and if in the process you can forget there's a world out there; if time disappears, weather recedes, even the cries of your loved ones grow faint—then you're on the right track.

So, let's say you manage to forget the world or the Out There, whatever you choose to name it—how then do you stand up and speak into that void? For this step, imagine taking on the anima of a wolf. And like a wolf who howls at night—sometimes to find a mate, sometimes to summon the tribe, sometimes just because the moon is full and it feels so damn good to let the jubilant ache out and hurl that unearthly wail into the universe—you'll need no further justification for being who or where you are, summoning all who wish to join your clan on that moon-washed hill.

6. *Each word is a living, breathing thing.*

This is the only purely positive statement in my cautionary list and bears repeating. There are so many facets to a single word—denotation, connotation, history, sound, even the shape it makes as it fills your mouth— that sometimes the phrase you're looking for will be a combination of words you never imagined could coexist in the same room. A lot of this territory is covered in statement #4, so I won't belabor the point, but I can't resist sharing

this quote by Mark Twain: "The difference between the *almost right* word and the *right* word is really a large matter— 'tis the difference between the lightning bug and the lightning."

In lieu of an "Amen!" (and even though it might come across as a bit pedantic), let's look at the differences in effect between the two phrases "ravaged country" and "blistered republic." In the first phrase, the *g* rips through "ravaged," dragging the two raw *a*'s with it into plump and comfy-sounding "country"; the phonics feel as violent as the actual deed. In contrast, "blistered" suggests a more devious savagery, a torture from within—the percussive hiss of *st*, the bubbling effect of *bl*; the word pricks, seethes, and spits. Combine this cauldron of vitriol with "republic"—a self-confident, almost smug-sounding word (those plosives, *b* and *p,* puffing up its chest)—and you have a festering wound threatening to burst. Both idioms resonate beyond their surface definitions, but what very different work they're doing!

7. *Talk ain't cheap: Party on.*

When writing my play, *The Darker Face of the Earth,* one of my biggest challenges was how to convey thoughts onstage. Such introspection is practically poetry's default setting—one can cry out from a personal crucible of woes or channel emotions through a persona; italics offer another handy way to distinguish thought from speech. But how to get a glimpse into a character's interior weather when the actor is talking and marching around the stage, constantly presenting a non-real persona as if she were genuine? Even the soliloquy, that Grand Aside, is nothing more than a lyric poem plopped into the middle of the action; and even

though an actor's gestures and facial expressions can signal clues as to what the person talking is actually thinking, there are also times when characters are chatting away and you know that what they're saying is not what they're feeling. How can an excess of words, of inconsequential language, be made to fade into background music, the better to hear the silence beneath?

We can never probe the silence absolutely—not at every moment, not even for a single instant in a single conversation. The poet confronts this silence with every word put to paper; every so often the inadequacies of language can overwhelm an already self-conscious intellect, and the poem shuts down. But if we treat that crushing silence as the background beat, if punctuation and enjambment can suggest the duration of each pause, if a line throbs under the pressure of the white space around it—then the silence underneath will put on tint and texture, and you will hear it, breathing.

If the words won't come, sit still and listen. If a poem insists on jabbering on and on, focus on those spots which try to talk over the silence, those places where talk fights against breath. Silence is not the enemy. It's an echo chamber, and language is the skin over a drum whose resonance depends on the hollow space inside. Point counterpoint: The song rises.

Once More with Feeling

CAMILLE T. DUNGY

The first thing a writer needs to do is to learn how to pay attention. Learn how to look at the world with brighter and sharper focus. That's the job of the artist—to pay what Jan Zwicky calls "animal-bright attention" to the world. When you do that, as she says, "the world begins to come awake and mean hugely and richly at all times." Consider what it might mean to walk through the world with the fully engaged attention of the animal you are—to pay the kind of attention that is required of an artist—to notice, really notice, what is around you all the time.

You get to the heart of what matters—to you and, perhaps, to the world—by paying attention. Look more carefully. Look as if our lives depend on what you see and how you see.

Try it right now. Pick a point of focus, set a timer for one minute, and write down everything that comes to mind as you remain engaged with that point of focus.

When the minute is finished, stop writing.

It is likely that minute felt like it lasted forever. For others, the minute might have flown by. When you're creating art, a minute is a really malleable amount of time.

If you continue this practice—setting a timer periodically

through your normal day, even for just one minute, to pay attention and write down what you apprehend—you can teach yourself to be a time bender. This kind of practice alters how you sense time. This will mean the poems you write will also be able to speed up and slow down the world for your readers. Furthermore, as you learn to pay detailed attention to the world, then go back about your regular business, you might very well find that even the usual business won't feel so usual. This kind of practice alters how you process your surroundings, which means your daily life—and how you write about that life—might start to feel more richly detailed. That's part of the power of heightened perception. You'll be able to feel and convey significantly more in less time.

Consider how we react in moments of crisis. People will often say something like, "It felt like it lasted forever. That car crash lasted forever," when really it could only have been a matter of seconds. When you're in moments of crisis, you start to pay "animal-bright attention" to things around you. Most of our lives we tune out a lot. We tune out sounds and smells, for sure. For instance, your under-arm deodorant is likely scented, but after the initial application, can you smell it on yourself? That new laundry detergent? The odors that linger in your kitchen even when you're not in the middle of prepping a meal? Look around the room you're in right now. Paper, ink, wood, plastic, skin, metal—these all have smells, but your brain has likely tuned most of these smells out. We just don't pay attention most of the time.

That's to be expected. We would be overwhelmed if we processed every sensory experience around us all the time. Unless something presents itself in a new or surprising manner, I have learned not to pay attention to much of what is around me. I don't feel my sweater. I don't really feel my chair. I am not naming the names of all my dead and my lost loves every second of every day, even if they come

to my mind regularly. There are so many things you don't actively sense—that you don't feel—that are there all along. We shut a lot of receptors down most of the time. Otherwise, we couldn't cope.

Side note: did you notice the shift of pronoun there? I took you out of your body for a moment, shifting the dominant pronouns in this document from "you" and "we" to "I." You might not have paid attention to that consciously, but I imagine some part of your awareness was sparked by the shift in perspective, just as some part of your conscious is triggered when a surprising new smell or color or sound drifts by. In the paragraph above, I quickly shifted away from the pronoun "I" back to "you" and "we," and so it's possible I soothed the alarmed reader quickly enough that some of you may not have even noticed these pronoun shifts until I pointed them out. As I said, we shut a lot of receptors down. Otherwise, it would take a very long time to read the world around us.

But when you're in moments of crisis and emergency, you DO pay attention to a lot more. You smell and you hear and you see things you would have otherwise tuned out. What this means is that you might take in what seems to be thirty minutes' worth of material in just thirty seconds. You pay attention differently, more precisely. The smell of fear will be associated with real smells: the rust of fresh blood, the hot tinge of tire skids on tarry asphalt, the heavy wetness of steam coming off an engine block's metal, the swell of sweat on winter-dry skin, the surprising scent of early spring coming through the car's broken window. Your peripheral vision will be engaged, and you will see that bicycle spinning out of your blind spot, the cyclist's red and blue plastic helmet, and a puff of dandelion fluff coming up where the bicycle landed on the grass and flowers of the median. You'll feel the seatbelt strap on your neck and shoulder—you hadn't realized the seatbelt sat so high on your torso until now. You'll feel the palm of your hand uselessly

turning the ridged plastic steering wheel to the left and the backs of your favorite shirt's mother-of-pearl buttons cold against your chest. The sky's colors will have names—a robin was on the median, too, you remember now—and you'll remember the words of the song you didn't know you'd been listening to. You might even taste the inside of your own mouth. How often, if there's not food or something wrong, do you taste the inside of your own mouth? When you're in a moment of crisis, you notice things you wouldn't notice in your normal course of business. Because you notice more in less time, it will be as if time has stretched.

If you can start to practice this, you can begin to pay attention, really pay attention, all the time—by training yourself to grab five minutes' worth of data in one minute, for instance.

As you're writing, stop yourself and cycle through the senses. You might start with your strongest two senses—for many of us, this would mean sight or sound—but don't overlook your less dominant senses as well. How would you bring taste into this moment? How would you bring in smell? What do things feel like right now?

That word "feel" is crucial. I meant touch and texture just then but, of course, to ask how you feel also has to do with the heart. We feel things emotionally when we have strong sensory—or sensual—experiences. One take on the word "sensual" is linked to intimacy and physical connection with another. When we experience such connections, our sense of smell and taste and touch are magnified. We pay "animal-bright" attention to ourselves and the other. Poetry can be another form of intimacy. Poetry can bring all five senses into play to create a connection with another. When written well, poetry can convey one person's feelings in such a way that another cannot help but feel them too—both physically and emotionally. It's partially through sensory details that this is accom-

plished. Slow down, then, and learn to describe how and what you smell, taste, see, hear, and feel.

You'd be surprised how often failed poems lack sensory details.

Remember, also, that some of these sensory details will come through well-crafted language. Look back at my car accident example. Note how the smell sentence relied heavily on sibilance, creating a repetition of a sinister s- sound as the sentence built toward its end. That's a way of getting sound into a poem that's about creating a sonic experience for a reader that mirrors an emotional response. The hiss of air out of a tire, the hiss of the steam I described, and the residual Judeo-Christian fear of hissing snakes are all brought out through the sibilance of that sentence.

Learn to describe what is obviously apparent in what you are seeing, but also learn to go another step. Begin to ask what's outside your immediate field of vision. Think about what you might have tuned out. Think, also, about what you might not yet know. Once you get to what's outside of your immediate field of vision, how can you shift and change and push up against what it was that you saw and believed and wanted to document? In my example, I hadn't noticed the robin, then I did. That detail and others reinforce for me and my readers the season in which this incident occurred. An accident in spring creates a kind of tension that I might not have directly considered if I didn't think to look beyond the accident itself and consider the context of the calendar. Proprioception, the sense of where our bodies are in space, is a sense many Western thinkers very rarely actively cultivate. We don't even name it as one of the key senses, though in other cultures and non-Western languages proprioception connects to central ways of understanding the world. It helps to learn to describe where your subjects are physically placed in space and time. I also didn't notice that s-sound sequence when I first wrote of the incident but, once

I did notice those sounds, I made their application purposeful. The last clause of that sentence was initially: "and the surprise scent of early spring coming into the car through a broken window." I cut out the prepositional phrase "into the" and added a possessive *s* to "car" to tighten up the *s* sounds and speed up a reader's progress through the line. My immediate collection of data gave me quality base material, but looking back more attentively allowed me to convey the experience with even more precision and depth.

When I say that writing like this allows you to stretch time, one thing I mean is that you can pack significantly more attention into a few sentences if you open up and let in significantly more sensual experience. (Real or imagined experience. When you do this well, it will be hard to tell the difference between the two.) Another thing I mean is that thinking this way allows you to be who you were in the car at the moment of the accident and also who you were before, immediately after, and years after the fact. What you know at the moment of the accident is different from what you know at any of those other times. Learning how to pay attention to the world in all those moments and learning how to bring that attention onto the page, gives you—and your readers—access to a wealth of experience.

Once we start to listen and hear and see and smell and feel beyond what it is that has been most obviously presented to us, we get all kinds of new opportunities. We can move between common experience and extraordinary experience. We can describe loss but also methods of survival. In the process of detailing our senses as I'm inviting you to do in your own writing, remember that you get to be part of the healing. Because you're listening and you're paying attention, you're doing some diagnosing. You're sometimes presenting real problems and shadows and darkness, but you're also remembering that you have the capability of paying attention to

beauty: the smell of early spring, the sky's colors, the robin, that favorite shirt, even the bright dandelion fluff, those are all moments of beauty and grace in the midst of a horrible scene. Bringing in different experiences, different emotional registers and tones, will also stretch time. These sensually grounded experiences will expand your reader's emotional journey as well.

Our pores should be open. We should be paying attention. The world will race by us, and we should be able to absorb what feels like a lifetime of attention. This is something that only takes a few minutes, but with those few minutes you might write the world.

Craft Capsules

An American Marriage

TAYARI JONES

Finding Your Story

Like most thoughtful people, I have noticed that the world is on fire, and I want to use my skills to help extinguish the flames. To this end, I set out to write a novel that addresses the injustice of wrongful incarceration. I applied for and received a fellowship to the Radcliffe Institute and I became a dedicated researcher. I learned a lot, so much so that I got angry just watching *Law & Order*, my ex-favorite television show. I was informed, "woke," and motivated, but I couldn't write a novel because I had no *story*. The problem was that I was trying to write to the issue, and I can only write a story that is issue-adjacent.

I know I have a novel when I have a question to which I don't know the moral/ethical answer. When it comes to wrongful in-carceration, I am not torn. The state should not imprison innocent people. Full stop. Also without ambiguity: The prison system is cruel, corrupt, and in desperate need of reform, if not abolition.

So, where was the novel?

The answer revealed itself in a food court where I spied a young couple. She was dressed in a lovely cashmere coat. He wore inex-

pensive khakis and a polo. They were clearly angry and clearly in love. I overheard the woman say, "Roy, you know you wouldn't have waited on me for seven years." He shot back, "What are you talking about? This shit wouldn't have happened to you in the first place."

Just then, I knew I had a novel. The reason is that I understood that they were both probably right. I didn't know him, but I couldn't quite picture him waiting chastely by for seven years. At the same time, I couldn't imagine her behind bars. But did he have a right to demand her loyalty when both seem to agree she would be in no position to demand the same? Was this question moot since she would not likely face this challenge? Was this a kind of privilege? Could she mitigate this privilege by waiting like a modern-day Penelope? Should she?

So, we have a couple with a conflict, and at stake between them are issues of reciprocity, duty, and love. Yes, there is the injustice of mass incarceration. And yes, this injustice is fueled by racism and prejudice. Neither of them doubt this, and neither do I. But the question of "will you wait for me" is foremost on his mind.

The result is my novel, *An American Marriage*. Roy and Celestial are newlyweds, married only eighteen months, when Roy is arrested for a crime he did not commit. When he is slapped with a twelve-year sentence, the questions of desire and responsibility are at the center of the characters' lives. As a writer, I was genuinely torn: Roy needs Celestial to be a link to the life he left behind, and Celestial loves her husband, but she has only one life. I wrote this novel not only to satisfy my heart's curiosity as to what they would do, but to also satisfy the part of my mind that wondered what *should* they do.

I realized that my passion for the issue of incarceration was the reason I couldn't write about it directly. A novel is not me, as a

writer, telling the reader what I already know. And an honest novel is not about me pretending to take on "both sides" of an issue about which I have a clear opinion. I had to start with my issue and then walk away from it until I found the thing I didn't know. To truly challenge the reader, I had to challenge myself as well.

The Scourge of Technology

The cell phone is the worst thing to ever happen to literature. Seriously. So many great fictional plots hinge on one detail: The characters can't connect. Most famous is Romeo and Juliet. If she just could have texted him, "R, I might look dead, but I'm not. Lolz," then none of this would have happened.

Both email and cell phones threatened my plot in *An American Marriage*. A good chunk of the novel is correspondence between our separated lovers. In real life, they probably would have used email. But the problem, plot-wise, is that email is so off-the-cuff, and there is so little time between messages. I needed to use old-fashioned letters. Their messages needed to be deep and thoughtful, and I wanted them to have some time to stew between missives. But who in their right mind (besides me) uses paper and pen when email is so much faster and easier?

The fix was that Roy uses his allocated computer time in prison to write email for the other inmates, for pay. As he says, "It's a little cottage industry." He also explains that he likes to write letters to his wife at night when no one is looking over his shoulder or rushing him.

So look how this fix worked: You see that even though he is incarcerated, he is still a man with a plan. The challenge was to figure out how to avoid email in such a way that it didn't read like I was

just trying to come up with an excuse to write a Victorian-style epistolary novel.

The cell phone was harder to navigate. Spoiler: Celestial has taken up with another man, Andre, in the five years that her husband is incarcerated. A crucial plot point, which I will not spoil, involves Andre not being able to get in touch with her. Well, in the present day there is no way to not be able to reach your bae, unless your bae doesn't want to be reached. Trouble in paradise is not on the menu for the couple at this point, so what to do? I couldn't very well have him drop his phone in a rest-stop commode!

To get around it, I had to put Andre in a situation in which he would agree not to call Celestial or take her calls—although he really wants to. Trust me. It's killing him. But he makes an agreement with Roy's father, who says, "Andre, you have had two years to let Celestial know how you feel. Give my son one day." Andre agrees and has to rely on faith that their relationship can survive. The scene is extremely tense and adds suspense to the novel. I had to get up and walk around while I wrote it.

I predict that future novelists will not grapple with this quite as much as we do, as technological advances will be seen as a feature rather than a bug. But for now, you can still write an old-fashioned plot that doesn't involve texting or tweeting—you just have to figure out a work-around that enhances the plot and understanding of your characters.

Finding the Center

An American Marriage involves a husband and wife with an unusual challenge: Eighteen months after exchanging their vows, he is arrested and incarcerated for a crime he does not commit.

I was equally interested in both their stories, but for some reason

early readers of the manuscript were way more interested in him (Roy) than her (Celestial). At first, I was convinced that this was sexism, plain and simple. Men's stories are considered more compelling. To try and make Celestial more appealing, I tried to give her a more vibrant personality. But regardless of the details I added to embroider her, beta readers still felt that she was "undeveloped" and that Roy was the character who popped. It almost drove me crazy. Finally, I realized that Roy held the readers' attention because his problem was so huge. (He's wrongfully incarcerated, for goodness' sake!)

Undaunted (well, maybe a little daunted), I read stories by my favorite women writers who write beautifully about women's inner lives. I checked out Amy Bloom, Antonia Nelson, Jennifer Egan. How did they manage to make emotional turmoil so visceral? In these writers' hands, a small social slight can feel like a dagger. Why couldn't I do this in my own novel?

I found the answer in the work of Toni Morrison, for all answers can be found there. It's a matter of scale. There is a scene in *The Bluest Eye* where the lady of the house is distraught because her brother hasn't invited her to his party, although she sent him to dental school. By itself, this is terrible and totally worthy of a story. However, in the same frame is Pauline, the maid who has suffered all manner of indignities in an earlier chapter. In the face of Pauline's troubles, the matter of the party seems frivolous.

With this, I discovered a fundamental truth of fiction and perhaps of life: The character with the most pressing material crisis will always be the center of the story. Although Celestial's challenges as a woman trying to establish herself in the world of art is intense, the fact of Roy's wrongful incarceration makes her troubles seem like high-class problems, and to center them in the novel feels distasteful

to the reader, like wearing a yellow dress to a funeral and fretting over a scuffed shoe.

The solution: I made Roy the protagonist. Celestial's voice is still there, but she is a secondary narrator. It was a hard choice because I was drawn to her story in the first place, but it was being drowned out by Roy's narrative. Finally, I had to stop fighting it. The protagonist of *An American Marriage* is Roy Othaniel Hamilton.

It took me five years to figure this out. Of course, every craft solution makes for new craft obstacles.

Every Novel Is a Journey

I came to this tale seeking to amplify the muffled voices of women who live on the margins of the crisis of mass incarceration. So it was hard for me to make Roy's story the main color of the take and relegate Celestial's point of view to a mere accent wall. It nearly killed me. I was prepared to pull the novel from publication.

Luckily, I had a craft epiphany.

Roy is a great character. He's like Odysseus, a brave and charismatic man returned home from a mighty battle. He just wants to get home and be taken care of by a loving wife and sheltered in a gracious house. His voice was very easy to write because he is easy to like; his desires and decisions make it easy to empathize with him. He is a wrongfully incarcerated Black man. What decent person wouldn't root for him?

Celestial was a bit more challenging. She's ambitious. She's kind of stubborn. And most important, she isn't really cut out to be a dutiful wife. Back when she was the protagonist of the novel, I used to say, "I am writing a novel about a woman whose husband is wrongfully incarcerated . . ." and everyone would expect the novel

to be about her fight to free him. And it wasn't. It was about her decision not to wait.

On the level of craft, it just didn't work. For one thing, you can't write a compelling novel about what someone *doesn't* do. (There is a reason why Herman Melville's Bartleby doesn't get to narrate his own story.) Second, Roy's crisis is just too intense and distracting for the reader to care about any other character as much.

So, what to do?

I foregrounded Roy. He is the protagonist and readers find him to be very "relatable" (my very least favorite word in the world). I took Roy on the journey, and I invite readers to accompany him. As the writer, I came to the table understanding that the expectations put on women to be "ride or die" are completely unreasonable; furthermore, there is no expectation of reciprocity. But rather than use Celestial's voice to amplify my position, I allowed Roy the hard work of interrogating his worldview, and the reader, by proxy, must do the same. The result is a novel that was a lot harder to write, but the questions I posed to myself and my readers were richer, more complex, and I hope, more satisfying.

Originally published as a series of Craft Capsules in *Poets & Writers Magazine*, January–February 2018.

Craft and the Art of Pulling Lincoln from a Hat

E. ETHELBERT MILLER

my father is a retired magician
which accounts for my irregular behavior

—Ntozake Shange

When Black writers talk about craft, it should begin with questions about Blackness. Didn't we have this conversation before? Yes, what did we all do to be so black and blue? Remember when the search for the Black aesthetic resulted in the endless discussion of the blues aesthetic? You never want a politician or even a family member to define Blackness for you. So here we are once again sitting on the shores of Africa waiting to depart into a great unknown. Before someone sings "Amazing Grace" or plays something by Sun Ra, let's ponder where we might be going and the skills it might take to navigate the great Black bottom.

Over the years I've corresponded with the novelist Charles Johnson. Johnson is the author of *Middle Passage* and a MacArthur Fellow. An outgrowth of our exchanges was his craft-oriented

book, *The Way of the Writer* (2016). A by-product of our interaction was what I came to define as race koans. These koans were a way of thinking about the subject of race as a problem not to be solved but to simply enlighten the many of us who kept rubbing our skin. What was this lovely, so dark and tender as the night?

As I begin this essay about craft, I keep juggling my own thoughts. How do I punctuate Blackness in a sentence? What's the difference between the blues and revision? If Nat Turner couldn't read, then what did he read when he read the stars?

Oh, place me in a corner of an MFA classroom and put a porkpie hat on my head. Workshop my sweat and tears. This is what I know. I didn't know it when I thought I knew it.

When I started writing there was no North Star. No Douglass or Tubman teacher to guide me. It was attending Howard University that served as my Middle Passage, introducing me to a curriculum of new Negro thought, enough to restore my buoyancy. In one classroom I sat next to Shine. This was before my graduation and my innocence shook. I was fortunate during my time at Howard to meet Sterling A. Brown, Leon Damas, and Stephen Henderson.

There were lessons waiting for me to learn. The focus was on folklore, things southern and then African. One learned the myths that came before history; the creation tales. As writers we were instructed to imitate before giving flight to improvising. One was first instructed to know the soil before embracing the air.

All this knowledge came along with the understanding of a key theme in Black literature: the issue of flight. From Flying Africans to feet running to catch a train heading north, the Black writer navigates a landscape of symbols and sayings.

The Black writer struggles to place the ear on the page. The sound of history's heartbeat? The writer must bend and shape the

language into shapes and things and forms unknown. Faith cannot be taught. The craft comes from an inner knowing and seeing.

To see is to hear. How we listen is the only way we will recognize the sounds of freedom. It takes work to live among the righteous, to even hum "A Love Supreme."

What is the craft that comes from living? What does it look like? How does it taste? What is the recipe for nourishment? How do we feed a people with one loaf of bread? What have we learned from Ellison, Morrison, Hughes, Wright, and Wilson?

Craft is not technique nor is it technical. It can be found and mastered each time you question why you write. Many writers can't breathe because the problems of race won't let them. Too often they tend to feel that mastering of white forms is the craft key to great art. They seldom inquire why a key is necessary or what's behind the doors.

Talk craft to someone and they might begin with Joyce and work their way to Faulkner. They might say Ashbery or Pound just to flirt.

Too many of us fail when it comes to learning magic. Success is a spell that can make a writer disappear. Why, when I think of craft (especially during these times), I hear Amiri Baraka whispering from "Sacred Chant for the Return of Black Spirit and Power" in my ear, "To turn their evil backwards is to live."

What It Look Like?

—

Form

Ready for the World

On Classroom, Craft, and Commanding Black Space

TONY MEDINA

I was looking at the ceiling
and then I saw the sky.

—June Jordan

Boom Bap Bop

I think now is as good a time as any to quote Plato, who said "Music is a moral law. It gives soul to the universe, wings to the mind, flight to the imagination, and charm and gaiety to life and to everything." And while I'm at it, let me balance it out by throwing in an Eastern philosopher like Confucius (for good measure) who said, "Music produces a kind of pleasure which human nature cannot do without."

I can't recall the exact moment I began using music as a main instrument of inspiration and influence in my poetry workshops. Perhaps it was when I conducted writing workshops for young folks in the schools, particularly in New York during the winter,

and Little Rock, Arkansas, in a church for Patrick Oliver's "Say It Loud" nonprofit during the summer. But I distinctly recall using it my last semester of graduate school at Binghamton University when, as part of my fellowship, I had to teach a creative writing course. I found myself lugging my little boombox into the classroom and playing music for each prompt. The students seemed to take to it, and it seemed to really affect their poems.

Today you can find me lugging a big-ass Radio Raheem boombox to the classroom in my creative writing classes at Howard, to the cracks and pleas from my students to get with the times and use an iPod. Nevertheless, I take my old-school approach and my CDs, and I hit them with John Coltrane, Miles Davis, Pharoah Sanders, Sade, Chaka Kahn, Tito Puente, Celia Cruz, Hector Lavoe, Bob Marley, Nina Simone, MJ, Prince, and Pavarotti and Leontyne Price.

Music allows me to set a mood for creativity as well as influence the direction of my students' poems. I tell my students: "I'm the deejay; you're the rapper!" And from there they take off into the world of their own thoughts. Of course, there are those who cannot focus with music or any kind of noise, forcing me to give them a *whatchutalkinboutwillis* dirty look and lower the volume.

But the fact of the matter is that music is an integral part of the creative process in my classroom. It is part of our everyday lives. There are folks who can go without TV like a camel can go without water; but no one that I have ever encountered can go without music. My students may look at me with shock and contempt when I ask them if they listen to the radio, but they damn sure listen to music on their iPods or through their cellphones and laptops.

So, when I introduce them to an original, contemporary African American form like Afaa Michael Weaver's bop, where song lyrics play a central role in the style and content of the poem, they usually

get excited. How I introduce it to them is also important. For in my classroom, I tend to build up to things. I like to lay a foundation for my students and ease them into certain forms, while simultaneously showing them how these forms relate. And in seeing the correlation of certain forms and poetic devices, they begin to take their own free verse more seriously in the poem, on the page, and in the open air (in performance).

Thus, in the march toward the bop, which is generally either mid-semester or on the down slope of the semester, I get started by having them write free verse, showing me the chinks in their armor. Then I gradually force some discipline on them by getting them to tackle the concision of syllabic verse forms like haiku and tanka. This all leads up to what many of them fear the most: the sonnet. Once they get a handle on writing sonnets, which are musical by nature, I begin to introduce them to the bop, which is, in my estimation, the love child of the blues and the sonnet.

I start by asking them what is one of their favorite songs. Then I get them to write down a couple of lines or a refrain from that song. Once they have written those lines down, I go around the room and have them recite the lines. Sometimes we break out into discussing memories around the song or the lines from the song: their first crush or kiss/memories of their parents or grandparents/ what age they were when they first heard the song. This tends to really ignite them; they begin to open up. In this way, they share intimate details and memories from their life experiences, bringing them closer together as a group. They get caught up in some of the stories from their classmates and how much they can relate to one another, generally and culturally. They really get excited when they recognize some of the lyrics.

After this initial aspect of the prompt (what I like to consider the marinating stage), I introduce them to the bop form itself, its creator,

and its history. This is followed by some published examples, as well as one of my own.

The bop is a popular and effective form because it allows one to grapple with a problem (posed in the first stanza), expound upon that problem (in the second stanza), and resolve that problem (or situation) in the final stanza (it also allows for an additional stanza, if need be), all balanced throughout with a song refrain that further illuminates the poem, giving it its emotional and intellectual gravity. It is an ideal form that speaks to the times. Where spoken word venues are spaces where poems are performed with text as well as song lyrics, to dynamic effect, the bop allows for both the formal discipline of the blues or sonnet, as well as the performative approach of introducing song lyrics organically. Students (and poets) gravitate toward it because its formal structure is not intimidating, yet it still manages to challenge, allowing for music to enter the poem in a more direct and deliberate manner. Once mastered, the bop allows for experimentation. Instead of song lyrics one can use quotes or platitudes—even utilizing clichés, one can breathe new life into poems for satirical and subversive means, putting the boom bap into the bop.

Here's a Black Lives Matter bop that appears in my latest collection, *Death, With Occasional Smiling*:

The Great Pretender

I only pretend to be dead—death is a
Dress rehearsal for a show never to be played again
Dying is so easy like a dog rolling over,
Playing dead; I only pretend to bleed
These wounds don't need to heal
Something will bloom sooner or later

Oh yes, I'm the great pretender
Pretending I'm doing well

This blood you see, what pools at
Your feet, don't mean much no more
What spreads and rises and stains
Your hands and feet—
The Nile (Denial? Duh-dum duh-dum—Oh, hell!)
I only pretend to be dead
This heart I have can play dead, too
Like a dog you teach a trick or two

Oh yes, I'm the great pretender
Pretending I'm doing well

I only pretend to scream—don't you know?
These words I write, these words I scream
And curse—figments of the imagination
For those who have no imagination
Or if they do—
 Spooks them white

Oh yes, I'm the great pretender
Pretending I'm doing well

I only pretend to breathe; the movement
Of my lungs a mere optical illusion
You'll see soon enough
The air leaking out like a tire
Oh no—I'll never retire from playing dead
I'll never turn you down

Oh yes, I'm the great pretender
Pretending I'm doing well
My need is such I pretend too much

To close out, I'd like to remind my dear reader that this essay is being stitched together and composed during a global pandemic more closely debilitating to people of color. A sort of population control, perhaps? This brings into question once again the notion of Blackness, the future, and space. But I digress. What I mean to say is that Black creatives will be at the forefront of writing and speaking on this pandemic for racism itself is its own pandemic, no? In any event, predominantly white institutions will continue to cockblock Black creativity, thought, imagination—and work to control and confine Black space(s). But of course, with our sense of morality, integrity, ingenuity, and profound pride, and prolific creative impulse toward propelling humanity into a progressive future, we will prevail.

Wrangling the Line,
Meditations on the Bop

AFAA MICHAEL WEAVER

In the twenty-five years that have passed since I created the bop, a workshop exercise for my Cave Canem students, it has traveled on the wave of exuberance that filled all of us as the retreat was launched. As it has become a poetic form, I have wondered about its ability to be sentient, become aware of its own life, and make choices as to how it wants to manifest in the world. In making its decisions, the bop must know by now that the structure I gave it is cellular, forged in mathematics, the golden mean, a method of composition used in painting and photography, and the refrain. Of course, the only sentience the bop can have is in the collective engagement of poets with it; over the years, some infrequent but significant conversations with poets who have taught the poem in various places have concerned me. In the space of this short essay, I want to address some of those concerns, beginning with what makes the creation of the bop a political act, and move on from there to discuss the nature of subject in the form, and the relation-ship between lyricism as it appears in music and poetry, and what

that has to do with anything but, most important, the success of writing a bop.

The political nature of the creation of the bop is part of a tradition that includes the blues poem, adapted by Langston Hughes from the stanzaic structure of blues lyrics, to jazz poetry as performed by Langston Hughes, Jayne Cortez, and Amiri Baraka, to name just three. These are emanations from African American culture, markers of cultural continuance. What I imagined in creating the bop was to inhabit Blackness, to speak from within it, as I know it, so that the bop can be a part of a web of resistance, a complex of creativity I sensed was happening in other places in the diaspora. In imagining that web of resistance to cultural exploitation, or hoping for it, I invested what I knew and felt to be a Black way of moving in the world, from the cool stillness of the African American southern agrarian culture to the way our bodies move in urban spaces. Bop, as such, denotes the preciousness of Black life and a faith in an eventual release from the way American structures are intent on consuming us, pressing against our humanity with commodification.

The golden mean looks to highlight beauty. In the bop it is being repurposed so that beauty is defined from within the African American experience of consciousness, a diverse consciousness. This is the typography of the form, with a suggested title.

A Summer Evening in Baltimore

After Kind of Blue *by Miles Davis*

_____ *R*

_____ *R*

_____ *R*

Looking at the map as reference, I would like to speak to the ekphrastic possibilities, as relates to the golden mean, in composing a bop, and then move on to other matters, including the choice of subject, in a way that I hope will be helpful to the evolution of bop poetics. However, before we examine those aspects, an urgent matter needs to be addressed. As a poetic form, the bop begs a formal definition, and I take this opportunity to give that definition as follows:

The bop, as a poetic form, is a vehicle for lyric expression in the space of three stanzas, an initial sestet, a medial octave, and a final sestet, with refrains following each of the stanzas. The refrain should be at least one,

and no more than two lines, making the total number of lines twenty-three or twenty-six. The refrains should be drawn from music, either created by the poem in response to instrumental music, where the words are original, or adapted from the lyrics of an existing song, depending upon availability and usage restrictions. The architecture of the bop is triadic, with mathematical emphasis on the possibilities of the numbers two and three. As opposed to English metrics, the rhythmical patterning in the form is determined by the refrain and the interaction of the refrain with the stanzas preceding it, such that the meter is variable.

In the map, we have an unwritten bop with a title and epigraph, both of which, I hope, begin to suggest a mood for the poem. It is set in Baltimore, during the hottest time of the year, and in Baltimore summer is also very humid. The harbor is actually a tributary of the Patapsco River feeding into the Chesapeake Bay, the largest inland harbor on the East Coast, and *Kind of Blue,* is, according to many, the album that is Miles Davis's masterpiece. That is the mood, and if you are, as I am, prone to writing around an image as idea, many things might come to mind. In keeping with the golden mean and, in that way, the significance of ekphrasis to the concept of this form, I am drawn to Roy DeCarava's 1949 photograph *Graduation.* This well-known photograph speaks to hopes and dreams, as well as to the reality that challenges them: a young African American woman, fully dressed for graduation, is walking down a street with evidence of urban disrepair all around her.

From the mood, a number of subjects may emerge, or some of the poet's preexistent subjects may find a place in the mood. My point here is to move away from what was originally accepted as the subject, the expression of anger, which I admit came from the early days of the bop. The form was conceived in the time of the deaths of Tupac and Biggie Smalls, both tragic deaths, and signs of the increasingly complex problems facing young Black people looking

to make a way out of no way, living in circumstances designed to increase and intensify Black folks' dependency on structures that are unhealthy at best, which led to steadily increasing rates of homicide in cities like Baltimore, where we can imagine the young lady in DeCarava's photograph full of dreams and hope.

The map will, I hope, deter the very thing diagrams are often assumed to do, namely, give a formula. Bop poetics, I think, have evolved to where the form can take on flesh in any circumstance, any configuration of subject matter, and any culture, as well as across languages and descriptors of who people believe they are. The bop is not formulaic. It is, as any form in poetry, a way to give generations a score, as in music, which they can use to inhabit the poem with the structures of their own bodies, which is to say people use the same anatomical features of themselves—voice boxes, teeth, jaws, etc.—to produce sound, and in that way, poetry carries across generations if it has something people can always turn to for hope, courage, or resplendent joy.

The italicized "R" indicates the refrain, and I should spend some time with this as it is part of what I call "the bridge of lyricism in song and poetry." It is an old subject, to use that word again, that of how much poetry and song resemble one another, or whether one performs lyricisms better than the other, and many are the traditions where poetry is sung in accompaniment with an instrument. The blues comes to mind first, and I offer Sterling Brown's "Chant of Saints" as a case in point, a hauntingly lyrical poem about a blues artist that shows, at least to me, the two modes of artistic expression. The poetry celebrates song in the lyric spirit of both modes, emanating from Big Boy, the character in the poem about which Brown writes with an admiration and love that deepens each time it is read, across the generations.

Looking at the outline of the bop, the photograph by DeCarava,

and listening to any cut on Miles Davis's album, my hope is that you, Dear Reader, can feel some moving of the spirit, some set of feelings and emotions, the start of what bop poetics can bring to the page and from the page to the reader's mind and voice. If you meditate on the outline as if it were a drawing, you can begin to sense how the introduction of the subject should be clear by the end of the first sestet, and no later than the second line of the octave. This is not to suggest that the subject be stated, as I myself have written in very early descriptions of the bop. That misconception might have led to the idea of the bop as having a formula, a mistake some devotees of formalist verse might make in producing verse that is devoid of the often-inexpressible way lyricism emerges in a poem. It cannot be calculated and, as such, I can only offer what I hope is inspiration. In that meditation on the outline as a drawing, you can also begin to see how the bop should begin to turn near the end of the octave, helped perhaps by the anticipation created by the refrain. As the placement of the subject in the photograph follows the golden mean of being approximately one-third of the way from the leftmost edge, so the subject of the bop appears the same distance from the opening of the poem. The resolution of the bop occurs in the final third of the space of the outline just as the placement of the garbage can in the photograph announces a necessary closure. The principle is the number three.

Three is, of course, the number of repetitions of the refrain. The power of the refrain is, risking redundancy for emphasis, in repetition. In its placement in the bop, it should establish a connection with what precedes it, which helps form the bridge between song and poetry, the place, sometimes contentious in exegesis, where there is a mutually cooperative link between the refrain and what precedes it. Just as the effectiveness of a sonnet is in its whole procession, its gradual accomplishment, so it is with the bop, but the

bop makes use of the refrain in ways that more resemble the villanelle than the sonnet, and neither the villanelle nor the sonnet was created in a digital world. DeCarava's photograph and *Kind of Blue* are readily available on the Internet, so the bop is formed in the interstices of what industrial society has given the world, and what it has taken away, creating and destabilizing at once. In songwriting vowels are preferable over consonants. Look no further than the book of rhymes, a tool of hip-hop and rap stylists.

May this unwritten poem write itself in your imagination and to whatever subject comes to you. May the process I've provided here help you in your general sense of being creative. If the bop has achieved sentience, as I have claimed, may it be enlarged in its creative potential and move and grow, joining the hopes of other Black artists, their hopes and their own aesthetic forms, to help poetry continue to grow as an active force in the lives of Black people as they meet the tremendous challenges of the twenty-first century and beyond. Bop poetics are elastic and embracing, emanating from a cultural center that is secure in its own being. In that way may it live and grow, grow and live. Let there be bops for bebop, let there be bops for Black theater, let there be bops for Candomblé, let there be bops for Yoruba, let there be bops everywhere, in all languages, wherever need arises. Let it be remembered that, in June of 1997, during the second annual retreat of Cave Canem, it was born in Mt. St. Alphonsus monastery on the Hudson, out of the womb of Black resilience.

Fiction Forms

How to Make Fun and Profundity Possible in Fiction

TIPHANIE YANIQUE

What Is Form? Why Bother?

Let me do a quick and dirty overview for those of us who hate form or don't like it or maybe say we hate and don't like it because, really, we don't get it. Poets use form to challenge themselves by the form's limitations and to participate in poetic tradition. In many cases, poets push against the limitations for and of forms as a way to push against the traditions which created those forms. Specific forms, however, have specific strengths which allow for specific dynamics to arise in the poem. To this end, poets have often created new forms as ways to reference new cultural limitations, create new traditions, and make possible new dynamics. For those of you who have studied poetics, this is nothing new.

Fiction writers, however, have not made as much intentional use of form, nor have we sought to make a legacy of forms for use in apprenticeship and conversation between writers of various generations. Though we often do abide inside of received

forms—we who write fiction sometimes don't know we are doing it, don't want other people to know we are doing it, or think that being in conversation with others might be reductive rather than productive.

So, what are the fiction forms? And what are fictional elements in the world that might be called upon as references for new written fictional forms? What new fiction forms does our culture need now?

Let's start with a poetic form from the European tradition: the sonnet. What is a sonnet, even? It literally means little song and was traditionally used as a love poem. But in grade school we often learn it just as a poem with fourteen lines. We might have learned that it also has a turn at the end. It is also a poem with a particular and rather strict rhyme scheme. It looks kind of like a block on the page, a tight almost square. Here is an example:

Shakespeare's Sonnet 130

My mistress' eyes are nothing like the sun;
Coral is far more red than her lips' red;
If snow be white, why then her breasts are dun;
If hairs be wires, black wires grow on her head.
I have seen roses damasked, red and white,
But no such roses see I in her cheeks;
And in some perfumes is there more delight
Than in the breath that from my mistress reeks.
I love to hear her speak, yet well I know
That music hath a far more pleasing sound;
I grant I never saw a goddess go;
My mistress, when she walks, treads on the ground.

And yet, by heaven, I think my love as rare
As any she belied with false compare.

Okay. So that's a sonnet. But so what? What is the sonnet for and what does it do?

It's a little song, so we can gather that it's a poem for singing. Its rhyme scheme, repetition of idea, and short length, in fact, makes it more easily remembered and therefore more easily sung. Its form serves this purpose.

The sonnet might also be an argument, directly building its case line by line but surprising us with a more profound conclusion than the argument seemed to have been adding up to. The turn at the end allows for that. The form allows for that.

Many poets argue that if this is what the form of the sonnet is for (to be sung, to make argument, to surprise, to be of love), then anything that does these things is a sonnet. Which means: You don't need the rhyme scheme. You don't need the fourteen lines. A sonnet might even be eight lines just with the turn, for example.

You might look at John Murillo's "Distant Lover (Or, When You're Teaching in Amherst and, While On a Late Night Walk, Your Wife Calls from Brooklyn to Say Goodnight)." It's not four-teen lines, it doesn't have an obvious turn, but it does what the sonnet does—it sings of love. You can find Nicole Sealey's reading of this poem online. She doesn't exactly sing the poem, but her reading is filled with musicality. Her reading is also filled with wonder and with adoration—the poem, you may know, was a love poem written for her. Once we understand the form and what it can do, we can get to the bareness of it—abandoning the strictness of the form along the way.

On the other hand, once we say "this is a sonnet" and we label

a poem a sonnet, then we might use the reader's understanding of what a sonnet is to challenge the form itself. We can then demand that the form, even in its strictest representation, be made to face our current historical and cultural reality. Here is "Sonnet" by Terrance Hayes.

We sliced the watermelon into smiles.
We sliced the watermelon into smiles.
We sliced the watermelon into smiles.
We sliced the watermelon into smiles.
We sliced the watermelon into smiles.
We sliced the watermelon into smiles.
We sliced the watermelon into smiles.
We sliced the watermelon into smiles.
We sliced the watermelon into smiles.
We sliced the watermelon into smiles.
We sliced the watermelon into smiles.
We sliced the watermelon into smiles.
We sliced the watermelon into smiles.
We sliced the watermelon into smiles.

This follows all the form rules of the sonnet. The love is for the watermelon. But it is not a settling love. The turn is ghosted, and so we see that these lovers of watermelon are not allowed to be released from their argument of who they are by a surprise turn at the end. This is a poem about how Black people are represented as minstrelled and happy but how that representation is a kind of violence.

Or we might even say that this form, the sonnet, in its traditional European form, cannot rise to the elements of our current Black and Brown reality. In this case we might call it a sonnet, make it

fourteen lines, to draw attention to the form's inability or to demand that the sonnet bend to our needs.

What Are the Fiction Forms and How Might We Use Them?

Okay. So back to fiction. We fiction writers are missing out on all of this deliciousness. This conversation, this freedom, this challenge, this apprenticeship, this rebellion, this renewal and discovery. What are the existing fiction forms and what new fiction forms might we forge or create?

One of the most taught and most familiar is the Hero's Journey. I've been in more than one classroom where the teachers argued that the Hero's Journey is really the only fiction form. That the Hero's Journey is a form that is in all cultures and can be applied to most stories. Some writers and writing teachers have simplified this to say that all stories are "a stranger comes to town" or "a hero goes on a journey"—which is really just the same form with opposing perspectives. I disagree vehemently with the idea that there is one mono-form for narrative. As I began teaching and even attempting to write within this form, its racist and sexist elements became clear to me. But racism and sexism aside, claiming that there is only one form is just another way to tell fiction writers not to worry about other influences and possible inventions. It's a way to leave all the fun and profundity to the poets. Novelists and story writers—why should we do that?

Here is one version of the Hero's Journey formula.

The Ordinary World
The Call of Adventure
Refusal of the Call

Traversing the Threshold

The Belly of the Whale

Tests, Allies, Enemies

Approach to the Innermost Cave or Meeting with the Goddess

The Ordeal

Atonement with the Father

The Road Back

Resurrection

Return with the Elixir

Master of Two Worlds

Freedom to Live

This is, to be sure, a useful way to craft a story. This form helps with scene, as the hero goes somewhere and then returns. There is character development, though it is archetypical and often stereotypical. But the Hero's Journey is also a form heavily focused on plot—which is why it also works for what we think of as plot-heavy genres like fantasy. All you have to do is follow those steps from 1–12 (or 1–9 or whichever version you want to follow). In fact, so many movies use this formula that many of us can predict how most blockbuster movies in the US are gonna go. Which is to say . . . that it is actually a very Western and male form. It is a form to express the adventure and risk that has defined white masculinity—that white masculinity goes forth, conquers and brings the bacon (the ring, the sword, etc.) back home. Further examination shows that it is a form about white masculine coming of age. The hero isn't generally married with kids, for example. That would make his leaving an abandonment, not a heroic journey. This isn't to say that the form is bad. It's just that the form has these inherent limitations, as all forms do—this is, in part, the pleasure of working within and against form.

So, what if we push against the Hero's Journey? What happens, for example, if we make our hero a woman? What happens if we really take her femaleness into consideration—not just make a girl but keep her journey looking pretty much the same as boys'? Does she meet a goddess or does she encounter her own self? And what if the hero isn't young? Does he lose the ordeal because he doesn't have both the strength and naïveté?

In my novel *Monster in the Middle*, I work each chapter/story through a different form of fiction. I thought first about what the form is meant to do and if that meaning is subverted when I put my own skill set and preoccupations to work.

In my story "The Special World," I asked what would happen if I put my young Black man into this white male structural form of the Hero's Journey. I also asked, what might this form, the Hero's Journey, have to say about Black male coming of age specifically.

In this story, the journey is Fly's freshman year of college. The ordinary world is Fly's home before college. The call is actual college things that a first-year gets called on to do, like attend orientation. Fly refuses them all, but then his RA pulls him across the threshold (literarily and literally). He meets a goddess and gets into her innermost cave—which I write as him having sex for the first time with a super-gorgeous and super-religious girl. He has to get saved to be with her, and then his parents initiate divorce, which is all an emotional ordeal for him. He faces his father. He starts on the road back.

At this point, if I am writing any sort of Black realism (in this case, a spiritual and psychological realism), I need to attend to actual Blackness as it is in the time period and space of my character—in this case 2007 or so in Atlanta, Georgia, USA—but also with the knowledge I had writing this chapter in 2020. I can gather that a Black boy who believes in a goddess will believe in God and will

be a boy prone to ruminations and actions of faith. The question I might ask of the form is: What does his belief system allow him when he meets the goddess (the girl he will lose his virginity to)? My answer is that he falls in love, of course. But can an educated Black boy, with parents who had never been to college themselves, "return" to the real racist world with the elixir of his new sexual self? Will racism allow him that or will it feel threatened by it? How can Fly be the master of two worlds when Blackness isn't even allowed mastery of this one? And forget about freedom to live . . . we've been through a summer of Black Lives Matter to know better than that.

So, I deconstructed the Hero's Journey form by leaving some steps out, moving some steps to entirely different stories that appear later in the book, and by doing so I argue, in "The Special World" specifically, and for this character of Fly specifically, that his Blackness is denied heroism, denied a hero's welcomed return, denied the elixir. I was true to my belief, which is that Blackness, in general, often requires community support, familial support, and partnered support to discover any elixir. It also seems to me that Black heroes in the world we live in now are rarely on an individual journey, if the journey is to be a successful one. For purposes of my use of this form, I don't even mention "freedom to live" at all.

In *Monster in the Middle*, I also use the Road Narrative in the opening chapter/story called "Oakland Gomorrah." The Road Narrative form is one that is most useful when creating scene. It might be particular to America because of the continental US's ease of interstate travel and its cultural history with the car. It helps with plot because you are on the road. The structure of the Road Narrative is something like this:

Two or more people know each other but not as well as they could.
An inciting event places them in a journey by vehicle, usually car.

They set off across the continental United States with a faraway
destination in mind.

There will be at least one digression of the planned route.

At some point after this digression, the emotional reason for the
journey will change from something that was concrete to
something more emotionally profound.

The characters will arrive or not arrive at the planned destination,
but along the way they will be bonded, fall in some kind of love
(friendship, romance, family).

The form's purpose is to explain that the land you are from, this
American land, makes you who you are. That you are free, yes—to
move and go—but that the land itself has an existential hold on you.
The choices of locations that the characters visit, pass through, stay
at a while, are all ways to communicate character development. The
movement between these places provides the plot.

For example, in the film *Queen & Slim*, the digression comes when
the couple veers off to visit Queen's mother's grave, and we finally see
that Queen has a tender side. *Thelma and Louise* is, of course, a classic.
In both *Thelma and Louise* (a feminist narrative) and *Queen & Slim* (a
Black narrative), the characters (spoiler!) die in the end. The messages
are that friendship between women is suspicious and women are not
allowed freedom on this land; and that two Black people in love are
dangerous and are not allowed freedom in this land.

In my short story "Oakland Gomorrah," it is 1989; the characters
are a white woman and a Black man, young, and romantically inter-
ested in each other. I wanted to use the form of the Road Narrative
but I also wanted to consider what the freedom of these particular
characters might look like. What freedom will be allowed or denied
them by the American landscape? What might the journey mean to
them as lovers, sick people, religious people?

In "Oakland Gomorrah," the land itself is pushing Gary and Eloise forward—they leave San Francisco running from the 1989 earthquake. They are also running from her religious upbringing and his mental illness. They go through the US south to do this. Their goal is to drive to Miami from where they imagine they might be able to get to a kind of multiracial utopia in the Caribbean. They stop at religious sites and at sites of racial integration. They digress to stop in Texas—which they had committed to not doing because they believe Texas to be racist—but Texas surprises them. They make love near a desert (they only feel safe with their love when there are little signs of life). In the desert is a biblical fig tree that feeds them.

I won't say too much more, so as not to give away my own plot, but unlike my goals with the Hero's Journey, I am faithful to the form of the Road Narrative. I chose not to challenge this form, but instead to work within it. I wanted to know what the form could do and what I could do in the form.

You might consider what this form might do on the roads of Nigeria. Or what it might do if it was by motorcycle and sidecar.

Throughout *Monster in the Middle* I use a number of other forms. I use the poetic form of the sestina to make a new prose form. This story is titled by its form—"Sestina." I understand the sestina as a poetic form about how language is made new and mysterious by context, but also how context is enriched by intentional language. It is also a form about desire and its attendant frustrations. The poetic sestina uses six words and puts them into the lines of the poem in a form that, when diagrammed, looks labyrinthian. I do the same labyrinth work in my prose sestina. The labyrinth itself, as a physical metaphor of the sestina, is about mystery, penance, and futile desire; you are on a journey but are also constricted by the labyrinth structure—its form. In my fiction "Sestina," I allow

individual words to lead plot movements. I also add another layer to my fictional sestina—one that emphasizes another point of form itself, which is to be influenced by another writer. I take my six sestina words from the opening line from *Love in the Time of Cholera* by the Afro-Caribbean/Latin American author Gabriel García Márquez. Thus, I emphasize a potential relationship between that book and mine.

In "Love Letter," I use an old form—the epistolary. We might think of letter writing as one of the most ancient forms of written fiction. As a structure, the epistolary communicates setting easily by use of dates, and time period easily by voice. The epistolary allows for direct statements, which might reveal character development for the speaker and the addressee.

In "Meeting the Monster," I use a much newer form, created perhaps in the last century but most utilized in fiction since the 2012 death of Trayvon Martin. We might call this the Police Encounter form, which is a form about Black vulnerability and white authority in a US context. As a structure, it allows for character development, has a clear inciting event that allows for plot, and has a strong sense of metaphor.

A form that I use in *Monster in the Middle* writ large is the decolonial Caribbean form that looks at the map of a place and meets a character or characters at different locations around the map. Often, these locations are landmarks which are important to insiders to the land but unseen or undervalued by outsiders. We also see how access to certain locations is more or less available to certain bodies and not others. The Map form suggests that a person is defined by the geography and the community she comes from, but also that important stories come from the emotional mapping a people might put on, or glean from, their own geography. The Map form serves scene and character development while also addressing po-

litical considerations of class, race, gender, and colonialism. Indeed, *Monster in the Middle* opens with a map to make this clear.

As we think through the usefulness of fiction forms, we must consider what forms we need now; the forms which already exist and how they might serve us; the forms that exist and how we may bend them to our realities; and finally, what structures exist out in the world that we may look at for literary structure.

Monster in the Middle is a book about romantic love. The thing I most wanted to say in this book was that our most intimate truths are determined by the political, social, spiritual, familial stories that we come to know as truth—even when they are always a fiction, curated by our societies and, as we become adults, by ourselves. We are not separate from our generation, our time, our land, our families. These things all give us the stories that we use to tell the story of ourselves. *Monster in the Middle* is a book about why stories themselves, fiction itself, is important to us. *How* we tell stories is form. In this essay, I hope I have helped show that the "how" might actually make some stories—ones you haven't yet been able to tell—possible. Most important, I hope I have shown that form clarifies for us fiction writers an important truth—that we are never alone. We write to communicate with readers of now and the future, but we are always already communicating with the writers and stories who have come before us. Recognizing and using received forms help us see that we are part of a tradition.

Craft

NIKKI GIOVANNI

I have no craft. I only have language which I try to weave into—
What? A something. I have a love of quilts. No matter the weather,
I weave my words into something to make me warm or keep me
dry. I love stews, any stew, so I keep whatever is left over to perco-
late all day. If I'm lucky I'll make biscuits to go with it. But I must
confess: I cannot roll out my biscuits like my grandmother did. I
can, however, make drop biscuits which I slather in butter and to
be honest I drink cheap champagne so it's a meal. I think jazz is
incredibly important and I have to snap my fingers and when I'm
alone I do a little dance my mother called "The Geek." Nat King
Cole, when he was still with his trio, sang it, but it's almost impos-
sible to find now. My favorite way of teaching myself how to tell a
story is by listening to the Spirituals. What does it mean "to pray?"
We cross Jordan or we bathe in Jordan. We lean on the Everlasting
Arms. I love the comfort, but there is also a story. I try to bring out
what I learn. John Lewis and Milt Jackson, Connie Kay and Percy
Heath taught me a lot about royalty. I could listen to *Fontessa* over
and over again though that is not craft; that is learning. The stars
talk to us if we just will have enough sense to listen. We recognize
the similarities between The Middle Passage and the galaxy. We

understand the necessity of Black Americans to lead the way to the next world. We know we will carry our okra pods and a peanut. We understand the need to create beer from peanuts. I can go on and on and on. But I lack the craft to show how that should be done. If I could double patience, I would make okra whiskey. I lack the craft to show how that would be done, but I do make great fried chicken wings. Our ancestors hid treasures away in home cellars where they rested with coal in a song, in a dance, in a story or a look. I don't have a craft. I have a love of the people who traveled the ocean to become a new people. I don't have a craft. I have the embrace and trust of my ancestors. And the language we created.

Jericho Brown in Conversation with Michael Dumanis

JERICHO BROWN WITH MICHAEL DUMANIS

The poet Jericho Brown had the following conversation with *Bennington Review* editor Michael Dumanis at the Ace Hotel in New York City on Saturday, October 27, 2018.

Michael Dumanis (MD): While in the moment of writing, it's a poem that's only pop-cultural?

Jericho Brown (JB): Exactly, and also in the moment of first reading. People really like to point to "The Day Lady Died" or "Personal Poem," the one with Miles Davis. People like to point to the political content of certain poems, but according to Frank O'Hara, the politics in the poems is happenstance. Politics is a part of life, so these political things, these social moments, are arising as a part of his life, which, to be quite honest with you, Michael, I am much more interested in. And I am concerned that people search for the political moment they want as their subject as opposed to facing the political moment that is a part of their lives.

So, no matter the race of the poet, I'm much more interested in a poem that is like the life we live. I want the poem that is like, "I

saw that people got shot at the synagogue today, and I had a sandwich, and I miss my daughter." And in actuality, that's what a day in our life looks like, and the poem has to carry the tones of all those emotions. Sometimes I think that poems lately are interested at the outset in settling on an emotion, as opposed to gradually discovering several tones and seeing if those tones might accumulate into a single poem.

But I also think that part of this has to do with the fact that I am directing a creative writing program and that I am teaching and that I am teaching much more intensely than I've ever taught before, so I've been thinking about pedagogy a lot differently. I think one of the troubles of being a younger writer, of being someone who wants to write poetry, is that you put the cart before the horse. You put the ideas that you want to get to, or that you think you want to get to, before your language. If you put language first, then you can discover your ideas. But if you are thinking about your ideas, then you're going to be at the mercy of the language you already know instead of one that you can figure out. And so maybe what I'm seeing in the writing of my students I'm ascribing to contemporary poetry at large. But I also do feel like I've read a ton of books in the last couple of years, and there's a lot of knowns that I see coming through in the poetry, as opposed to unknowns that the poems discover.

MD: So, for example, people are announcing things politically that are already familiar?

JB: Yeah, so what is the way around that? Because I do want poets to feel empowered to announce politically, but I also want them to go beyond the pronouncement. What happens at the beginning of your poem has to—because it's a poem—be transformed by the end of your poem. So, if the triggering moment for the beginning of your poem is a known political moment, I am fine with that; that's

great. But as I'm reading, I expect it to change because that was just the trigger. So I'm let down if everything is only some form of outside political thing or even inside political thing. I want the world in the poem to expand. I want the world in the poem to change. At least I want that for my poems. If I start with my mom, then I might end with the police. If I start with the police, then I might end with my lover. But if I start with the police, I don't imagine I'm done with my poem if I'm still talking about the police. I just can't imagine that.

MD: The title poem of your new book, *The Tradition,* is a sonnet that connects the cultivation of a flower with the development of a poem, exploring American political, historical, and racial reality as the conversation moves from the planting of a garden to the recent deaths of Black men at the hands of the police while it also approaches the concept of tradition in multiple ways: the sonnet tradition, the tradition of racial injustice in this country, the tradition of continuing to plant gardens. So that's an example of that kind of move.

JB: Yeah, though if my memory of writing that poem is accurate, a lot of that only happened on a subconscious level. Of course, I've been thinking about the murder of John Crawford and the murder of Mike Brown and the murder of Eric Garner over the last few years of my life—how could I not be? How could we all not? But when I'm coming to language, when I come to the poem, I am not submitting myself to my ideas about those things. Those ideas might come up, and thank God they do, because then I get a poem. But I'm just really thinking about what sounds good to me, what makes music, oh, this is a line of iambic pentameter, oh, this rhymes with this. And often I don't want to make sense of these things until much later in the revision process.

MD: So, you started writing about flowers?

JB: Well, I'm a poet, so historically we kind of get interested in flowers. And their names sound good. In reality, we're all Adams, we all want to name things, and it does sound like something is happening when you're naming flowers, or when you're looking at something that has a particular name and you can say what it is. And I was enjoying that moment while I was making this poem happen.

I was also thinking a lot about Ross Gay. The truth about that poem is, I was trying to write a poem for Ross Gay. So I was like, if you're trying to write a poem for Ross Gay, you're gonna have to write about a garden, there's got to be a garden in this, do you know what I mean?

MD: Did Ross Gay know the poem was for him?

JB: Yeah, I sent it to him. But when I was initially writing the poem, I was like, "Oh, I should write a poem that Ross would like." So, ultimately, I'm like, "Oh, I'll just start with the sounds of flowers and I'll think about a Black man taking care of flowers." And then it turned into Black men and Black boys taking care of flowers, and of course, because I'm thinking about these other things that are going on, here comes Mike Brown, here comes John Crawford, here comes Eric Garner. But I didn't have that in mind at first. At first I had in mind my friend Ross Gay, a poet I like, who I admire, who, when I graduated from Cave Canem, introduced me at my graduation. All of those are just emotions, they're not political . . . And yet I'm sure they are in many ways political, because Cave Canem is involved in those emotions. And at the same time, they don't feel initially political. They feel like, "Oh, I should write a poem for my friend. Somebody is taller than me, thank God, so I should write a poem for him."

I think that's the thing about working with language in a way that is subconscious. It defies memory. When you're a poet, you're a wizard. You know the spell is right. I don't know at what point

I figured out that this poem was going to be about race. The real question is, when did I come up with the phrase, "Men like me and my brothers." Because obviously that's the trigger in the poem that might later let me know, "Oh, I could be going . . . that might be where I'm going back to, to my brothers." But I begin in music, I begin in line. Usually my poems are in a tetrameter or something close to that. Nobody seems to notice or talk about this, but that's fine. This poem is, I think, in more of a five-beat line, but usually it's a four-beat. I can get in the groove of a four-beat line. And when I'm in the groove of a four-beat line, I'm also paying a little bit of attention to what I'm saying, but not too much, then I'm also trying to create resonances, like I'm remembering, "Oh, I said that earlier, so I should say something like it later." And I just figure it out later, like, don't worry, I'll get it to make sense or to make nonsense later. I work on a poem for a long time, I mean, that poem was a year old before it got published anywhere. So I was working on it for a year. You just keep going back to a thing.

MD: I'm interested in how organically you just brought up form and prosody, and I want to talk to you about what role they play in your work, in *The Tradition* and prior. How has your thinking about formalism in poetry been shaped, and how has it evolved?

JB: One of my first two poetry teachers was a New Formalist—Kay Murphy—and the other, John Gery, wrote in form sometimes. Kay used to write in free verse, but at the time when I was her student at the University of New Orleans, she had two books in a row that were both formal and confessional. It was very important to Kay and also to John Gery that their students know about form, so I know what canzones are, whereas other people might not know or care. I know what villanelles are, so there's a way that, yes, it is a part of my investment. But then again, maybe it's not really a part of my investment, maybe it's just the way I grew up.

So one of the things that has been really important both to me and to them is that the form has something to do with the content of the poem. That our form informs our content, that they're hand in hand, that they go back and forth with one another, that they're having a conversation. Often, I think the form of the poem can tell me things about the poem upfront, leading me toward knowing where I'm going to end or knowing what to say next or what I have to say—at least, if not what to say, how it's going to sound. I think a book called *The Tradition* is clearly going to be interested in form, but I wasn't conscious of that when I was writing.

However, here are some of the questions I was asking myself. What does a sonnet have to do with anybody's content? And if the presumed content of a sonnet is that it's a love poem, how do I subvert that? How do I trick that out? And how do I nevertheless make it a love poem? And if I'm Jericho Brown, what is a Jericho Brown sonnet? That gave rise to my desire to create a new form for this book, which is the duplex. Though I may not be, I do feel like a bit of a mutt in the world. I feel like a person who is hard to understand, given our clichés and stereotypes about people. So I wanted a form that in my head was Black and queer and Southern.

MD: So you see this form you've invented in *The Tradition*, the duplex, as inherently a Black form, a queer form, a Southern form?

JB: Since I am carrying these truths in this body as one, how do I get a form that is many forms? I was looking at sonnets, looking at ghazals. I got really interested in ghazals when writing my second book. In ghazals, you take couplets that are completely disparate, then juxtapose those couplets so that some kind of magic happens because of the juxtapositions. So I was like, "Oh, if I can take a sonnet and I can take a ghazal and I can take the blues—we're not gonna get around taking the blues, since I'm Black—if I take those

three things, is it possible for me to merge them into a single coherent form?" And that's how the duplex came to be.

MD: Can you describe the duplex as a formal structure a bit more?

JB: I would first say it's a form of repeating lines, where the poem's first line is going to also be its last line. And because it's a form of repeating lines, it depends on variation in order to have ant progression. Also, it's syllabic rather than metrical—nine to eleven syllables per line, which, sure, ultimately gets us to something like iambic pentameter, and that was something that I wanted. I wanted East married to West, so I started thinking about syllabics, and yet I was still thinking about meter. So I'm like, "Oh, if I can make the syllabic structure loose, like instead of saying it has to be a nine-syllable line, if I say nine to eleven syllables, then I'm dealing with something that also will, because of American English, be related to iambic pentameter."

So I'm trying to make this mutt of a form where you start with a couplet of two lines that are completely different, then you repeat the second line and then another line that's different, then you repeat that line and then another line that's different, until you have seven couplets. And in the final couplet, you get back to the poem's first line, which is also the poem's fourteenth line. It rhymes because you're repeating the lines, and it turns, so it's definitely a sonnet. Part of the reason why I wanted to invent a form is because I want full participation for myself, but also for anyone who's writing after me, in the tradition. And the way that you become a part of it is that you literally deal with it. You participate by writing in received forms, but also by creating forms for others to receive, and also by subverting forms, by thumbing your nose at them.

MD: One thing I find particularly engaging about you inventing this form is the term you chose for it, because a duplex is also a very particular kind of living space in America. A duplex carries with it

a certain amount of socioeconomic stratification, where you think you have a house, but not really—you just have half a house that you pretend is actually a full house, and you share a wall, which is like the juxtaposition of two lines—you share a wall with someone and you don't necessarily have control over whom you are going to coexist with, so your house is always inherently divided. What are the implications of the term duplex for you?

JB: You know, people keep talking about the ways the country is divided, and I wasn't aware that the country hadn't always been divided. If you listen to people, it's like they woke up and the country was divided, and as a Black person in this country, I find that really offensive. I think about Max Robinson, the Black reporter, the first Black male anchor on the nightly news. He made a TV special about Washington, DC, and the fact that Washington, DC, was Black. At the time, it was as if nobody outside of Washington, DC, thought of it as a Black city. He called it The Other Washington. Even back then, like it or not, there's this division. So I was trying to make a form that asked, What is it about this very capitalist nation, with all of these people and their middle-class aspirations? How do I capture that in the title of this poem and in what the poem does? How do I capture this sort-of-making-it but barely-making-it life?

And I really like what you say about sharing a wall. That we're inhabiting this together, but that the goal is to pretend, "Oh, I have everything under control, over here, by myself."

MD: "Because I can't see what's on the other side of the wall."

JB: Exactly, that's it. And there's a way that the couplets are not aware of one another, and yet they must be if they're repeating information from the preceding couplet. That's what I wanted from the form. When I was working on it, I told my friend, the poet Sean Hill, that I was thinking about calling it a duplex, and he said, "Oh, so it has two addresses." And I was like, "Oh shit, that's right."

It's like a single place with two addresses. It's getting its mail, but it's also talking to two different people, and it isn't even aware that everything it says comes from the same mouth.

MD: As soon as we started talking about the duplex, you identified the form as Black, queer, and Southern. I don't know if this is an anecdotal or overly subjective experience of reading, but reading poems in form, I feel like the function of form in African American poetry is inherently different in some way I can't quite grasp from the function of form in American poetry overall. Sometimes I see why a given person might gravitate toward a given form: I see how a poem interested in the post-colonial, for instance, might want to be a pantoum, which is originally Malay, or a ghazal, which is a form in Urdu and Farsi. When I think of contemporary American formalists that excite me, I think of poets of color like Randall Mann and Evie Shockley almost immediately. Do you think there's something to the idea that form inherently functions differently for some writers because of race and background?

JB: You know, the eighteenth-century poem "On Being Brought from Africa to America" by Phillis Wheatley is I think her most famous and most quoted because it allows her to subvert discourse on race in a way that feels subversive even now. There's a moment in that poem where she expresses gratitude for Christian missions to enslaved Africans, arguing that the reason Africa needs to be under the thumb of Europe and under the thumb of the white Americans is that when we get to Heaven, now that we have become Christian, everybody's gonna get to be together. All the Black people and all the white people are gonna hang out together. And there's a way that no one white on Earth had really thought about that or would have wanted that at that time.

I think this idea that form functions differently is definitely the case for somebody like Gwendolyn Brooks, though not for some-

body like Langston Hughes, which is why Hughes is interested in inventing a form, or taking something outside poetry that the folk are already using and making it into a form, as opposed to using a traditional form himself. But I do think that somebody like Brooks, and people like Countee Cullen and Claude McKay, 100% Claude McKay, are interested in what happens when you put the Black body inside the sonnet. When I make formal the Black body, it is still a Black body and you will still be offended by its presence. But then you have to face your excuse. So there's a way that you have to deal, as in the Phillis Wheatley poem, where the Black body says, I'm enslaved because I'm a savage and you're going to Christianize me. But then, once I tell you I'm a Christian and I'm going to Heaven with you and we'll hang out there together, you then have to be faced with your excuse. You've made an excuse for your evil, and now you're going to have to be faced with it, because here's my subject-verb agreement, here's my rhyme, here is me knowing what a pentameter line is. So, if your excuse was that I was illiterate, if your excuse was, as Thomas Jefferson says, that there's no poetry among Black people, then you have to be faced with the fact that, actually, you're just a hater. I think there's something much more automatically and subconsciously political going on when Black people write in a form that has to do with participating in a larger culture outside, and I shouldn't say larger, but participating with the culture that Black culture circulates through and dwells within.

MD: But wouldn't there also be a motivation to reject Western formal tradition?

JB: Yeah, we see much of that throughout the Black Arts Movement. And, of course, everybody's not writing in form. But the people who are writing in form, I think they mean just that though, do you know what I mean? I'm thinking of, think, Natasha Trethewey's poem "Miscegenation" and that sonnet that's also a blues poem in

Native Guard—"Graveyard Blues"—about the burial of her mother. By merging the sonnet with the blues, Natasha splices together two very different traditions and stands up inside both of them, saying, "I'm here, I'm in both of your traditions. What are you gonna do with me? How will you deal with me?"

MD: Some years ago, I heard the poet Claudia Rankine question the act of writing for posterity, for a reader who may not exist yet, as opposed to writing for the present. This made me think of poets in the Black Arts Movement consciously writing to a particular community, or of writing about what's on the news at the moment you're writing. Do you feel like you're increasingly writing more for the present than for posterity, and is this something you think about a lot?

JB: I think I use the tools that are given to us, and those tools have something to do with immortality and posterity. For instance, the tool of metaphor is human and everlasting, and when we think, whether we like it or not, we make use of metaphor in order to better process certain things. I think structure, I think narrative, I think order, I think juxtapositions, I think certain things are going to be the tools that everybody uses, regardless of when. Ultimately, I don't have tools that are different from Milton's tools, though I might know more about poetry, quite honestly, than what Milton knew. Because he didn't have access to the poetry of the East, for one thing. He also didn't have Langston Hughes, do you know what I mean?

MD: He didn't have access to all the incredible things that happened after he died, which you do.

JB: And also, he made those incredible things happen. They would not have existed without him. You know, Milton's like my homeboy lately. Everybody gets sick of me talking about Milton.

But I think either Claudia says what you heard her say a lot or

maybe I was there for that same conversation, because that comment of hers has long been on my mind. This was before I had a first book, when I heard her say this. It's interesting when you're not aiming for your poem to live forever while every poet around you seems to be. It's like everyone was aiming to write the immortal poem, and I was like, "Who told us that, that that was the most important thing in the world? I'm going to die, so why can't a poem?"

MD: Can literature do that?

JB: Yes, but only in an individual, not in a widespread, political, governmental way. As far as I know, the books of contemporary poetry most widely read before the last presidential election were Natalie Diaz's *When My Brother Was an Aztec* and Ocean Vuong's *Night Sky with Exit Wounds* and Claudia Rankine's *Citizen*. Every poet I know was reading and talking about those three books, these three poets of color. So, if that's the case, how does Donald Trump get elected? I'm not under the impression that my poems are going to affect anything beyond a person. Now, do I believe that poems change persons? Yes. Do I believe they change people? No.

But let's think, let's really think about this, Michael, let's think about Adrienne Rich and let's think about Allen Ginsberg. I hate talking about social media, let alone participating in it, but when Hillary Clinton was running for office, I put something positive about her on my Facebook wall, and there were all these people, who you would think were human beings, saying all of these crazy . . . as if it was the time for it. Like somebody literally said, for instance, "I don't know, Donald Trump is interesting, we've never had anything like him before. Might be nice to shake things up." And I'm not even talking about a general population. I'm talking about the people who would see my Facebook wall. That's hugely problematic after—forget the current moment, forget Claudia Rankine, forget Ocean Vuong, forget Natalie Diaz—how does

this happen after Adrienne Rich and Allen Ginsberg, after Audre Lorde? Everybody wants to believe in the ripple effect, that oh, you put a little bit down—I don't think Adrienne Rich put a little bit down, I think she put a lot down. The fact of women studies programs, the proliferation of women studies programs on college campuses can be traced in many ways to the essays and the poems of Adrienne Rich—so yes, there is that, but is that indeed wide enough? What do you think Adrienne Rich would say about this moment?

Me, I'm out here writing my poems because it gives me joy and pleasure. And yes, I do believe because of what reading a poem can do to me, that a poem can do something to a person, that a poem can change a life. But I'm not under the impression that poems are gonna go out there and suddenly everybody's gonna vote right. I'm not under the impression that poems are gonna go out there and suddenly people are gonna stop shooting up synagogues and schools. I have no reason to believe that. And I think it's okay for us to be writing for pleasure, as long as we're honest about what we're doing. I don't want to seem like I'm talking out of two sides of my mouth. The poem is going to be political if you're being truthful in the poem, and there won't be a way around that if you're indeed allowing all of yourself into the poem. The poem will make use of what it needs. And there's no part of our lives that isn't also a political part of our lives. So, if that's the case, we don't have to sit down at the poetry table in front of our computer or with our pen and say, "Oh, I gotta go get Congress today for what they've done." Do you know what I'm saying? We don't have to do it. It will happen.

MD: You have two poems in this current *Bennington Review*. How did "Shovel" come into being?

JB: One of the book's goals was to write poems that didn't use met-

aphors, that instead employed a lot of metonymy. And so I ended up with poems like "The Rabbits," "The Hammers," the this, the that. The goal was to focus in on a thing, to say what the thing was doing or could do. "Shovel" started that way, but I could never focus in on the shovel. Instead, I kept trying to figure out what a person was doing with this shovel. That made me wonder who the speaker was. And I realized, oh, this is the guy that gets rid of the bodies when someone is tortured and murdered.

Of course, I don't fully understand the circumstances under which people might be tortured and murdered. I know that people get tortured and murdered; that's all I needed to know. And I know that their bodies have to be disposed of. And I kept thinking, if their bodies don't get burned, their bodies must get buried. And who does that? And I kept thinking, I'm the person who buries the body, and I don't know why I thought this, Michael. Maybe I was watching too much TV or something. Maybe this had to do with me watching a great deal of the show *Scandal*.

But I kept thinking about how the world of torture and murder is a world made by several people. There's a conglomerate of folks that comes together. There are the people who do the kidnapping. There are the people who do the torturing, the people who kill people. There's somebody who signs something saying it's okay to let it happen. So I was thinking about that, and I was like, so who gets rid of the body? I wanted to write a poem in the voice of the guy who gets rid of the body. A poem about what it's like to be used, what it's like to be a cog in a wheel of torture, what it's like to be robotic. What do I have if I have a person who is also a machine who has no thought or feeling of the fact of the dead body? Or of the fact of the people who killed the person who was once in the dead body? And I was also thinking, as I am daily thinking, about capitalism, how there's no way around it for us.

MD: There's that wild moment in the poem where the speaker starts singing a love song to himself . . .

JB: Because I wanted him to be a person who has the same things that I have. I have love songs, Michael, and I sing them to myself sometimes. Alan Shapiro once pointed out to me that the same poems Jews were reciting in concentration camps to help them get through the experience of being in places like Auschwitz were the same poems Germans were reciting when they took their bodies and threw them in ovens. Everybody had the same poems. Everybody had the same songs. The reason why Josephine Baker could do the kind of espionage that she did during World War II is because the Nazis wanted to hear Josephine Baker. Just as Martin Luther King did when he had her standing next to him during the "I Have a Dream" speech.

MD: Could you say a little about your poem "Virus"?

JB: You know, my dad literally cut yards for a living—that's how we ate as a family—so I learned a lot about lawn care. And flower-beds. And because I've been able to buy my own home and have a flowerbed, I have all these things I can look at out my window all of a sudden. So in "Virus"—another persona poem—I try to allow the virus inside me to see the same things, the same flowers I'm looking out at as it speaks to me. And if I can hear it, then whatever it has to tell me has to do with it reminding me it's there. No matter how healthy I am, it wants me to know, you think you're healthy, but oh, I remember, I am capable, I have done such stuff to people you wouldn't believe. In many ways that poem is thinking about HIV's history much more than about HIV in its present tense. We now know that once we're medicated, the disease becomes incommunicable, and yet the history of the disease will always overshadow its present tense. An entire generation, Michael, an entire generation of people, of men who were not there when I was coming of age as

a gay man. And I think that's important, that I could not meet Essex Hemphill because he was dead. And so Essex Hemphill never had the opportunity to be my mentor or to shun me. And I never had the opportunity to see which way it was going to go.

You mentioned Randall Mann earlier, and I think about him a lot. I'm in conversation with a lot of the work that he's doing recently and also with others in our generation of gay men, Aaron Smith, James Allen Hall. It's not like we did not have queer influences, but many of the ones that we would have had we couldn't touch, we couldn't go see. And not just in poetry but also just in life, like walking up and down the street, because they were dead or they were dying. That will always be the story of HIV, so I wanted to know what HIV thought of that story.

I'm interested in persona poems still. I haven't given up on them. I think there's a possibility for them in the world. It's interesting for me to make the choice of speaking through people that we cannot see or, in this case, through something that is not actually a person.

MD: There's something particularly curious about the persona poem where the persona is something that is speaking back to the writer and/or speaker. The virus is not just a persona speaking outward. It's a persona speaking back to the creator of the persona.

JB: That's interesting. Maybe that's another way to think about some of the troubles people have had with persona. Or is all poetry just a conversation with the self? If that's the case, then that speaker, whether it's you or some persona, will always just be speaking back to you.

Originally published in the *Bennington Review*, 2018.

Who You With?

—

Collaboration and Risk-Taking as It Relates to Writing the Other When You Are Someone Else's Other

Those Words That Echo . . . Echo . . . Echo Through Life

JAMAICA KINCAID

How do I write? Why do I write? What do I write? This is what I am writing: I am writing "Mr. Potter." It begins in this way; this is its first sentence: "Mr. Potter was my father, my father's name was Mr. Potter." So much went into that one sentence; much happened before I settled on those eleven words.

Walking up and down in the little room in which I write, sitting down and then getting up out of the chair that is in the little room in which I write, I wanted to go to the bathroom. In the bathroom Mr. Potter vanished from my mind; I examined the tiles on the floor in front of me and found them ugly, worn out.

I looked at the faucet and the sink in front of me, but not too closely; I did not examine those. I flushed the toilet and I thought: Will the plumbing now just back up? Does the septic need pumping? Should I call Mr. A. Aaron? But Mr. A. Aaron's name is not that at all. His real name is something quite far from that. His real name is something like Mr. Christian or Mr. Zenith, though I cannot remember exactly. He only calls himself A. Aaron so he can be the first listing in the telephone book under the heading

"Septic Tanks & Systems—Cleaning." I come back and look at Mr. Potter.

"Mr. Potter," I write, and I put clothes on him, even though I do not see him naked, for he was my father, and just now he is not yet dead. He is a young man, and I am not yet born. Oh, I believe I am seeing him as a little boy; as a little boy he has clothes, but he has no shoes. I do not place him in shoes until he is— I have not decided when exactly I shall allow him to wear shoes.

And then after many days of this and that and back and forth, I wrote, with a certainty that I did not necessarily intend to last, "Mr. Potter was my father, my father's name was Mr. Potter." And Mr. Potter remained my father, and Mr. Potter remained my father's name for a long time, even up to now.

And then? I grew tired of that sentence and those eleven words just sitting there all alone followed by all that blank space. I grew sad at seeing that sentence and those eleven words just sitting there followed by nothing, nothing, and nothing again. After many days it frightened me to see nothing but that one sentence and those eleven words and nothing, nothing, and nothing again came after them. "Say something," I said to Mr. Potter. To myself I had nothing to say.

Speaking no longer to Mr. Potter, speaking no longer to myself in regard to Mr. Potter, I got up at five o'clock in the morning and at half-past five o'clock went running with my friend Meg and a man named Dennis Murray; he builds houses of every kind in the city of Bennington in the state of Vermont.

"My father is dead," I said to Dennis one morning as we were just past the Mahar funeral parlor on Main Street. I never make an effort to speak before the funeral parlor. I despise death and consider it a humiliation and in any case much overdone and so plan never to do it myself and plan never to have anything at all to do with it, for

it is so contagious. I have noticed that when you know people who die, you catch it and end up dead, too.

"My father is dead," I said to Dennis, but he could not hear me for he was far ahead. He runs at a faster pace than I do, and he thought I was agreeing with something he had just said about the weekend he had just spent hiking into the woods and spending the night and fishing with a friend whose name I cannot remember and catching many trout and cooking them and eating them and going to sleep in a tent while there was a great downpour of rain outside and waking up the next morning and having the best pancakes and fishing again and doing everything again and all of it as perfect as it had been before and then coming home to his wife who loves him very much.

And the perfect narrative of Dennis's life, uninterrupted by any feelings of approaching and then leaving behind the Mahar funeral parlor, did not make me envious or make me grieve that Mr. Potter's life remained frozen in the vault that was his name and the vault of being only my father.

The days then rapidly grew thick into all darkness with only small spaces of light (that is autumn) and then remained solidly all darkness with only small patches of light (that is winter), and then the darkness slowly thinned out (that is spring), but the light was never as overwhelming in its way as the darkness was overwhelmingly dark in its way (that is summer). So, too, was the night dark except for when the moon was full and the day bright with light, except for when clouds blocked out the sun. And Mr. Potter remained my father, and my father's name remained Mr. Potter for a very long time. One day when I seemed uncertain about which foot to put first, the one in front of the other, my husband said to me, "Mrs. S., Mrs. S., how are you doing?" and "Are you OK?" The first letter in his family's chosen name is S. Our children go

to school every day on a great big bus that is painted yellow and driven by a woman named Verta. A man named Mr. Sweet came and picked up our rubbish.

In the American way we have much rubbish, and Mr. Sweet is hard of hearing. Saying to him, as I feel I must if I see him, I must say to him, "Hallo, Mr. Sweet." And since he cannot hear me, he is deaf, he looks at me and then holds his ear forward, cupping it in the palm of his hand, as if it were a receptacle, for he wants it to receive the sounds that I am making.

"What?" says Mr. Sweet. "Hallo," I say again, and Mr. Sweet is then very nice and sincerely so, and he asks if I could pay him for the eight weeks he has picked up the rubbish without being paid.

"But no," I say to him, and then I explain that I am not allowed to write checks because I never put the debits and balances in their proper columns, and I make a mess of the household accounts. Mr. Sweet says, "Yep, yep," and then Mr. Sweet says he will see me next week. Mr. Sweet does not know about Mr. Potter, not in the way of my writing about him, not in the way of Mr. Potter as a real person.

And one day, after all sorts of ups and downs and many travails that are interesting, especially to me, Mr. Potter was driving a motorcar and dressing in a way imitative of men who had enormous amounts of money. And, of course, Mr. Potter was right to imitate the wardrobe of men who had enormous amounts of money, for without the existence of Mr. Potter and people like him, working very hard and being paid a mere pittance, there can be no enormous amounts of money. And I am Mr. Potter's daughter, so I know this.

But that "and one day" left me bereft and exhausted and feeling empty, and that "and one day" is just what I want when in the process of encountering a certain aspect of my world.

And then that one day, that one day after Mr. Potter's life advanced and exploded on the page, I had to have my lunch, but I

could not eat too much of anything, not even plain green leaves. I could only eat very small amounts of anything, for I wanted to fit into my nice blue (tilting to lavender) silk taffeta skirt, a skirt that has box pleats. And I so love my nice blue (tilting to lavender) silk taffeta skirt with the box pleats and will not eat too much of anything, even just plain green leaves, for I look very beautiful in it. I look most beautiful in it when I am in a room all by myself, just alone with only my reflection, no one at all there to observe me.

In the early afternoon, just after I have eaten my lunch, I look at Mr. Potter, in my own way, a way I am imagining, a way that is most certainly true and real. (His name really was Roderick Potter; he really was my father.) He cannot look back at me unless I make him do so, and I shall never make him do so.

The telephone rings, and I do not answer it. The telephone rings, and I do not answer it. The telephone rings, I answer it, and on the other end is someone employed by one of my many creditors asking me to satisfy my debt. I promise to do so in a given time, but I have no money. I like having no money. I do not like having no money. I only like to have contempt for people who have a great deal of money and are unhappy even so or are happy with money in a way that I find contemptible.

Driving past a sign that says "Yield," driving past the house where a dentist lives, driving past the house where the chiropractor I see from time to time lives, swiftly I pass by a sloping moist field that in spring is filled up with marsh marigolds. Swiftly I go past the home for delinquent children. Swiftly I go to await my children getting off the bus with Verta.

My children will soon get off the school bus, the one painted a harsh yellow, and it is driven by Verta. "Mr. Shoul," I say to myself, for I am all alone in the car having driven so swiftly. "Mr. Shoul," I say, for I now can see that I have saddled Mr. Potter with this

personality, Mr. Shoul. And Mr. Shoul is a merchant, an ordinary merchant, specializing in nothing particular; he sells anything. Mr. Shoul sells everything. Mr. Shoul might sell Mr. Potter; on the other hand, he might draw the line at selling Mr. Potter. And I have saddled Mr. Potter with Mr. Shoul.

Mr. Potter does not know the world. He is produced by the world, but he is not familiar with the world. He does not know its parameters. Mr. Potter was my father, my father's name was Mr. Potter. My children pour out of the bus. My daughter (she is fourteen) hurls an insult at my son (he is ten). His small self (the self that is not seen) crumbles to the ground; I rush to pick his self that is not seen but has fallen to the ground and bring it back together again with his self that I can see.

I look at her, my daughter. What should I do? For her selves (one or two or three or more) are not all in one bundle, tied up together either.

"Mr. Shoul," I say to myself, for I am at the bus stop and can tell no one what I am really thinking. "Mr. Shoul," I say. What to tell Mr. Potter about Mr. Shoul, where to begin?

"Mr. Shoul!" I shout at Mr. Potter, but Mr. Potter cannot hear me. I have left him at home on the page, the white page, the clean white page, all alone with Mr. Shoul. "Mr. Shoul," I will write, "Mr. Shoul," I will tell Mr. Potter, "Mr. Shoul comes from Lebanon."

Originally published in the *New York Times*, June 7, 1999.

Write What You Know or Nah?

TRICIA ELAM WALKER

Why Write about the Other?

Years ago, when I was learning to become the writer who lived deep inside me, over and over I heard, "Write what you know." It was the dictum in writing workshops, and it was also carved into craft books and the creative writing courses I took while in college and, later, in some MFA classrooms. When I first began teaching writing, I passed it on to my students. They often translated the adage into writing what they experienced or creating characters modeled after friends and family, leading them to defend their critiqued work with, "But it really happened!" (Note here that even if something actually occurred, you still have to convince the reader who wasn't present.)

Probably faced with similar stories from her Princeton students, Toni Morrison famously told them, "Don't pay any attention to that ['write what you know']. First, because you don't know anything and second because I don't want to hear about your true love and your mama and papa and your friends . . . [Instead] imagine it, create it."* Yes to Toni Morrison for those words! Feeling her kind of pain, I needed to nudge students toward more expansive thinking,

* Toni Morrison, "Write, Erase, Do It Over," interview by Rebecca Sutton, *American Artscape Magazine*, no. 4 (2014): 3.

so I asked them to adopt a strict "no writing about yourself diet" and remove any resemblance to their own lives.

Writing, like every art, demands practice. Stretching yourself as a writer to venture outside of your own world experience can be part of that practice. I shared with students how Edward P. Jones filled *Lost in the City* with Black women who make us nod, say "amen," and feel all the familiar feels. James Baldwin wrote *Giovanni's Room* convincingly from the perspective of white characters. Jhumpa Lahiri folded compelling male protagonists into many of her taut short stories. All impressive and ripe for study, but I am blown away by the accuracy displayed in "The Darkness of Love," a complex and lengthy story about a Black policeman who struggles with internalized oppression and a dangerous yearning for his wife's sister. His flaws make him wrenchingly believable, as are the trio of Black women in his life. I was surprised to learn the story was written by Robert Boswell, a white writer. How did he finesse the inner workings of Black folk, especially the nuanced layer of self-hatred? It was as if he stealthily uncovered a locked-away secret. Research, the powers of observation and insight, I believe were his metaphorical keys. Boswell says doing his best writing means "pushing my narratives to be different, insisting that I try something new."[†] He didn't settle for surface; his characters live, breathe, love, and hurt themselves as well as each other and his readers are grateful.

Research and More

Over time, the concept of "write what you know" has morphed into "write what you've come to know." The catch is you have to

[†] Michael Hinken, "On Mystery and Drafting: An Interview with Robert Boswell," *Fiction Writers Review*, May 12, 2011.

write truthfully. Neither the character, nor the story itself for that matter, should be based on stereotypes, symbols, or broad-brush painting. As with all characters, you must understand their greatest desires and know and care about them enough to keep readers turning the pages. Much of what you don't know can be learned visiting the library, checking Google, eavesdropping on folk, watching YouTube videos, shadowing subjects and subject matter, interviewing those who can help, sleuthing around, etc.

When my now twenty-eight-year old daughter was in second grade, a writer for the Washington, DC, *City Paper* selected her for an article about the life of a seven-year old. This writer, a young white woman named Laura Lang, asked if she could follow us around for two weeks. I agreed to it because I appreciated that she wanted to write authentically about my daughter's life. Laura spent each day accompanying us to her school and extracurricular activities. She also ate meals with us and even spent the night once. Because of the time and effort Laura put in, it was no surprise that the article was thorough, moving, and true. In terms of takeaways, I always suggest students "immerse" themselves by following around (or at least, interviewing) someone who's in the profession they desire to write about. I did this with a social worker and a photographer when writing my first novel. It resulted in a specific idea and, thus, replica of what their day-to-day was like.

Beyond or in addition to research, novelist Nathan Englander says the write-what-you-know guidance is not simply "about events" but rather emotions like jealousy, longing, loss and that all humans are guided by certain hopes and fears and loves and lusts.[‡] Agreed. That work doesn't change if the character is an age, gender,

[‡] Jason Gots, "'Write What You Know'—The Most Misunderstood Piece of Good Advice, Ever," *Big Think*, March 1, 2012.

race, culture, ability, or religion distinct from our lived experience. Our emotions can be the entry point. Even though we may not be a parent who has lost a child, for example, we have all lost someone in our lifetime, and we can call up those feelings to give as a gift to our characters.

Why Are Some Differences Harder Than Others, Especially Race?

Writers research all kinds of things when we decide to write about a place or a setting we haven't experienced. We research careers we haven't held. We write about marriage and children without having either. And often we write about or from the point of view of the opposite sex. What challenges one writer might not challenge another as much, but many admit to stressing the most when creating characters who are different in terms of race, ethnicity, ability, and sometimes sexuality. Perhaps because there is much more at stake if and when a writer goes awry. To write a book featuring a dyslexic lawyer, crime writer Stephanie Kane reached out via a survey to people with learning disabilities, as well as their teachers, friends, and families, and asked numerous questions to make her character realistic. She calls her quest for authenticity "crashing into new worlds."[§]

When it comes to race though, some, like Jonathan Franzen, don't even try to write outside of their familiarity. He blames this on his "limited firsthand experience" and adds he is especially unable to create a Black woman character because he has "never been in love with [one]," a statement he later eschews as "an embarrassing

[§] Stephanie Kane, "Crashing into New Worlds: Writing about the Unfamiliar," *Writer's Digest*, October 29, 2020.

confession."[1] This is pretty ludicrous. Who says you have to actually be in love with someone to develop a similar kind of character?

Meanwhile, short story writer Danielle Evans's latest collection, *The Office of Historical Corrections*, features a white male protagonist. When interviewed about how she did so convincingly, she responds that like most Black people, she has been in the room when "white people are talking amongst themselves" and being themselves. Most Black people have quite frequently been the only Black person in the class, the seminar, the meeting, the audience, etc. In those instances, white people often don't see us. And, thus, we are able to fully see them and re-create them, perhaps with more ease than vice versa.

A Black person writing white characters may also need to venture beyond observation to imagining what it's like to walk through the world feeling privileged in spaces they usually don't. In my first novel, *Breathing Room*, I created a white love interest for one of my Black women characters. I focused on his obliviousness to microaggressions against her, but a review I read later (side tip: don't read reviews!) referred to him as "slightly wooden." Ironically, his name was Woody, and the critique made me contemplate whether his perceived stiffness was due to my discomfort creating him.

On a different note, some Black writers have been discouraged from using white protagonists by their publishers and agents. A few years back, author Leonce Gaiter was cautioned that his book with all white characters wouldn't sell. Gaither says: "There remains in publishing a very Jim Crow notion of what Black authors should write. . . . We can write about slavery and the civil rights movement.

[1] Kate Samuelson, "Why Jonathan Franzen Won't Write about Race," *TIME*, August 1, 2016.

We can write protest fiction . . . victimized characters. . . ."** He had enough industry clout and longevity, however, to publish the book anyway.

The Bottom Line

In our quest to write "the other," author Dani Shapiro reminds us that "characters aren't types. Elderly people are not always craggy, wrinkled, stooped over or forgetful or wise; babies aren't always angelic or cute; drunks don't always slur their words. When creating a character, it's essential to avoid the predictable. When it comes to character, we are looking for what is true, what is not always so, what makes a character unique, nuanced, indelible."†† In addition, author Stella Duffy says, "We can write who we are not and do it well if we write with passion, strength—and care. We're bound to get it wrong sometimes, but that doesn't mean we shouldn't try. If we want our writing to reflect the truth, then our characters and their experiences must be as diverse as the world in which we live."‡‡

Methods to Try When Writing the Other:

1. Immerse yourself by following around (or at least, interviewing) someone who's in the circumstance, career, etc. you desire to write about.

** Leonce Gaiter, "Black Authors in the 'Write White' Trap," *The Boston Globe*, November 24, 2014.

†† Dani Shapiro, *Still Writing: The Pleasures and Perils of a Creative Life* (New York: Atlantic Monthly Press, 2013).

‡‡ "Whose Life Is It Anyway? Novelists Have Their Say on Cultural Appropriation," *The Guardian*, October 1, 2016.

2. Keep journals as if you are the characters you are learning about. Think about what that character dreams about, is afraid of, eats for breakfast, etc. Go through a few days journaling as if in the character's body and mind. The more specific, the better, as always.

3. Create a playlist for your characters. The more you know about your characters, even if it doesn't directly go into the story, the more three-dimensional your characters will be.

4. Eavesdrop as often as you can, making sure to seek out varied conversations by putting yourself in settings outside of your comfort zone, where different ethnicities and income levels congregate. Additionally, I know writers who cut out magazine pictures of people who resemble their characters and locate actual houses and streets that their characters would live in and on.

5. Read aloud! Read aloud! Read aloud! I say this over and over to students, but it bears repeating because some writers don't want to take the extra time to do it. It's worth it! Reading aloud will point out wrong notes and awkward rhythms as well as grammatic inconsistencies. Walter Mosley goes one step further and reads into a tape recorder and then plays it back.

Overall, the best advice I ever received: You can never go wrong by doing too much to create authentic characters.

Nations Through Their Mouths

Silence, Inner Voices, and Dialogue

RAVI HOWARD

In the first chapter of her memoir-in-verse, *Generations*, Lucille Clifton answers a phone call in response to a newspaper ad she placed looking for information on a family name, Sails. The caller, a white woman, seems to be expecting white relatives, but Clifton is searching for any record of her ancestors, enslaved by the woman's family. Clifton and her late father often discussed this heritage, and these questions were about to be answered. Maybe. The woman could just as easily hang up the phone. The narration builds anticipation of the eminent speech as Clifton's interior monologue shows her careful consideration of the next words.

"What shall I say to this white woman? What does it matter now that daddy is dead and I am a Clifton," she writes.

We anticipate both the speech and the silence where the inner voice considers this old family question. She says names the woman doesn't recognize and then clarifies. "Slave names." Once the revelation takes hold, the caller offers some sympathy and a sigh. "I'll help you," she says, but this will be the last conversation. However,

she does send the records, and the final dialogue happens between Clifton and the family members listed on those pages.

"I look at my husband and our six children and I feel the Dahomey women gathering in my bones," Clifton writes.

Clifton shows her answer to an essential set of questions that fiction writers and memoirists face across a project, but especially within a scene. Which voice? Interiority or dialogue? Her questions—*What will I say? What does it matter?*—can be evergreen questions to consider in building stories. The choice between inner voices and speech connects to Black histories and context.

Clifton also models the resistance against a default assumption in creative writing instruction that identity and technique are separate. Clifton navigates a conversation where identity is paramount. The acoustics of the interior are shaped by history, culture, race, gender, and other factors. An earlier example from Zora Neale Hurston of this relationship between race, dialogue, and interiority comes in the opening scene of *Their Eyes Were Watching God*:

> It was the time for sitting on porches beside the road. It was the time to hear things and talk. These sitters had been tongueless, earless, eyeless conveniences all day long. Mules and other brutes had occupied their skins. But now, the sun and the bossman were gone, so the skins felt powerful and human. They became lords of sounds and lesser things. They passed nations through their mouths.

Both Hurston and Clifton give a vivid sense of why and when the silence is broken. Clifton had to navigate the limited access to her family's record. Hurston shows silent workers who had to hold their voices until they found the safety of home. Black history informed the craft decisions. What racial and cultural realities

left some questions unasked and some voices silenced? When were those voices free to move freely?

Beyond these big cultural questions, the balance of silence and speech can charge subtle moments. While the point of tension in Caryl Phillips's essay "Rude Am I in My Speech" feels like a minor issue, he shows how the racial subtext can charge both the dialogue and the silence of the moment as Phillips and his father have a meal at a London restaurant.

My father ordered a Scotch and I asked for a glass of Sauvignon Blanc and, having informed us of the specials, the hostess left us alone. Five minutes later a waitress arrived with our drinks. As she withdrew we raised our glasses and clinked, and then I sipped and grimaced. My father asked me if there was a problem and I said that the wine was not Sauvignon Blanc. It tasted like Chardonnay. I signaled to the waitress and then I saw a flicker of panic pass across my father's face. He asked me if I couldn't drink it. I said, "why, it's not what I ordered."

Was this carelessness or an assumption that he wouldn't know the difference? Either way, it was a slight. The father has probably seen these slights before, over and over, and his stoic response is likely well practiced. Phillips writes that his father's generation, new to England, received pamphlets telling them to wait for the bus in a single-file line and avoid work lunches with strong aromas. They were the equivalent of the "tongueless, earless, eyeless conveniences" Hurston described in central Florida. The stillness and the muted palette matched the silencing. This blanding of the self was intended to make Black immigrants more tolerable to white society. A country that needed their labor didn't want their presence. Even if the father's silence was a tool to survive, work, and protect his children,

Phillips shows how generational tensions can inform speech and silence: "For a few moments I made inane conversation, then eventually the waitress returned with the new glass of wine and I tasted it. Better, I thought, so I nodded and thanked her and she left us alone. However, the atmosphere between father and son remained strained."

Nonfiction writers like Clifton and Phillips use the sense of family closeness and history to redefine interiority. First-person narrators can have a familiarity with friends and family that serves the same function as interiority. Phillips can read his father's expressions and Clifton carries her father's questions. The sense of the interior, the source well for the dialogue, is curated from family memories.

Danzy Senna's "Triptych" shows how this generational back-story can show what the silence conceals. Senna gives us three versions of a story where three young women—Andrea, Yvette, and Soledad—experience slightly different versions of the same story. Each young woman has just lost her mother due to cancer, and the family is gathering for the funeral. But the relationship with the mother was the only true bond, and the story becomes a final gathering before her exodus from the family. She is saying a goodbye only the reader can hear.

Senna changed the racial and cultural identities of the characters and other details, and a key change is the level of interiority in a heightened moment where she silently responds to an uncle's laughter at her expense. (The final section of each is highlighted for emphasis and not a part of the original story.)

1. Cherries in Winter

Aunt Mabel made all the food. She and Uncle Gus drove from Syracuse this morning with a whole trunkload of steamy Tupperware.

"Have you chosen a major?" Gus asks her from across the table.

"Fine arts."

"Better than crude arts." He snorts with laughter.

Andrea just nods and takes another sip of wine.

2. Peaches in Winter

Aunt Grace made all the food. She and Uncle Byron drove all the way up from the city this morning with a whole trunkload of steamy Tupperware.

"Have you chosen a major?" Byron asks her from across the table.

"English. Literature."

"Uh-oh, you know what that means, James," he says. "She'll be moving back home after graduation." He snorts with laughter. "All these liberal arts kids do nowadays."

The thought of moving back here after college has filled her mouth with the taste of metal. She takes a sip of sweet tea, trying to wash it away.

3. Plums in Winter

Aunt Rose made all the food. She and Uncle Izzy drove down from Boston this morning with a whole trunkload of steamy Tupperware.

"Have you chosen a major?" Izzy asks her from across the table.

"Women's studies," she says.

"Uh-oh, Dave," Izzy says, smirking at her father. "Sounds like trouble. Should have sent her down south for college."

She wants to say to him what she has learned, none of it in class:

Some women are born to play dumb, and some women are too smart for their own good. Some women are born to give and some women only know how to take. Some women learn who they want to be from their mothers, some who they don't want to be. Some mothers suffer so their daughters won't. Some mothers love so their daughters won't. She wants to tell him that she has lost the one thing tying her to this scene. That nothing binds her to this anymore. That she is light and she is free and she is mourning not just her mother but her prison too.

Instead she forces a smile at him and sips her water.

All three versions take place in the time it takes to lift a glass. A forced smile in the first example, after the preceding six pages of story development, leaves space for accurate assumptions of Andrea's interior. In the second example, the metallic taste in Yvette's mouth is more visceral, and the narration briefly shapes the readers' assumptions. The third gives Soledad's interior monologue a charged clarity.

What will I say? What will it matter?

The protagonists here all show that they will say nothing, because their voices don't matter here. So the tension remains interior, and the story directs the momentum forward, past the exodus when the voice finds a place to resonate. When the scene ends, the daughter will take flight, leaving her seat empty like her mother's.

This inner voice does the work in concert with the silence. Dialogue could escalate this moment, but the muted response fuels the scene with the unsaid truth. Dialogue is a function of a broader idea, the fluid possibility of speech. Once the writer develops the well of history, questions, memories, fears, and desires, the writing benefits from the anticipation of what is said and what remains within.

Writing Through Loss and Sorrow

Poetry as a Practice of Healing

FRANK X WALKER

Reflecting on Pain

I used to joke that I wrote poetry because I couldn't afford a therapist, and while creative expression is not a replacement for medical care, it has the power to move us toward a wellness through care and healing. The experts say that anything experienced but not expressed eventually becomes repressed. We allow ourselves a degree of empathy when we examine, interpret, and respond to the creative works of others. I believe in the power of poetry when being introspective and examining our own lived experiences, particularly when navigating the terrain of real and even metaphorical death.

My uncle Bruce, whose sharp wit and tongue has always believed in delivering the truth unvarnished, no matter how ugly or painful, shared some advice about death when I visited him prior to the last family funeral to see if he wanted a ride. I knew he would refuse as soon as I saw him in jeans, sock feet, and a ragged t-shirt.

"Oh no, I'm not going," he said. "I think funerals are morbid. I'm never going to another one."

"What about your own, Unk?" I said.

"I don't wanna go to that one either. I tell everybody. Just say whatever words you feel like saying at the graveside and drop me in the hole."

I couldn't help but laugh, which I'm sure was his goal. I didn't even try to disguise the hurt still weighing on me after burying my sister Wanda three weeks earlier. I knew that he shared that pain, and his smoke-filled living room was a safe place if I needed or wanted to cry. Listening to the awkward spaces between my words, he assessed just how unwell I was, then lined up his medicinal jokes to try to prevent me from spending more time than I needed in the bottomless, immobilizing chasm that grief often is.

Uncle Bruce reminded me that death was inevitable, that "none of us are getting out of this alive," and then he recommended that I find myself some quiet space to process it all. The blank page is my quiet space. Writing is how I begin to process it all.

I had sat dry-eyed and mute at my father's funeral contemplating how much progress we had made by holding hands for the first time, on his death bed. I remained composed while speaking at my mother's homegoing service, then went to her house afterward, collapsed on the couch in a fetal position, quaking, and unleashed a torrent of tears. In both cases, I performed my generation's warped definition of a man by exhibiting a controlled public somberness while only expressing my true feelings privately. When my sister died, however, I didn't weep at the service. I shrieked and howled, conjuring up every snotty, convulsive, babbling, breathless thing that is sorrow, especially at a Black funeral, one of the rare spaces we are allowed to take off the masks that hide the "torn and bleeding hearts," so aptly described in Paul Laurence Dunbar's poem, "We Wear the Mask." In that communal space of mourning, there is an understanding which makes space for public and shared grieving. Although my uncle, well-known for protecting his privacy,

doesn't trust the public, he's open and honest inside his small personal network.

Wanda and Uncle Bruce weren't just close. Each of them seemed to find something in the other that nobody else alive could provide. For my sister, I think he was the father figure she needed after a traumatic string of failed relationships that always left her more broken. For him, she was a substitute for the lifeline and trustworthy conduit to family that our mother, his sister, had been when she was alive. When any of the four of us were together, there was always lots and lots of laughter, even if the reason for gathering was to lay another loved one to rest. My mother used to beg us to stop before she peed on herself, which was a high compliment. Experts say that laughter induction initiates the fight-or-flight stress response, but that after laughter, physiological measures such as heart rate, blood pressure, and muscular tension drop significantly, causing a physiological and psychological calmness. In our culture, in this country, we often laugh to keep from crying. And when the laughter reaches its zenith and is joined by tears it can move us into a space of healing. Laughter encourages us to reach past the burdensome weight of difficult emotions and experiences. Music and other kinds of entertainment can allow us to escape. But poetry can pave for us a path away from or deeper into our emotional selves and provide a space in which we can attempt to express or at least explore exactly what we are feeling.

Many artists and writers experience a creative shutdown when the pain and trauma associated with grief, sorrow, and loss consumes them. All too often, they are simultaneously shut off from the balm or cure just when they need it the most. No two artists or art products are alike, but across all genres, languages, cultures, and modes of expression, the one thing all art has in common is its capacity to evoke an emotional response, to move the consumer, and at the highest levels—the potential to heal. I believe that the

popularity of so many anthologies and collections of poetry about death, grief, and loss is because the need to heal is as ever present as the inevitability of death. The idea that time heals all wounds is just a poorly fitting cliché when it comes to emotional trauma from personal tragedies, grief, and loss. What might be truer is that if you live long enough, something more tragic will eventually supplant it or our ever-fading memories will eventually misplace it. The coping mechanism that works for me is not hoping the pain will go away but doing my best to try to learn to live with it and to eventually try to write my way through.

Writing toward Healing

A generative journal entry turned poetry exercise that can be useful for writers attempting to craft poetry out of grief or loss is one that I call "How much do you weigh?" This is not about the numbers that might appear on a scale if one stepped on it but rather about the metaphysical weight we bear when dealing with burdensome emotions like fear or loss and sorrow. The weight under discussion is more subjective and more about how you might feel and respond after asking yourself a series of personal questions, writing down your responses, and using the collective answers as a lump of clay out of which you can craft objects in the shape of poems. As with any work that excavates deeply personal and emotional responses, a content warning that this can be a difficult or triggering exercise is always a good idea. It is okay to step away from the exercise and take whatever time you need before continuing.

The first question is: What is happening in your personal life that currently causes you stress? The stressors might be societal like a public health crisis, a natural disaster, police brutality, the latest public lynching, or they may be individual challenges like cov-

ering your bills, unreliable transportation, your child's or a loved one's health, a bad relationship, etc. Understanding that the answers aren't necessarily meant to be shared, ask yourself questions like: What other things are you wringing your hands about? What makes you angry? What is the source of any anxiety you're feeling? What thoughts make it difficult for you to get to sleep? What wakes you up in the middle of the night? What unresolved baggage do you carry with you wherever you go? Who desires but has not received your forgiveness? Whose forgiveness are you still waiting for? Who do you miss so much it hurts? What losses are you still actively or passively grieving? After you have given voice to your worries and concerns, change directions and begin a new list of things that make you feel good and light. When was the last time you laughed so hard you cried? What do you regularly engage in that gives you joy? Examples can include simple things such as watching a favorite movie, babysitting, watching TV or films, reading, talking with trusted friends, etc. Try to articulate everything you are currently engaged in to release stress (i.e., gardening, exercise, therapy, massage, cooking, eating, bird watching, watercolor painting, sex, etc.).

Look at these two lists side by side. Examine them close enough to determine whether you are engaged in enough activity to counteract the stress you carry. Imagine that you and the items on both lists are suddenly placed into a deep pool of water. The first is a list of all the heavy things that will weigh you down. The second list is made up of things that help you float and make you feel buoyant. The most important question has now arrived: Are you being intentional about having enough things in your life to keep your head above water or are you drowning because you're carrying too much? If you are being honest, this will be difficult. Honest responses will likely produce emotional content. If you can articulate the emotions and write your way through them, they can yield cathartic results.

This written introspection can be shared but need not be. The exercise is meant to open the door to your most vulnerable self and to reveal the things you are often afraid to write about. Nikky Finney often asks the question, "What is it that you're trying so hard not to say?" Say it! The closer you are to being honest with yourself and to sharing the list and answering the original question, the closer you are to giving voice to the healing we all so badly need in our lives. If you can name fears and write them down, you can put them in your journal, close it up, and put it on the shelf. When you find the strength to share poems born from such personal and painful excavating in a safe space, you might feel moved to a new understanding. You might also have created a cathartic moment for someone in the audience. Someone might experience it as a reader after encountering a poem born from your personal artifact in a book without you being present. Nobody owns abuse, addiction, heartbreak, divorce, victimization, trauma, or death. Naming, journaling, eventually writing about, and finally sharing our stressors in the form of poetry can provide healing for ourselves and others. Decide for yourself. Are you writing to entertain or to also be of service to yourself and others?

To get from a journal entry to a poem, review your short responses to the series of questions. Pay attention to how what you've written makes you feel. Underline or circle those words, phrases, or passages that resonate the most with you. Now read through the highlighted sections and select one to use as a prompt for a free write. If you are able, read the results of your free write aloud. Ask listeners to write down and then repeat back to you the words and phrases in the exact language that catches their ears, captivates, startles, or interests them the most as soon as you are finished sharing. Use this feedback to identify what could be the heart of a new poem and build on it by initially paying special attention to the emotional

temperature of the contents. Hold off on being concerned with the shape or form until you are satisfied with what you have gathered. In subsequent drafts, you can continue crafting the poem by experimenting and making decisions about the optimal shape of it, sharing it with the intent of getting feedback to see where it is succeeding or challenging readers/listeners, and running it through your personalized revision checklist to move it toward being the "best words in their best order" and the final poem it is meant to be.

Today, many of my poems represent how I was able to begin articulating the pain and vulnerability I experienced surrounding the deaths of my favorite aunt, my emotionally unavailable father, and my beloved sister. I have attempted to write about my mother's death but have not yet succeeded in getting anywhere close enough to draft a poem worth sharing. This exercise is designed to provide a buffet of things to write about. Attempting to write about the most difficult among them could provoke some residual grief. Take a risk but tread lightly. Be sure to give yourself permission. Take your time. Be honest with yourself. And don't force this exercise on others. Write your first responses in a journal, so that you can revisit as often as necessary and write through at least some of what weighs you down.

Seeking out other means of exploring your feelings can also lay the groundwork and bring the clarity needed for shaping your emotions and ideas into a poem. Whether that is therapy and other forms of medical care, exercise, spirituality, or medication, caring for ourselves while exploring our pain, can "give us a unique perspective, a deep sensitivity to the suffering of other people, [and] a capacity for great humanity" as noted by Terrie M. Williams in *Black Pain: It Just Looks Like We're Not Hurting*. Resources like Williams's book, coupled with other approaches, including engaging poetry, can help all of us explore, identify, understand, and respond to the pain and depression in our lives and communities.

An Interview with Barry Jenkins and Morgan Jerkins

BARRY JENKINS WITH MORGAN JERKINS

This interview took place onstage in Las Vegas at the Believer Festival in April 2018.

I. Jojoba Oil and Shea Butter

Morgan Jerkins (MJ): One of the things I wanted to talk to you about first was adapting stories that are not your own. I think a lot of times in literary circles you think about cultural appropriation, whether or not white people can write people of color well. *Moonlight* is a story about queer Black men, and you are not queer. So I wanted to ask if you had any apprehension about adapting the story.

Barry Jenkins (BJ): Yeah, I did have some reservations and doubts, because, as the world knows now, I am straight. But it was funny, because when the movie came out, at first I'd do these interviews and people kept being shocked. "Oh, wait, what? You're not queer?" And I'd be like, "No, that's, like, Tarell [Alvin Mc-Craney, cowriter of *Moonlight*]." And I remember when [his] play [*In Moonlight Black Boys Look Blue*, which the movie is based on],

first came to me, I had the same conversation, you know, the question you just asked. I asked myself, Where is the line? I feel like there is a ceiling on how close a storyteller can get to someone else's experience.

And I think sometimes people approach stories with the best of intentions, but you can't get to the one-to-one if you can't literally put on someone's shoes, you know. If the shoes don't fit—or, to be brutally honest, [if] you would never wear that damn shoe, because your life is comfortable enough that you don't have to—then it's hard for you to create a piece of art about what it's like to wear that damn shoe.

In this case, Tarell McCraney had written the foundation of the piece, the play. And I didn't know Tarell, growing up. We were on this track to go to the same high school, but Tarell went to, like, the fancy arts high school downtown, and I stayed on the track to go to our hood-ass high school, Miami Northwestern, which is what the film is based off of. So our lives were pretty much the same up until the age of sixteen. And when I say the same, both our moms were addicted to crack cocaine; we were born a year apart from [each] other; both our moms contracted the HIV virus from intravenous drug use in the 1980s; Tarell's mom passed away of AIDS-related illnesses; my mom is still alive but HIV positive. So it was just everything you could imagine [would be the same between] two people who grew up within four blocks [of each other], their lives being mirrors of each other's, with the exception of [their] sexual identity.

And I thought, Well, if this person and I have all these things in common, and then I meet this dude, and he's a much taller, much more handsome, much broader-shouldered guy than I am—if you've met Tarell, you know what I'm talking about; he is like a Greek god, this dude. I was like: If, with the exception of him being a much more attractive human being than me, we have all these

things in common, with the exception of this one thing, I am then explicitly saying that someone's sexuality is such a barrier to me being able to identify with their experience that I'm just gonna . . . I don't wanna believe that about the world.

And so, because so much of our lives were the same, I thought if I could be responsible for learning as much from Tarell directly about his experience, I could then, as an artist, take that and put it into the work. And so it really was Tarell saying that he trusted me that gave me the strength to go and do the piece.

Having come out on the other side of it, I would hope that even if Tarell hadn't given me his trust, the fact that he had given himself so much in the source material, maybe that would have been enough. But I'm glad I didn't have to ask that question, because, I mean, so many people have told me what that movie meant to them, and Tarell's not a filmmaker, you know? So it was up to me to translate it to the screen.

MJ: Yeah, I was gonna say, for those creators who do not have an exceptional story like yours and Tarell's, who wanna write about others' experiences that they can't immediately identify with, whether it's sexuality or race, what type of advice would you give to them?

BJ: I remember a time when there was no Internet, you know? I went to high school without email. And so now you can look up pretty much anything you want, you know. I think in 2018 you have to really want to be ignorant of someone else's experience. You have to willfully be ignorant. So I don't think it removes the question; I don't think it absolves the maker or creator of that question. But I do think that if you do the work, you can get there.

You know, it's funny, the last time I got this question, I gave a really flippant answer. I was like, "Has anybody ever been to fucking Mars? How many stories have you seen told about going to Mars, you know?" People do it all the time.

Now, by the same token, going to Mars is one thing. Knowing what it's like to be Tarell McCraney is a whole different thing, you know? But I think it's possible.

MJ: Okay, so, growing up, you were a quiet kid. I was not. And I think that in *Moonlight* silence functions in a very special way. From the first scene, we don't hear Chiron talk. I remember when I was sitting in the movie theater, I was like, When is he going to talk? Are we ever going to hear him talk? And then at the end it doesn't end with dialogue. I wanted to know, from a director's point of view, how do you convey to people that silence is a form of communication? Especially among Black protagonists, because oftentimes when we're speaking, we speak in a certain way, maybe too defensively, too aggressively. How did you do that?

BJ: You know, there was one of the earliest reviews of the film—it wasn't, like, an official review; it was like a blog post or something—that really cut me. And it wasn't about a critical read of the film; it was about the character Chiron. And it described Chiron as being autistic. And it was because he goes so long without speaking, and that had just never, never occurred to me. I grew up in very similar circumstances to this character, and I just grew up in a way where I just didn't talk to a lot of people, you know? I was often by myself. My family background is very, very complicated. I wasn't raised by anyone who was a blood relative of mine, and yet I could see my blood relatives all around the neighborhood because things were just so, so bad. The 1980s were just a very rough, rough time in many of the inner cities around the country, but especially in Miami, so I just grew up not speaking. I was a person who lived through observation. I would watch people. And I felt like people would watch me because I wasn't giving them a lot in the way of conversation. My grandma would have to look at me and be like, "You hungry?," and I would just nod and say, "Yes."

And so as I was building the piece—you know, to go back to your previous question, because Tarell is tricky, man. Tarell can be very quiet and he can be very animated, you know? It depends on how comfortable he is with you. But for me, I had to fuse the character of Chiron with myself and Tarell. And so it was really rewarding for me to, again, take another step into the character, and I felt like, Yeah, Chiron's gonna be someone like myself and Tarell. People are gonna have to really watch him to understand how he's feeling, and if someone crosses that threshold to speak to him, that's how he knows: I can trust this person.

So when Juan shows up, he's skeptical. He's like, Oh, he's still looking at me. He's looking me in the eye. I can trust this person. And especially when Janelle [Monáe, who plays Teresa] shows up, with her moon of a face, oh my goodness. He's like, I can trust this person. In the screenplay, there's a lot of action description, you know. I can't do what these folks do, but in my screenplays I try to do a little bit of it, which is kind of a cheat.

And so there's this simple scene in the film where the two characters are wrestling, the two boys on the field. And in screenplay terms, that's an eighth of a page, which would just be one line: "They wrestle in the grass." I looked at the screenplay recently and it's, like, three-quarters of a page because I'm trying to communicate that there are things happening in the silence. And so the film is structured that way, from the script to the shooting, and what I love about cinema is [that] there are certain things about the image and there are certain things about these actors, these human beings' faces, that can just communicate so much more than I feel spoken words can in that context. And you don't get to see—it's just one of the realities of the film business—you don't often see that kind of aesthetic principle applied to characters who are not white and who are not straight.

But I feel like I grew up with a lot of young men who, as they aged, they spoke less and less. And they ended up being closed off from the world, and I wanted to make a film about one of those characters.

MJ: Piggybacking off what you said about the aesthetic principles of Black faces, I want to talk about the lighting of Black faces, too, because that is extremely difficult. Many of you who know about photography [know] it has a very racist history with regard to how to capture Black faces. If any of you are fans of Issa Rae's *Insecure*, they do an immensely good job with lighting Black faces. And so can you talk a little bit about the process of that?

BJ: When I first got into film school, I was way behind the curve because I'm a little bit older than I seem. We shot everything on film when I was in film school. So you had to really learn how to expose an image, and that image went off to the lab, and it was like magic. It came back and you couldn't see it on set, what it was. So I had to learn these techniques of how to expose skin on film. And both my films in film school featured people of color. I made one short film called *Little Brown Boy* that featured a protagonist very similar to Chiron in *Moonlight*. Then the other—I don't know how the fuck this happened—is about an Arab American couple washing American flags in a post-9/11 South. And a lot of things in this country are systemically fucked-up. And the history of camera emotion, 35 mm emotion, is racist. It just is. It was marketed and calibrated to sell to suburban white families. And so 35 mm film was never intended to accurately reflect or replicate darker skin tones. So I learned all this shit on film because I kept making things and being like, Why does this look so bad? And there's this cinematographer who used to work with Spike Lee named Malik Sayeed, who shot a film called *Belly*. And *Belly* is the most gorgeously shot film. *Moonlight*'s cool. [In] *Belly*, the cinematography

is crazy. I mean just insane. And then there was a film called *City of God* with this Brazilian DP, César Charlone. And I remember listening to the commentary on *City of God*. There's a scene where the actors are up in a tree. [It's a] very dark film, like dark in tone and also very dark skins. And they shot it . . . I thought it was day-for-night, but it wasn't. And I was like, How are they getting people who are darker than me to reflect, literally, moonlight? And César talks about taking—I mean, hey, this is Brazil, so they had to do what they had to do—like, literally taking cooking oil and just rubbing it all over the skin of the actors so it would literally catch the light and reflect it. And I was like, Oh, that's a dope concept. And so typically when you make a film, you have a makeup department, and the makeup department uses what? Powder. They just put powder over everybody. But you don't put powder on Black skin. So I told my makeup person, I said, "Hey, this is a no-powder show. We need jojoba oil and shea butter."

MJ: Yes!

BJ: And so everybody in *Moonlight* is just wearing oil. And then the other part of it, too, which is really cool: I feel like so many things that happened with *Moonlight* [were] just [about] timing. I'm just a very lucky and privileged person, because there's this camera called the ARRI Alexa. And the Alexa is made in Germany. And we used these lenses called Hogg lenses that are also made in Germany. All the technical, like, lenses and glass in *Moonlight* come from Germany, which is a very strange thing. But this camera is digital, so it doesn't abide by the rules of the systemically racist 35 mm emotion. Because of that, you can put a very dark subject next to a very bright subject. And this thing has so much latitude that, when you get in post, you can reach down into the shadow and you can pull it up however you want, and you can take that brightness and you can put it down how you want. So now you can calibrate it to

whatever you want to calibrate it to. I think, had this movie been made in 2012, at the budget that it was, there's no way it would look the way it did.

II. My Tweets Are Not Mine

MJ: *Moonlight* is based in Miami, but we're not seeing South Beach or anything like art deco hotels. We're seeing Liberty City. I think of other Black directors who feature places that are as active as the protagonists themselves, like, for example, Spike Lee and Fort Greene, Brooklyn, or John Singleton with South Central LA. I wanted to talk about what Liberty City means for you and how important it was for you to make sure that this particular neighborhood of Miami was pulsating, was moving along with the characters.

BJ: Yeah, you know, that's complicated, man, because I was born and raised in Miami. I never made any art that was set in Miami. Like, my life as an artist was completely separate from my life growing up in Liberty City. There was nothing in my world that pushed toward art. I was an athlete, but there were so many amazing athletes that I knew there wasn't a future for me in that. And I kind of just stumbled into film after being in film school, so making *Moonlight* was something that terrified me.

That's why I'll always big up Tarell McCraney, because I don't think I would have had the courage to have made a film or to tackle a story that was set there. So, once I knew that we were going to do this thing, once I decided I was going to go back home, it felt like a great opportunity to show a version of Miami, a depiction of Miami, that was just as true. Because, you know, give Michael Mann credit: all that shit's real. You got the art deco and the neon, and all that craziness is still there. But there is this whole other world too.

I'll give some of the hip-hop cats credit, you know, the people

like Rick Ross who have talked about [Miami] and have always put it in backdrops of their music videos. But I think characters like Chiron also exist beside characters like Rick Ross. And people like Chiron weren't having their stories told. So, when we went back, it was very important for me that the city speak for itself, you know? It was very important for me to be able to point the camera in any direction and be okay with who's walking through the frame, you know? And have the blessing of whoever ends up in the frame. And so, when you watch *Moonlight*, we have all these amazing Hollywood actors in it. You know, Mahershala Ali and Naomie Harris, Janelle Monáe, all these people, but the first voice you hear is this guy named Shariff Earp, who was a dude who walked into a community center—because we went down there during the course of the year and said, "Hey, we're making this movie. No acting experience required, you know. Just show us what you can do." And Shariff came in, he read for this part. But he was just not a good fit for it. But we started talking, and he was talking about how he wanted to change his life and how he'd done all this stuff, and as he was talking, I just heard his voice, and his voice was the sound of Miami.

So, the first voice you hear is somebody who literally walked into the youth center, this guy who had just gotten out of the county three months prior. And, you know, I mention it because *Moonlight* went all over the world. We went to France and Germany and all these places the movie was released. And so it had to be subtitled. And so you send the screenplay, you send the film, and people who speak like you . . . I would always get these emails from distributors [who were] like, "Hey, they need some help with, like, the first five minutes of the movie." And I'd be like, "Huh?" They'd be like, "Yeah, it's like they say it's English, but it's not English."

And I would always think, like, Oh shit, that's right. It's not in

the script. This is this guy. I let him go. I just want you to be you. And as I started subtitling, I realized something had happened. You know, when you walk into the cinema to watch *Moonlight*, the first thing you hear, which is a little heavy for some people, is "Every Nigger Is a Star." That's the first thing you hear. Like literally the first fucking thing you hear in this movie. And then the second thing you hear is the voice of Miami. You just see that this is gonna be the Miami that you have not seen before, but you're welcome to sit down and take a journey. So, yeah, it was one of the things I'm proudest of with the film.

MJ: Now, usually in the beginning for artists, before they reach their success, they're working up to it, right? But now that you are successful, do you feel like there are other pressures? And do you feel like, because of said pressures, whether it's from your team or your fans—

BJ: Can you tell? Can you tell? Can you tell?

MJ: Do you feel like it's harder to be experimental?

BJ: It's not harder to be experimental, because I'm still working with the same people. And also, too, the movie that put me on is hella experimental. So it's kinda like I walk into a room for a meeting and people know what they're getting, in a certain way. Some of the actors nobody's gonna know. Places where people should be talking, it's gonna be quiet. And then you're not gonna understand why the hell the camera's there. But eventually you'll catch up to it. So the experimental part is not the question.

There's a responsibility I feel, like with the spotlight that has been put on someone like me, who kinda came out of nowhere. And you learn very quickly there are things you are equipped for, which is creating. As a creator, I'm thirty-eight. I've been making films for sixteen years. I can do that. All this other shit surrounding it? I have no idea what this is, you know? And I never expected to

be in the center of it, so it's a learning process. And the only way I've been able to navigate it so far, as well as I have, is to know that I'm still working with the same people.

So, if I get out of pocket, people who've known me since I was twenty-two are gonna be like, *Hey, you being a little bit much right now, you know? You need to check yourself.* And it helps me check myself. You try to just continue making things the way you always did and, most important, for the same reasons.

MJ: Mm-hm. What type of other shit are you talking about?

BJ: I mean, like, I was on a plane, I was drinking, and somebody was watching *Notting Hill*, and so I started tweeting about somebody watching *Notting Hill* beside me—

MJ: I think I saw this.

BJ: And it became, like, a news story. And I was like, "That's a bit much. That's a bit extra, you know?" But what it does is it makes me realize, Oh, my tweets are not mine. That's a very simple way of putting it, but, you know, I don't have the anonymity that I once had. And I think, you know, I can be an off-brand kind of person. I want to do things quietly, but I can't do things quietly anymore. I have to not question: Oh, I wanna talk about this in public. Oh shit, do I wanna talk about this in public? Do I wanna have a conversation about this in public? Because talking about it in public is going to create a conversation about it in public. Those are, like, some of the simple other things that come with it.

But the more important thing is, I'll go to a gallery opening or a museum, and there are young Black filmmakers who are there, and I can tell immediately, from the moment we start speaking, that they are looking to me as a symbol. And I think there's a responsibility that comes with that, and yet I have to continue making things the way I've always made them, and for the reasons I've always made them. But I can't absolve myself of

the responsibility of knowing that I am a symbol. So, yeah, it's tricky.

III. Be Patient and Forgiving with Yourself

MJ: You're also doing a project based off Colson Whitehead's *The Underground Railroad*, which is a novel.

BJ: Yeah, and [James] Baldwin's *[If] Beale Street [Could Talk]*, which is also a novel. You know, my first job in the industry was at Harpo [Studios]. I was working for Ms. Winfrey when they did *Their Eyes Were Watching God*, which Halle Berry starred in. And then Darnell Martin and Suzan-Lori Parks were there adapting some things, so just somehow I've always ended up in that space.

I'm a very visual storyteller, and so for me to have someone like these brilliant folks do most of the story work is awesome, because then I can come in and figure out, okay, how can I visually translate this story? So it's just always been the way. But the beautiful thing about *Moonlight* was [that] it was like half a story. And so there was enough room for me to sort of, like, come in and also still be a writer or storyteller, but be a visual storyteller.

MJ: What are other things that you're reading? Whether it's books or, you know, long-form, short-form work on the internet?

BJ: Oh! So I try to reread the things I'm working on, so I'm rereading *The Underground Railroad* often. Rereading *If Beale Street Could Talk* often. And then there's this French actress, Isabelle Huppert. I'm reading all these French books that have been translated into English, because we're trying to find something to do with Isabelle Huppert. And then I like interviews. I read a lot of interviews with people. I have this stack of this magazine called *Acne Paper* that doesn't print anymore, and a lot of *BOMB* magazines. So I go in between novels for work and interview magazines.

MJ: I wanna talk about your Twitter presence, because you're very active on Twitter. And usually—

BJ: I'm dialing it back, I'm dialing it back.

MJ: No, no, it's good, it's good. So, you know, sometimes when I talk to other artists, they're like, "I don't wanna be on it." It's a distraction for other people, especially people of color. It's a form of creating or sustaining some type of community. So how do you use it? Is it just for fun or is it also a way to just reach out and get some ideas churning, or what now?

BJ: Now, I am friends with, like, seventeen-year-old kids in, like, Scotland, you know? How am I gonna have a friend [who's] seventeen in Scotland, who is just obsessed with movies, you know? And I follow, of course, journalists, like everyone else does, to try to figure out, okay, where are the journalists who are seeing the things that end up, you know, in the articles that I'm reading? *The Washington Post, The New York Times*. So that's part of it. I mean, Black Twitter is just, like, amazing. It's like its own news source and it's real-ass news. Like, if I see it on Black Twitter, I know it needs to be paid attention to, you know what I mean? And so at first, before *Moonlight*, I had, like, maybe two thousand followers, and that was the perfect way to operate on Twitter. I mean, it was kind of, like, selfish, though, because I was doing more listening than speaking. And now I feel like I don't use it for promotional tools; I try not to. Because I want it to function, for me, the same way it did before I had a following. But yeah, I just think it's a very liberated space right now where you can go. Especially because as a writer you spend so much time alone that it's nice. But it's a hell of a distraction, man. Ugh. If I'm somewhere where I can't get to Twitter, I get a lot more worked up. But it's nice to be able to check in and see, like, what is really going on. So, yeah, I love it. It's the one social media platform that I've been holding on to.

MJ: What other filmmakers do you think we should pay attention to?

BJ: Oh, man, that's a tough one. I program short films at Telluride, so I'm always watching a lot of short films. I mean, look: Ryan Coogler, obviously. Ava DuVernay—people like that you should definitely be following. I think there's a lot of people working in music videos right now [who] are really cool. There's this band called the Blaze. They're, like, a French duo. They have a song called "Territory," and rather than hire someone to make a music video, they made the music video themselves. And it is the best thing. The best film I saw in 2017 was a music video called "Territory" by the Blaze. And it's a very simple story, I wanna say, about an Algerian boxer who's been living in Paris and has to go home, is forced to go home. And it's just about his homecoming.

So if I was gonna recommend filmmakers, it would be people who are, like, Vimeo staff picks, you know. This guy named Carey Williams, who just won Sundance and South by Southwest, who made this film called *Emergency*. I would seek him out. Most of the visually aggressive things that I'm seeing are happening in the short form.

MJ: Do you have any writing processes or rituals? What do you do to get yourself going?

BJ: Coffee, coffee, coffee. And then, sometimes, whiskey, whiskey, whiskey. I have two bachelor's degrees: one in creative writing, one in filmmaking. Now, they're both from Florida State, so, you know, who knows the quality of those degrees, you know. Because you went to Princeton, right?

MJ: No, don't do that! Don't do that. Don't do that.

BJ: I'm just saying! I'm punching above my weight up here.

MJ: I'm not an Oscar-winning director.

BJ: So I just sit down and try to work, you know. And the thing I say—I teach every now and then—the thing I say is to be very pa-

tient and forgiving with yourself. There are some days where I get nothing done and then there are other days where I might get eight pages. And I try to feel as good about the days with no pages as the days with eight because I can't control it. And maybe, as I become a better writer, I'll be able to control it. But *Moonlight* was a script that I wrote in ten days, and I've never written anything that fast. And it was just one of those periods where it just really kind of just happened, you know.

I wanna go back to the filmmaker conversation, though. Because it is a cool time to be a Black filmmaker—any filmmaker who is from the outside right now—because the outside is in, in a certain way. And the quality of the work is supporting the reasoning for the outside being in. There was this tweet about Ryan Coogler making *Black Panther*, and when we were in postproduction on *Moonlight*, Ryan was in preproduction on *Black Panther*. And, you know, I used to live in the Bay Area, so I met Ryan before *Fruitvale [Station]*. And he came down for a meeting with Marvel and just snuck in some time to come and watch a cut of *Moonlight*. He gave two or three really great notes, one that ended up in the film. And I remember him leaving and I shot off a tweet like, "Man, Ryan Coogler's really busy right now. But every time I call him, he picks up the phone. And he helps me out."

So, what's so beautiful about being in the position I am [in] right now—I think for people who see folks like myself, Ava, and Ryan, and Jordan [Peele] coming up—is there are no crabs in this barrel. Everybody supports one another.

And I say that because two weeks ago—I'm in post right now on *Beale Street*, and Ryan knows I don't enjoy postproduction—out of the blue, I get a text message, and it's Ryan Coogler, and he's just like, "Hey, Barry. Just checking in on you, man. Just want you to know I'm thinking of you. Hit me up if you need

something." I'm like, "You should be fucking in, like, Tahiti. You should be, like, in Tahiti on an island, because I know how hard that movie was." And this dude is checking up on me. And he's young! He's, like, ten years younger than me! This dude is checking up on *me*. And it's like, it's just such a blessed time to do what we do. And so, for me to, like, complain or feel any kind of way about it, I'm just like, How the hell did this happen? You know? How did this happen? And then I try to think about it and just keep moving forward.

Originally published by *The Believer*, November 30, 2018.

How to Read

—

Influence and How Writers Use Their
Reading to Lead to New Writing

Nothing New

Black Poetic Experiment

EVIE SHOCKLEY

Let's start with a question. Oops—I blew it. Bluet: a proposition that I make Black by making it blues. There's no question about it. Still, thanks to *its* slipperiness, we may ask: is experiment (experimentation, experimenting) in poetry a craft? And, if so, is it one a Black poet can step into, without rocking the boat, and sail on down the line?

If you're still reading this—perhaps wondering just what a paragraph like the first one introduces, perhaps wondering whether you've imagined a reference to Maggie Nelson or the Commodores, perhaps wondering if the word *craft* has any other meaning in its noun form—then stay with me. I want to lure you further away from authenticity, deeper into ambiguity, far past the clearly marked boundaries of Black Poetry. (Who marked them? And why? Who gets ~~hurt~~ mad if we pull up the markers and chuck 'em into the trash?)

Transgression, but not transgression for transgression's sake. When a poet transgresses—*goes across*—some line drawn in the cultural sand, they redefine the territory.

New story. A Black poet walks into a bar in 1920. The bouncer kicks them out, so they go to a rent party up in Harlem and invent the blues poem. Or a Black poet walks into a bar in 1945. The bouncer checks their ID with a fine-tooth comb, then finally lets them move past the entryway. They sit down quietly at the little table in the corner reserved for Black poets and write poems that make that dusted demi-gloom gleam like bronze. Or a Black poet walks into a bar in 1965. They join the crowd of Black poets in the corner, LOUD, rowdy, about to drown out whatever's happening under the spotlights with their assassin poems, *omm bomm ba booming* to beat the band. Or a Black poet walks into a bar in 1990. They sit down at the side table labeled *Stein Stans*, but turn their chair so they can see the *Hughes Crew*. They write poems in a red and white, white and blue banner manner, trimmed in feathers, in bananas, with slumming umbra alums. Or a Black poet walks into a bar in 2010. They never sit down, because they're pulled into the posse of Black poets standing in the center of the room. They prop a laptop on the countertop and create poems out of expressive fonts, shark jokes, and the souls of Black automatons. And the moral of the story is . . . ? Think fast. It's time sensitive.

This essay is an experiment in crafting a lesson. The first rule is follow the rules. The second rule is follow your heart. The third rule is break the rules. The fourth rule is . . . never mind, someone else will do that for you.

An experiment is useless to someone who (supposedly) knows everything, because an experiment emerges from a question. But it has to be a good question, a question that isn't born out of ignorance. Know your tools. Know their strengths. Know their limits. Know what they were made to do. Then make them do something else.

Blackness is a tool. One of its strengths is that many people don't know that it's a tool. Those who know that it's a tool can write

"Black"—on a table in a bar, on style of poetics—and (re)organize people and poems accordingly. Language is a tool. One of its limits is that to use it effectively you need to have some kind of power—the force of law, the backing of the bullet, the potency of beauty. Both Blackness and language were made to control people. Make them do something else.

But how? That's the experiment. Hone the question. Craft the rules. Try your hand at creating a poem that transgresses the boundaries meant to control us. Remember that an experiment is site-specific. Water boils at one temperature in Charleston and another (lower) temperature in Denver; altitude makes a ten degree difference. Know your audience. Ask: Who are they and what gets them fired up? Ask: Do they need to be fired up? Why? Know the boundaries. Ask: Why is a line drawn right here? Ask: If you cross it, what territory gets expanded? Who gets displaced and where do they go?

Maybe this all sounds esoteric, abstract, meaningless. What is poetry *for*? *Who* is poetry for? When and where are you asking these questions? Maybe you're in twenty-first-century Nashville, Tennessee, watching the city gentrify right before your eyes. Is your poem a critique of the way systemic racism prices Black people out of the very neighborhoods their grandparents were segregated into? Or is it a documentation of the people and places passing out of memory? Or is it a map of the connections between ecology and race that manifest as the absence of public transportation, the gridlock of rush hour traffic, and the disappearance of trees and countryside in the face of urban sprawl? Can the poem be all three things at once: diagnosing a problem, memorializing a loss, connecting the dots? Or, to ask the question in a different way: What does a poem need to be to do all three of these things? Can the poet, sitting at their metaphorical window, look out and see it all—and describe it in a

way that adheres to the conventional rules of the lyric poem? What "voice" can sound the three notes in a dissonant chord at once? What chain of language can be forged to string together three fires? With what combination of discourses and devices do you simultaneously ensnare the arsonists *and* salve the burns *and* call for water?

Don't wait here for answers from someone who cannot know if these are even the right questions. The questions ultimately have to be your questions—real and burning. If you aren't compelled, driven, by questions about how to wrestle poetry into doing things it hasn't done before . . . that's perfectly fine. There are other mountains for you to climb that are just as steep. You may be inclined to boil your water atop the mountain of mastery, where different elements of craft take precedence. You may be called to walk into the bar on the peak of narrative, where poetry's stories are paramount. This essay is for the poet for whom beauty is less the goal of writing poetry than it is a potential, perhaps fortuitous, by-product. This essay is for the poet who feels that clarity is sometimes the obstacle to, rather than the *sine qua non* of, poetic process. Maybe every poet is this poet from time to time. Almost no poet is this poet all the time. Circumstances change by the year—by the day—and, accordingly, our art and our lives demand many different things from us. It can help, though, to ask yourself which mountain (you think) you're heading up when you start to write.

Take every declarative statement—most of all, mine—with an ocean of salt. Throw the baby of certainty out with the manifesto wastewater.

A fascist anti-Semite once said: *Make it new.* As a Black poet writing in a world where history hangs around the neck of the present like a noose tied to an anchor, how can I argue with that? As a Black poet writing in a language that has my absence, my death, my

negation embedded in its etymology, its syntax, its grammar, how can I argue with that? I want to make everything new. Fortunately, I don't have to take his words for it (though they were pounded into the heads of generations of American poets), and neither does any Black poet. Black poets have been exploring ways of breaking out of colonial or imperial languages—or breaking into them—breaking them down or breaking them up—for as long as we've been stuck speaking them. We've experimented so long and so hard, the question now is: Where's left to go?

Anywhere better. Pick up anything you can use from any place you can reach, like his Purple Majesty did, even if it causes some controversy. Transgress—but not for transgression's sake. Bring yourself to the task of description, dissection, delight with a sense of what's possible (what has been done) and what's needed (something else). Be dissatisfied with anything—any image, any phrase, any form—you've seen before, unless you're doing something different with it. No Afro, unless it's a balloon that rises above the grubby streets of capitalism and takes along anyone who grabs its trailing string. No grubby streets of capitalism when they could just as easily be tree-lined avenues or blistwhicky thoroughfares or plump, promiscuous back alleys moist with deals. No sestina, unless learning to wind through its patterns can teach us to slip the yoke of the changing same. Fuck the familiar—it never goes far enough fast enough to get us out of here. And elsewhere is where this guide is pointing.

Is it a *craft*, this process, this practice of taking a hammer, or a blowtorch, or an auger, or a wrecking ball to the language? Must it be so aggressive? Might we approach language more deftly, with sandpaper, or a chisel, or an awl, or a scalpel, or a toothbrush—so long as we're prepared to rub, chip, pierce, slice, or brush until we see language's blood and bone? Is it a *craft*, this process, this practice

of taking a language hostile to Blackness and trying to mash, distill, or remix it into something that can carry Black experience gently, proudly, inquisitively, intelligently?

If it is a craft—poetic experiment—and a craft the Black poet can still make good use of, the way to learn it is not by reading this essay. The way to learn it is by reading—picking your way through the rubble of, analyzing the alchemy of—previous experiments by Black poets.

- Go dig how Helene Johnson raises an eyebrow at romanticizing the motherland: "Some bozo's been all the way to Africa to get some sand" ("Bottled").
- Go catch Aimé Césaire's alleluia of understanding, that "my negritude is not a stone, its deafness hurled against the clamor of the day" (*Notebook of a Return to the Native Land*).
- Go tune into the fraught frequencies of Bob Kaufman, who assures us that "THE / POEM IS NOT TO BE / EXPLAINED. IT IS WHAT IT / IS . . . / A FISH WITH FROG'S / EYES, / CREATION IS PERFECT" ("The Poet," *Cranial Guitar*).
- Go get you some Kamau Brathwaite, poem-painting the dis-place-ment that became a home-place: "And black black black / the black birds clack / in the shak shak tree // the slack / wing'd gaulin swings / through the fishnet air" ("Legba," *Islands/The Arrivants*).
- Go hear what Jayne Cortez will tell you about "the word that was always divided into / bamboo sticks & steel band revolts / & possessed in feathers / & mummified in flint" ("Spoken Word," *On the Imperial Highway*).
- Go follow the rituals Jay Wright chants, "trying to push / the curve of speech / past the short rib of my body" (*The Double Invention of Komo*).

- Go examine what Ed Roberson has constructed with "the glareglarity/clarity of . . . vision" that becomes so solid "that. / chaos is the real ground" ("I jacket," *When Thy King is a Boy*).

- Go check Elouise Loftin's stories about how "me and god dont want / to come to your class and tell people poetry / aint hard as they think crazy people are" ("Popcorn," *Barefoot Necklace*).

- Go unearth the lessons between Lorenzo Thomas's lines: "He / Church in trembles // Joy? // And struggle. // Jjjoy and and struggle" ("Spirits You All," *Dancing on Main Street*).

- Go listen to the music Nathaniel Mackey has been channeling for decades: "Took between his lips her /cusp of tongue's foretaste / of 'heaven,' ravenous/ word they / heard urging them on, loquat / spin" ("Song of the Andoumboulou: 24," *Whatsaid Serif*).

- Go see what NourbeSe Philip has to say about writing in "a foreign lan lan lang . . . l/anguish" ("Discourse on the Logic of Language," *She Tries Her Tongue, Her Silence Softly Breaks*).

- Go grasp the slippery syntax of Erica Hunt: "Proof in the tongue of ruin and burn. Fluent in the language of minus" ("Proof," *Piece Logic*).

- Go trace the path John Keene makes between his poems and Christopher Stackhouse's abstract sketches: "Phonemes hover, sediment as subfolds. Convexion, complexity: copulae. Fragments to be reconstructed if you can just model the trajectory" ("Folds," *Seismosis*).

- Go stare into the abyss Dawn Lundy Martin carves: a brother "opens his mouth as would a hewn structure, a crack in a thing so swollen it betrays the soul, becomes all body, brutal body, brutal sideway" (*Discipline*).

- Go swallow the juice filling LaTasha N. Nevada Diggs's lines: "bloom. the dandelion dance of Keisha's mane. a Wave / of bush. her kitchen pearls & truffula treetops" ("bacche k ptR," *TwERK*).

I send you out into the vastness of Black experiments past, to create your own anthology of unthroated ache, hashed alphabetic tags, and split-infinity spit. Come back clear that there's nothing new under the sun. Then try to figure a way out from under the sun.

Yearning, Despair, and Outrage

Writing Loss in Fiction

ANGELA FLOURNOY

The phrase I heard the most following my mother's death was this: I can't imagine what you're going through. Friends and acquaintances in text messages and on the internet, a good amount of both categories being fiction writers, would reach out to tell me that they could not imagine loss like mine, that it was impossible to fathom. This is a problem, a problem both for me and for them, this failure of imagination. I hoped "I can't imagine what you're going through" was simply a figure of speech, just a thing people say reflexively like "safe travels," or "it's nice to meet you," when it may not be nice at all to meet someone and they are not particularly concerned about someone else's travels.

But what if people truly can't imagine immense loss until it befalls them? If loss, like the pain of childbirth, lies stubbornly in the abstract, no matter how florid the details or visibly anguished the next of kin, we are all in trouble. It creates a kind of psychic distance, more handy than using a character's full name or any syntactical trick: You are over there in the land of incomprehensible

loss; I am over here among the whole, the steady, witnessing you. I thought this back in February 2020 when my mother passed, not knowing there would be so many more sudden deaths, more mothers snatched away in mere days, loss by the tens of thousands within weeks, over half a million in a year in the United States alone.

We do indeed have a problem, I see now. Many of us seem to have trouble imagining loss that is not ours, and by extension our own demise, despite the accumulated *New York Times* obituaries and stories of refrigerated trucks used to transport corpses. It is easy to think that it is just people in the highest offices who have this lack of imagination, but there is evidence that the deficiency lies within many of us. It manifests itself in our behavior, our language, and our literature.

Literature abounds with grief. Fiction writers often write about the long tail of death, about the father whose shadow continues to loom, the child taken prematurely whose adult life a mother imagines. We can build entire characters around the deaths in their backstories, the turning points and memories attached to a loved one no longer present. But what about the more immediate after, those wrecking days and weeks and months where a person still picks up the phone to text a friend before remembering they're gone? When typing the true, straightforward statement out in an email—my loved one is now dead—is unbearable?

I am interested in the long tail of grief, but I am just as interested in the short, sharp teeth of sorrow, which clamp down soon after the loss itself and blot out all other sensations. Fiction often skips over this early, terrible period when it shouldn't. A better understanding of these short teeth might help us all moving forward. When you are deep in fresh sorrow—"Circles and circles of sorrow," as Toni Morrison calls it in *Sula*, which we will look at soon—you need reassurance that there might be a way out of it, that there is more than sharp pain ahead for you. But more important than that, you need

to know that you are not alone, that someone else has taken the time to imagine this unfathomable place, that they have not created psychic distance between themselves and your pain.

And so, in my grief I turned to literature as I turn to it always, for some way out of my own confusion, my own quarantined despair.

It wasn't difficult to find poetry that looked at loss straight on, but it took me more time to find the right fiction to reflect what I was going through. The longer I looked for it, the more bothered I got by not finding it. So much fiction quickly turns the page on the immediate, short-teeth impact of death. Writers seem to want to nod to this period of time via purposeful silence, or insert a bit of metaphorical, and sometimes literal white space between Act 2, when a death is rendered, and Act 3, when the characters involved have had time to regroup, or even, to my fresh horror, transcend. The reader is left to infer what sort of internal struggle characters overcame to shake off the short teeth of sorrow with such success.

Or else death is written as impetus, as the inciting incident from which a plot spurs into action. This can be useful, structure-wise. Nero, the main character in Annie Proulx's "The Half-Skinned Steer," gets a call that his brother has died—"Killed by a waspy emu"—so he hops into his Cadillac and begins an ill-fated cross-country road trip in hopes of returning to his hometown as some kind of victor.

Then there is the question of manners. The death of Beth March in *Little Women* is rendered as tragic, yet genteel, and Louisa May Alcott does not linger on the short-term fallout this death has for the other March sisters; how one or two of them maybe unraveled due to the loss. They remain, for the most part, dignified in their lingering grief.

I am not interested in dignified sorrow nor stoicism in the face of loss. This is, bafflingly, the type of behavior still too often expected of us in real life, which is perhaps another reason we seem to have

so much trouble fully grasping the calamity that is our hundreds of thousands dead. In May 2020 I attended the Zoom memorial for one of my former students who died of COVID-19 while on the way to the hospital. She was younger than me, kinder than me, and better than me in many ways. During the memorial her relatives apologized more than once for crying when they spoke, for not being able to keep their emotions in check so soon after such a devastating loss. I thought about how many messages of condolence they'd received with the words *I can't imagine what you're going through* embedded therein.

The best argument against stoicism, against the absurd suggestion to "not dwell on it," that I have encountered in fiction comes from Toni Morrison, which is really no surprise when we think about the care that Morrison ascribed to intimate relationships and mortality writ large. Here, the character Nel in *Sula* considers how one should behave in the face of loss:

> On her knees, her hand on the cold rim of the bathtub, she waited for something to happen . . . inside. There was a stirring, a movement of dead mud and leaves. She thought of the women at Chicken Little's funeral. The women who shrieked over the bier and at the lip of the open grave. What she had regarded since as unbecoming behavior seemed fitting to her now; they were screaming at the nape of God, his giant nape, the vast back-of-the-head that he had turned on them in death. But it seemed to her now that it was not a fist-shaking grief they were keening but rather a simple obligation to say something, do something, feel something about the dead.

The women of Medallion, the fictional town in *Sula*, know that the dead require lamentation, that to rush through this phase of grief is folly, and harmful to the community itself—for who in this

segregated, cruel world would take the time to note their departures from it if not them? "Good taste was out of place in the company of death," Morrison writes. "Death was the essence of bad taste." If good taste is to behave as if reserved, to keep our cards close to our chests, then death requires the opposite, it requires real feeling and real attention, both in life and on the page.

The scene preceding this statement about grief and decorum is actually not about physical death at all but about the death of two relationships. Nel has just walked in on her husband committing adultery with her best friend, Sula. Nel takes their betrayals to signify the end of her marriage and the end of the long, complicated, and passionate friendship she's had with Sula. Morrison renders these fractured relationships as a kind of death because these are the stakes of intimate relationships in the world of *Sula*, so it is fitting that she takes us from a contemplation of proper funereal behavior to a close-third examination of how sudden grief can slip into quiet, long-lasting despair.

Nel sits in torment on the bathroom floor, waiting in vain for her body to let forth the kind of cry the women made at Chicken Little's funeral. Instead, something shifts within:

The odor evaporated. The leaves were still, the mud settled. And finally there was nothing, just a flake of something dry and nasty in her throat. She stood up frightened. There was something just to the right of her, in the air, just out of view. She could not see it, but she knew exactly what it looked like. Just there. To the right. Quiet, gray dirty. A ball of muddy strings, but without weight, fluffy but terrible in its malevolence.

This gray ball, "terrible in its malevolence," arrives early in the novel but lingers; it is Nel's long tail of grief. We'll return to it in a little while, but first let's go to England.

When writing about death in fiction, how to address the expectation for transcendence, for whatever kind of narrative shift that takes place to also include a character overcoming, making it through? I am suspicious of stories of pat transcendence; the journey is windy and muddy and the light at the end of it all may be faint indeed. In *To the Lighthouse*, Virginia Woolf uses imagery and syntax to suggest that the lowest point of sorrow might still lead to some shift in perspective or marginally higher ground. The novel is multi-POV, but the reader gets the sense early on that Mrs. Ramsay, matriarch and in many ways head of her summer household, with its children and visitors and eccentric neighbors, is the central point of view. She is afforded the last moment of interiority at the end of the first section, so it is a shock in the second section, titled "Time Passes," when we discover that she has died. You're not supposed to be able to do that—kill off the character we've grown to know so well, but Woolf does because she understands that death often claims the ones we think it might never claim, the people seemingly built to outlast us all. After the section "Time Passes," Woolf revisits the remaining characters, reuniting them in the ramshackle summer house where they all used to gather, and the reader is able to feel the long-tail grief for Mrs. Ramsay. But "Time Passes" itself manages to get at both the short sharp teeth of loss and nod toward what might come after without making any promises about how much time either part of the process might take.

The news of Mrs. Ramsay's death is delivered during a description of her husband's walk along the beach.

. . . the sea tosses itself and breaks itself, and should any sleeper fancying that he might find on the beach an answer to his doubts, a sharer of his solitude, throw off his bedclothes and go down by himself to walk on the sand, no image with semblance of serving

and divine promptitude comes readily to hand bringing the night to order and making the world reflect the compass of the soul. The hand dwindles in his hand; the voice bellows in his ear. Almost it would appear that it is useless in such confusion to ask the night those questions as to what, and why, and wherefore, which tempt the sleeper from his bed to seek an answer.

[Mr. Ramsay, stumbling along a passage one dark morning, stretched his arms out, but Mrs. Ramsay having died rather suddenly the night before, his arms, though stretched out, remained empty.]

This is a cold-blooded parenthetical, downright cruel. Woolf employs this last sentence precisely because it is abrupt, jarring the reader much like death jars us all. The syntax is strange—why order details so that the news of Mrs. Ramsay's death comes in the middle of this description of Mr. Ramsay's arms? It may suggest Mr. Ramsay's own temporary disembodiment at the sudden loss of his wife. But even before we are gut-punched with the news of Mrs. Ramsay's death at the end of this passage, Woolf begins to create the atmosphere of the short, sharp teeth via language. She describes the sea teasing and breaking itself and a restless sleeper seeking company on the beach and finding none. The language hints at the alienation that will accompany her character's sorrow before providing the cause. And when the cause is made clear, the section ends with Mr. Ramsay's outstretched arms remaining empty. But not too long after the abrupt revelation of Mrs. Ramsay's death, Woolf hints at hope.

Loveliness and stillness clasped hands in the bedroom, and among the shrouded jugs and sheeted chairs even the prying of the wind, and the soft nose of the clammy sea airs, rubbing, snuffling, iterating,

and reiterating their questions—"Will you fade? Will you perish?"—
scarcely disturbed the peace, the indifference, the air of pure integ-
rity, as if the question they asked scarcely needed that they should
answer: we remain.

In contrast with the arms that remain outstretched in the prior
passage, here "loveliness and stillness" are described as two hands
successfully clasping. The sea wind, full of destruction and rest-
lessness before Mrs. Ramsay's death, still do carry the question of
mortality in this section—"Will you fade? Will you perish?"—but
now this question "scarcely disturbed the peace." As the narrative
moves forward from Mrs. Ramsay's abrupt death, Woolf suggests
a kind of calming in the world of the book and by extension her
characters' minds. This is not the same as ascribing a kind of facile
transcendence to her characters; they are irreversibly changed by
their losses. But over time, struggling through the short teeth of
sorrow, which this section of the book encompasses, has yielded an
answer to the questions that the death of a loved one puts forward.
The answer is: "we remain."

———

I mentioned earlier that in *Sula* grief gets a hold of Nel after the
end of her two most important relationships, long before anyone's
actual death. But the character Sula does perish in the latter pages
of the novel, and the same townswomen who understood the im-
portance of mourning earlier in the case of Chicken Little initially
refuse to mourn her (Nel isn't the only person Sula betrays). Instead,
it is Nel herself who calls the authorities to come collect her old
friend's body. "The white people had to wash her, dress her, and
finally lower her," Morrison writes, this outsourcing of community

duties being one final rebuke. At the last minute, at the gravesite, the Black townspeople show up, "with hooded hearts and filled eyes," to sing for Sula, to mourn her just the same. This funeral, and the begrudging affection showed by other people Sula had harmed, crack something open in Nel.

> Suddenly Nel stopped. Her eye twitched and burned a little.
>
> "Sula?" she whispered, gazing at the tops of trees. "Sula?"
>
> Leaves stirred; mud shifted; there was the smell of overripe green things. A soft ball of fur broke and scatted like dandelion spores in the breeze.
>
> "All that time, all that time, I thought I was missing Jude."
>
> And the loss pressed down on her chest and came up into her throat. "We was girls together" she said as though explaining something. "O Lord, Sula," she cried, "girl, girl, girlgirlgirl."
>
> It was a fine cry—loud and long—but it had no bottom and it had no top, just circles and circles of sorrow.

Nel finally gains access to the kind of manners-be-damned, full-bodied grief that she searched for on the bathroom floor earlier and couldn't access. The more removed form of grief that she'd been holding onto—that soft gray ball of fur—breaks open, allowing her the "fine cry" that her love for Sula warrants. Her words rush together, and her emotions have a physical component to them; they press her down and come up into her throat. This moment is the final scene of the novel, such is the value Morrison placed on love and bereaving those we've lost. Of course. Through Nel, Morrison posits to the reader the same question I put to you as a fiction writer: how can we truly understand what we've meant to one another without acknowledging what it means to have it all come to an end? We can't.

Journal

TERRANCE HAYES

Journal, Day One

A fear of boredom (what's the medical term for that?) compels me to try something different every day here: lists; imaginary poems, novels, and essays; little book reviews. We'll see. I'm currently teaching a poetry seminar in Lewisburg, Pennsylvania, and maybe that alone will be enough to blog about. For example, I gave a lecture on the tension between voice and craft a day ago. (Let me know if this bores you.) (I love parentheses.) Ever since an epic discussion-disguised-as-debate I had with my friend Renegade, I've been thinking about it. He believes there are specific principles to what constitutes a great poem (or work of art). I disagree. "There are many forms of great, many ways to be great," I told him. "Claiming there's a set of predetermined principles—that's too conservative for my tastes," I said. (Note: you should never call someone named Renegade "conservative." Nor should you imply another poet is not thinking like an artist. He's kind of stopped speaking to me because of it.)

Yesterday I was listening to a podcast (like blogs, they are a form of tedium that can occasionally be enriching) on *Science and the City* where V. S. Ramachandran gave a lecture on "Synesthesia and the Universal Principles of Art." He claimed in the more speculative part of his talk that principles like peakshifting, grouping, and iso-

lation determine how we judge and respond to art. All very compelling, but for me, Renegade and this dude are talking about art from the outside—from the perspective of the gazer/audience, not the artist. Even if it's misguided, the artist needs a healthy sense of individuality to sustain his or her imagination. The "principles of art" might help guide the imagination, but they should not determine it. Shouldn't we say as much about craft, the most used word (other than the word "poem") in poetry workshops everywhere? Craft is a guide, not a formula. The elements of craft are how we know we're reading a poem and not a short story or newspaper piece. Even in prose, poems examining the elements of craft (tone especially, but also imagery, metaphor, structure, if not form) tell us whether we're looking at a poem or a prose paragraph. Discussing craft allows us to break poems into parts: the frequencies of diction and meter, the concrete blocks of imagery, the equations of metaphor. Craft gets at the science and engineering of poetry. It makes poems machines. And though I'm about to tell you poems are not mere machines, I fully acknowledge the value of talking about them this way. Craft gives us a common language, common tools. It also gives the teacher a way to measure and evaluate poems. Evaluation is easier when one sees poems as machines.

But if a poem is a machine, it's an animal too. Depending on your stance: an animal with a machine skeleton (say, like Steve Austin, the bionic man) or a machine shell with an animal heart (say, like Robocop). I'll say here that I think the poem is mostly an animal. We work to tame it, to train it, but ultimately it has a mind of its own. It's a child we're raising, a child we birthed and are responsible for, but a child we do not "own." And if it's alive (language is alive, right?), we can't just saw off a leg without ramifications. In fact, if it's an animal, we accept it even if one leg is shorter than the other. (One of Jesse Owens's legs was shorter than the other, and look how

far and fast it got him.) If the poem is an animal, we are not after perfection (the thing we are after if we view it as a machine); we are after what a parent is after. We are helping the poem discover its dream. Every poem has a dream. Hell, every word has a dream that, as far as I can tell, might best be described as a wish to be useful, indispensable, maybe unique. Renegade wasn't hearing this. Once he and I argued late into the night (argued until I lost my voice) about whether or not Billie Holiday was a great singer. He said in what I remember now as the voice of Mr. Spock that she might have been a great stylist, but that her singing was never technically correct. Her poor technique had, in fact, ruined her voice, he said. I don't think Billie Holiday was after "craft" or technique. Maybe this is too romantic, but I think she was after something beyond "craft." And I'm suggesting that there is something beyond craft where poetry is concerned too. Has to be. Otherwise, a mastery of craft would mean a mastery of the poem. We'd expect a mature poet with control over "the principles of craft" to never write poorly. With the exception of Stanley Kunitz, most poets seem to get worse as they "mature," not better . . .

In the lecture I brought in poems by poets who demonstrated a "mastery" of craft in their first books but inevitably moved beyond craft to something else. Amiri Baraka is an easy example. The poems in 1961's *Preface to a Twenty Volume Suicide Note* show that he obviously knows (or knew) "the rules." The first five lines of the title poem:

> *Lately, I've become accustomed to the way*
> *The ground opens up and envelops me*
> *Each time I go out to walk the dog.*
> *Or the broad-edged silly music the wind*
> *Makes when I run for the bus . . .*

But five years later with *Black Art* he announced that he was after something else. The first lines of the title poem:

> *Poems are bullshit unless they are*
> *teeth or trees or lemons piled*
> *on a step. Or black ladies dying*
> *of men leaving nickel hearts*
> *beating them down. Fuck poems*

Which is better depends on your tastes, I suppose. I tried to tell Renegade I was less interested in good/great vs. bad than in the relationship between craft and voice, tangible and intangible. One of the reasons we don't talk much about voice is its slippery, atmospheric quality. It's a close cousin to tone, which is maybe the most difficult of the craft elements to teach. Tone and voice are matters of sensibility. You can't teach sensibility, can you? Maybe sensibility can only be shaped/filtered through craft: sometimes enlarged by it, sometimes obscured. (I love the word "maybe" only slightly more than I love the word "perhaps.") Tell me how you'd define voice in poetry? Tell me in a way that would make it useful to students. Tell me in a way that would convince Renegade. Maybe we don't even have a good definition of craft yet. I'd vote for adding "culture" as an element, for example. Where would you discuss the influences of race, class, and gender on theme and language if not in a discussion of craft? Including culture as an element helps me argue for the poems Baraka has been writing since *Black Art* as poems, not polemics with line breaks. His infamous poem "Somebody Blew Up America" makes use of all kinds of figures of speech—especially irony ("Who the richest / Who say you ugly and they the good lookingest."), even if ultimately those elements are funneled toward a particular (polemical) intention. Intention is perhaps closer

to *function* than *craft* because it involves a poem's purpose; it involves how the writer intends the poem to "function" for readers. (Perhaps craft should/does help one discover function and intention.) "Somebody Blew Up America" is a bad poem for me because it lacks *consistency* of craft/design, not because it lacks craft. It possesses a clear voice (Baraka Persona), but the articulation (construction) of voice is not necessarily independent of craft. It's a matter of which comes first, maybe.

At what point does craft (the principles of poetry) give way to voice (the sensibilities of imagination)? And vice versa: when does/ should the imagination (voice) give way to the principles (craft) that guide a reader through the poem? (Say, maybe it's called "craft" because it's what transports the language . . .) I'm thinking of folk like Wallace Stevens, Frank O'Hara, and Lucille Clifton. Aren't their best poems the ones that "match the rhythms of their strides," to adapt a Wally Stevens line? Shouldn't we be wary of any "principles" that flatten or normalize those rhythms? Shrug. I could go on, but what would I have to talk about tomorrow. I'm gonna call Renegade soon. Sooner or later . . .

Journal, Day Two

First off, sorry about that long-ass blog yesterday. Performance Anxiety. I plan to write less and less each day. Maybe just my name by the end of the week.

I jerked upright in bed somewhere around 6 a.m. today and blurted: "Chuck Norris!" to an empty room in an empty house. Maybe I thought someone was lurking about. All day I've been troubling myself with why it was Chuck Norris (and not Bruce Lee or Jim Kelly). He's a Republican, I think. And with each year more and more strange looking. An image of Chuck Norris decapitating

(dechoppitating?) a bad guy's head is among my earliest memories of drive-in movie nights with my parents. I assume my parents took me with them to see such things because they thought I'd forget them. They were partly right. I only remembered enough to constitute occasional nightmares; enough to constitute a worldview that is mostly dream. Do you too believe surrealism is often more real than realism? What was Plato thinking to distrust "reality" in the hands of artists?

I ask because I bought Anne Carson's *Economy of the Unlost: Reading Simonides of Keos with Paul Celan* along with me to Lewisburg. It's a terrific book. A mix of classics, history lesson, and philosophy, which I realize describes lots of her work. She shows us how poems are the most polymorphous/polytypic of literary forms: they can be or blend the techniques of journalism, fiction, theatre, cinema, manuals, and on and on. (Where are the science fiction poems: automatons, cone-shaped rockets, women with three eyes, and men with none?). In a section called APATE (the art of deception), she says Plato "deplored poetry all the way back to Homer, [because] it cut words free from any obligation to reality." This may be a simplified translation of Plato (simplified by my hands, not Caron's, no doubt), but I'm drawn to questions of reality versus deception in art. Elsewhere in the chapter she says Gorgias, the sophist, believed the word that tricks you is more just than the word that does not. "Teachers like Gorgias and Protagoras alleged that the proper activity of words is not to describe but to deceive."

I said as an aside yesterday that there is a relationship between craft and function. A few questions: Does the political poet place function beside craft, if not before it? Is poetry directly engaged in political discourse deceptive? Are poems about personal subjects (family, gardens, sunsets) "benevolent" deceptions? *Baldwin said*

something like art is that which reveals the questions hidden by the answers,
so I figured I'd just ask, not attempt to answer. (Can a question deceive?)
I want to believe it's only "deception" when the artist lacks mo-
rality. Is all true/great/enduring art *moral art*? You ask, "What do I
mean by morality?," and I ask, "What does Plato mean by 'reality'?"
Is reality (which is not the same thing as science) more subjective
than morality (which is not the same thing as religion)? These are
questions worth wrestling with—maybe just outside the door of
poetry.

Really, reading Anne Carson (and this writer Rebecca Solnit.
Check out *Wanderlust* and *A Field Guide to Getting Lost*), I am over-
come with the wish to weave such questions into the fabric of a
poem. Poems can hold anything. I also want to poke Plato in the
eye and cut the imagination free of any obligations to reality. Hell,
reality makes me want to do it! And yet, I know catchphrases like
"Weapons of Mass Destruction," "War on Terror," "Commander
and Chief," "Home of the Free" magnify the problems with "cut-
ting words free." Are politicians the poets Plato was thinking of?
The word that tricks you is not always just, Gorgias. Language is
deceptive, yes. It is only occasionally a deception. Here's Stephen
Colbert twisting the twisted in on itself at a Knox College com-
mencement address. A deceptive deception:

And when you enter the workforce, you will find competition from
those crossing our all-too-porous borders. Now I know you're all
going to say, "Stephen, Stephen, immigrants built America." Yes, but
here's the thing—it's built now. I think it was finished in the mid-'70s
sometime. At this point it's a touch-up and repair job. But thankfully
Congress is acting and soon English will be the official language of
America. Because if we surrender the national anthem to Spanish,
the next thing you know, they'll be translating the Bible. God wrote

it in English for a reason! So it could be taught in our public schools.

So we must build walls. A wall obviously across the entire southern border. That's the answer. That may not be enough—maybe a moat in front of it, or a fire-pit. Maybe a flaming moat, filled with fireproof crocodiles. And we should probably wall off the northern border as well. Keep those Canadians with their socialized medicine and their skunky beer out. And because immigrants can swim, we'll probably want to wall off the coasts as well. And while we're at it, we need to put up a dome, in case they have catapults. And we'll punch some holes in it so we can breathe. Breathe free. It's time for illegal immigrants to go—right after they finish building those walls. Yes, yes, I agree with me.

I'm out like Chuck Norris.

Journal, Day Three

What does the internet and its boundless resources mean to the poet compelled to turn information into imagery and ideas? Maybe this could describe all poets. Surely someone somewhere has discussed this question once or twice. Last fall when my poet-wife entered a Library Science master's program (in part to get away from the goo attached to living as a poet and teacher of poetry), one of our first discussions/debates concerned what the Internet meant for the library. I argued that the library was on its way to becoming a kind of museum; that its role as a locus for information was being replaced by the internet. She disagreed, not only because of the class presumptions I was making (not everyone can afford computers and Internet) but because I had no idea what was going on in today's libraries. I was/am mostly at the keyboard. True, true, but I'm on a tangent here. (Plus I lost the debate.)

I find the kinds of information online both overwhelming and endlessly interesting. Today when a student read a poem framed by a fairly obscure religious reference, another student admitted to using Wikipedia to learn about it. I and half the class chimed "Ahh, Wikipedia," while the other half stared blankly.

[Commercial break: Students invariably ask how important it is to know all of a poem's references and allusions. My response: one can admire/appreciate a portrait (for its brushstroke, composition, color, etc.) without knowing who the subject of the painting is. If the painting is no good, knowing who the subject is doesn't make it better; if it is good, knowing the subject enriches the experience.]

Maybe the ease of research in the age of Google means everyone should be informed. Everyone should know everything. This reminds me of Ralph Ellison's 1978 essay, "The Little Man in Chehaw Station: The American Artist and His Audience," which says the nature of America is such that there will always be someone in the room who knows more about your subject than you. Remember the bar scene in *Good Will Hunting*, where Matt Damon's character (janitor, genius incognito) corrects and thoroughly embarrasses some smug Harvard PhD student about an obscure theory of economics? Well, all through that movie, Damon is playing the little man (albeit a romanticized version of the little man, because I can't believe a "genius" who looked like Matt Damon would ever be a janitor). Knowing Mr. Joel Dias-Porter (a.k.a. DJ Renegade) I have no trouble believing the idea of the little man. Ellison says the little man is an inescapable figure because he (or she) is a product of "America's social mobility, its universal education, and its relative freedom of cultural information." Though I can't get with the holey optimism of "social mobility" and "universal education" (Ellison must have had his eyes closed when he said it), it's not hard

to believe "cultural information" is freer than ever. (I can hear my wife saying my eyes are closed too.) Will the Internet proliferate little men and women, America becoming one big Chehaw Station? I hope so.

A student trying to get on my good side today suggested I was some sort of intellectual. I'm no intellectual. Just a nosey bean with a mild obsessive-compulsive disorder and access to the Internet. How to be as smart if not smarter than Terrance in eight easy steps:*

1. Wikipedia: a cooperative free-content encyclopedia at http://www.wikipedia.org. 1,176,523 articles and counting.
2. *Science and the City* (http://www.nyas.org/snc/podcasts. asp.), where you'll find podcasts featuring interviews, conversations, and lectures by noted scientists and authors.
3. David Byrne (http://journal.davidbyrne.com). Visiting this site will also make you as smart or smarter than David Byrne.
4. Phrontistery (http://phrontistery.info/index.html). From the site: "If you're looking for an online dictionary, a word list on a given topic, or the definitions to rare and unusual words, the Phrontistery is for you." There is a 15,500-word dictionary of obscure and rare words.
5. Ron Silliman's blog (http://ronsilliman.blogspot.com). It exceeded 750,000 visitors this week and is as compelling for Silliman's ideas as it is for the poets, wannabe poets, sycophants, and weirdoes who respond to his posts. Plus you will be a hit at the next Language Poets Party or Charles Olson Fan club meeting.

* Results may vary.

6. Slate (http://www.slate.com): today's papers: A daily
 summary of what's in major US newspapers. The contrasts
 in headlines covering the same information are often
 unsettling. Example: the *New York Times* says: "Bush Takes
 Steps to Ease Increase in Energy Prices" where the *USA
 Today* says: "Effect of Gas Plan May Be Limited" and the
 LA Times says: "Bush's Proposals Viewed as Drop in the Oil
 Bucket."

7. Boing Boing (http://boingboing.net). Simply described as "a
 directory of wonderful things." From today's page: "How to
 turn a $60 Linksys router into a $600 super-router"; a video
 of a shredding machine violently "deconstructing" a BMW;
 a World Cup played by ants; everything you ever wanted to
 know about Victorian London.

8. Step 8 will remain undisclosed, Sucka.

Journal, Day Four

"You may not like my stuff, I'm kind of a nature poet," a student
said at the beginning of our conference today. I instantly won-
dered which of my anti-nature poems she'd been reading. "A good
poem is a good poem," I said even as I wondered who decides the
"kind" of poet we are to be? The poet Bob Wrigley lives in rural
Idaho (all of Idaho is rural) and often writes about animals. His
book titles, for example, include: *Lives of the Animals* and *Reign of
Snakes*. And the big clue: in his author photos he's often outside!!
Still, I knew I'd made a mistake calling him "a nature poet" to
his face once. I backtracked: "Oh yes, there's a lot of other stuff
in your poems, my bad." Fitting Wrigley on the Nature shelf is as
problematic as fitting me on the—actually I don't know the name
of my shelf . . .

Can the poet claim a style and still claim to resist categorization? Should a poet bother claiming a style? (No.) If categories are unavoidable, does it make more sense to categorize the style of the poem and not the style of the poet? Writing nature poems does not make one a nature poet, just as a poet who experiments is not necessarily experimental. It makes sense that a poet would resist these labels, if only because they imply one's approach to poetry is fixed.

The wish to categorize may be an inherent part of reading and comprehension. Maybe it's bound to a wish for clarity—a clear sense of order (organization/direction). More often than not, categories lead to presumptions. The easiest example would be the problems in reading a lyric poem as if it were a narrative poem. Since a poem rarely announces itself as narrative or lyric, a reader can be forgiven for making certain assumptions before entering a poem. But to exit a poem with the same assumptions is obviously a fairly limited engagement. What seems to be an effort to comprehend is often an effort to impose a narrow meaning or to strip meaning away. I'm thinking about the dynamics of the typical workshop, of course, but I'm also thinking about the broader implications of a fixed "standard of excellence" in art. Such an illusion of good and bad allows a reader to insist the problems are always with the poem and not, at least to some degree, with how the reader has read the poem. It is like listening to Bach and saying it's bad because it has no rap or guitars. Obviously, as a different style of music, it requires a different set of criteria.

The way we judge a "nature poem" should not be the way we judge what I've heard called an "urban poem." (Did you know "urban" replaced "inner city" which replaced "ghetto" which replaced "Black"?) I'd argue that even the criteria specific to a "performance poem" differ from the criteria specific to a "spoken

word" poem. Of course, such an array of styles means a reader is expected to constantly shift and mix perspectives. Not just from style to style but poem to poem. That's a good thing. Jay-Z has been mixed with the Beatles; Biggie Smalls has been mixed with Frank Sinatra—it is possible to value two very different things at once. No reader should want a poet to be one thing. No poet should want to be one thing, to have one style. This is why we're looking for the "urban nature poem" (I think Major Jackson's "Urban Renewal" poems come closest to such a thing). And we're looking for the child of Gertrude Stein and Billy Collins; the child of Lucille Clifton and Wallace Stevens. Imagine those children. Imagine their poems.

Journal, Day Five

Sometimes just after two writers meet and sometimes just before they separate the question, "What are you reading?" enters the conversation. In my imaginary city, all people greet and depart in this way.

Trying to make you fall in love in 5–6 lines . . .

> *Speaking indifferently to him,*
> *who had driven out the cold*
> *and polished my good shoes as well.*
> *What did I know, what did I know*
> *of love's austere and lonely offices?*

You best know this one, but if you're just learning to read: Robert Hayden's "Those Winter Sundays."

———

I love this body, this
solo & ragtime jubilee
behind the left nipple,
because I know I was born
to wear out at least
one hundred angels.

From Yusef Komunyakaa's "Anodyne." Let it burn a trail across your scalp.

———

Love is a word, another kind of open—
As the diamond comes into a knot of flame
I am black because I come from the earth's inside
now take my word for jewel in the open light.

From Audre Lorde's "Coal." Four lines, but what more do you need?

———

Sometimes I like to think about the people I hate.
I take my room at the Hate Hotel, and I sit and flip
through the heavy pages of the photographs,
the rogue's gallery of the faces I loathe.
My lamp of resentment sputters twice, then comes on strong,

From Tony Hoagland's "Hate Hotel." Had there been time, we might have talked about Hoagland's PERSONA poem, "The Change."

———

I want the water to go on without its bed.
And the wind to go on without its mountain passes.
I want the night to go on without its eyes
and my heart without its golden petals;
if the oxen could only talk with the big leaves

From Frederico García Lorca's "Ghazal of the Terrifying Presence." Its lesson: Mystery is not ambiguity.

———

The beekeeper's daughter. With a sack full of bees.
She'll come in, quiet, from the orchards, figs in her shawl
and gather the bees from their white boxes.

And Professor Garcia, the music instructor. With bare hands.
In his empty house, he'll play his piano and each note
will be one of my fingers in a jar.

From Joshua Poteat's "People Who'd Kill Me (Spain, 1939)" (from *Ornithologies*). We love some of the same people, Joshua.

———

God is the bony man leading the goat-cart
full of garden vegetables, giving them away
to the villagers—cauliflower to the widows,
pole beans to the mischievous boys, cucumbers

to the balding attorneys, potatoes to the gamblers,
turnips to the housewives, middlings to the chickens.

From Maurice Manning's "Dramatis Personae" in *Lawrence Booth's Book of Visions*. One of the best books in the Yale Younger Poet series in the last decade. I'm almost afraid to tell you how good it is . . . Poems that cannot be read, only reread.

———

I sleep. I dream my feudal fruitless wars.
I dream of peace the dovewhite dawn explodes.
Man is a weapon of mass destruction.
I know this now. Man's the best rhyme for war.

From Todd Hearon's "What Is Man That Thou Art Mindful of Him." Who is this dude? You can find the whole poem in the Slate poetry archive: http://www.slate.com/id/2137014/?nav=navoa

———

Five non-poetry books:

- *Oreo* by Fran Ross (she was one of Richard Pryor's writers)
- *So Long, See You Tomorrow* by William Maxwell
- *In the Break: The Aesthetics of the Black Radical Tradition* by Fred Moten
- *Condition of the Spirit: The Life and Work of Larry Levis*, edited by Christopher Buckley and Alexander Long
- *The Grand Hotels (Of Joseph Cornell)* by Robert Coover. A slim imaginary book you should read once a week for at least

a year. If I were to try excerpting it, I might quote from the "Grand Hotel Nymphlight": "Although Childhood is the source and model of all architecture, grand hotels included, the Grand Hotel Nymphlight is the only one known to be specifically devoted to 'the child within,' as the hotel brochure puts it."

A last thing about craft and voice. In *Night,* A. Alvarez says maybe all aesthetic judgments boil down to "not the rightness of form, since forms change . . . but the rightness of feeling."

Originally published on poetryfoundation.org, June 5–9, 2006.

Muscularity and Eros

On Syntax

CARL PHILLIPS

As far as I can tell anymore, all that poetry is at the end of the day is patterned language. The relationship between pattern and the meaningful disruption of that pattern gives poetry the muscularity required to become memorable. The careful calibration and manipulation of this relationship is, if not entirely the definition of what seems to be meant by "the art of poetry," then a very large part of that definition—all the rest being vision which, of course, isn't parsable: when I encounter vision, I recognize it. Recognition is a form of respect. Respect is not analysis. Neither is homage.

What do I mean by muscularity. I mean that a poem is a bodily thing. Robert Pinsky has spoken of the poem as bodily in the sense that it is made up of words that we hold in the mouth and release from it, all engineered by breathing; so, to read aloud is a physical engagement with the poem, in the course of which we make language itself physical. But I mean something more than this, namely, that the poem is itself essentially a body, comprised of various parts

that work in various relation to one another—which could also be said, I know, of machines, but because poems are written by human beings, these relationships are unpredictable. A successful poem will never feel robotic or mechanized. It feels felt.

What do I mean by a poem as a body? Think of raising your palm to your face and then turning the palm outward. To do so, various muscles shift in relationship to other muscles, tendons and ligaments serve as pulleys, the elbow bends, the hand rises, the hand turns at the wrist, but we see none of what allows this to happen. Just so with a poem. We feel that something has happened; there's movement, things change, and we're not quite sure how. But just as the body's actions can be explained, so can a poem's actions and the effects that follow.

It all comes down, I believe, to the patterns established and disrupted within the poem at the level of, in particular, syntax, grammar, tense, point of view, sentence length, line length, and sound—which includes rhyme, meter, assonance, and alliteration. To begin somewhere, here's Elizabeth Bishop's well-known "One Art":

> The art of losing isn't hard to master;
> so many things seem filled with the intent
> to be lost that their loss is no disaster.
> Lose something every day. Accept the fluster
> of lost keys, the hour badly spent.
> The art of losing isn't hard to master.
> Then practice losing farther, losing faster:
> places, and names, and where it was you meant
> to travel. None of these will bring disaster.
> I lost my mother's watch. And look! my last, or
> next-to-last, of three loved houses went.

The art of losing isn't hard to master.
I lost two cities, lovely ones. And, vaster,
some realms I owned, two rivers, a continent.
I miss them, but it wasn't a disaster.
—Even losing you (the joking voice, a gesture
I love) I shan't have lied. It's evident
the art of losing's not too hard to master
though it may look like (Write it!) like disaster.

It is, of course, a villanelle, which is to say it has a fixed pattern, in terms of rhyme, in terms of the repeated lines, and in terms of meter, each line a pentameter—five-beat—line. The poem presents itself, we might say, as utterly regular. And it is, when it comes to stanzaic and rhyme pattern. Another structuring element adhered to in a fairly regular way is the steady alternation of grammatical mood—i.e., we shuttle steadily between statements (declarative mood) and commands (imperatives). But in concert with these forms of regularity, there's also a breaking of regularity at work—a necessary breaking, since the risk of too much regularity (or pattern) is monotony. One element that refuses to stay static is point of view. For three stanzas, everything is delivered in the third person, at least explicitly—the imperatives imply the second person, but not so intimately as what will occur later. At stanza four, the entrance of the I makes what was academic personal. And it immediately boosts the poem's authority: we believe the statements because the speaker speaks from personal experience. But what creates the visceral turn in this poem, at the final stanza, is the turn to the more intimate second person; we are pushed from the personal I into the intimacy of the speaker's relationship to an individual you, a you associated with the only abstract things that have been lost ("the joking voice, a gesture/I love")—which is to

say, there's a shift in pattern at the level of images, as well, from concrete (for five stanzas) to abstract.

A third shift at the final stanza is that its first sentence is the only one in the entire poem that opens with a dependent clause—it relies on our learning the subject of the sentence—I—to make sense. This is the only sentence, then, where the I is not the starting point—i.e., the self is held back, foregrounding the lost beloved. This is the work of syntax, which allows us to move words/clauses into more than one position. To be consistent, Bishop could have said, "I shan't have lied, even losing you." Syntax offers a choice—and the choice makes all the difference. The you receives emphasis, syntactically eclipsing the self, suggesting a vulnerability to the self, and in a sense enacting how haunted the self is: she has lost the you concretely, but is haunted abstractly (voice, gesture). That is, she can't forget.

What happens at the opening of stanza six is an example of pattern being *meaningfully* interrupted. The shift to the you and to abstraction occurs precisely at the moment when the speaker shows what she hasn't earlier: vulnerability. The lingering over the gesture and voice, something that the speaker still loves (present tense) after losing the you, suggests that she has not reconciled herself to this particular loss. Which gives to the final repetition of the line about the art of losing a poignancy it didn't have before. To go back to the raised arm, we might say that this poem is, stanza by stanza, a steady raising of the hand up to the face; then, at stanza six, the hand turns palm outward, as if to ward away what's not wanted, "don't hurt me." This is what I mean by muscularity, an interchange between pattern and what isn't that pattern, the calibration of that interchange so that, in terms of timing, the musculature of the poem shifts when something shifts in the poem both emotionally and psychologically. The effect is of *feeling*, not thinking. The speaker says what she says, but the *prosody* tells us what she feels. The mus-

culature of the poem is what triggers this feeling. Meanwhile, as the surface patterning of the poem—the villanelle form—remains constant, the sentence-patterning within the poem (again, point of view, grammatical mood, and syntax) is in motion. The tension between this motion and the surface stillness is, to my mind, what gives the poem resonance, that quality that makes the poem linger beyond where it ends on the page. It has resonance the way bodies have resonance, the way machines do not.

Robert Hayden's everywhere-anthologized poem, "Those Winter Sundays," doesn't hide its subject—the poem tells us straight out that no one appreciated a father who worked hard for his family:

> Sundays too my father got up early
> and put his clothes on in the blueblack cold,
> then with cracked hands that ached
> from labor in the weekday weather made
> banked fires blaze. No one ever thanked him.
>
> I'd wake and hear the cold splintering, breaking.
> When the rooms were warm, he'd call,
> and slowly I would rise and dress,
> fearing the chronic angers of that house,
>
> Speaking indifferently to him,
> who had driven out the cold
> and polished my good shoes as well.
> What did I know, what did I know
> of love's austere and lonely offices?

"No one ever thanked him," "speaking indifferently to him," "what did I know/of love's austere and lonely offices" (i.e., a fa-

ther's familial responsibilities)—all of these tell us what the poem is about. The poem's musculature *enacts* what the poem is about and makes us feel it. The subtler instance of this is at the level of syntax. Reminiscent of the final stanza of the Bishop poem, the only two sentences in which the father is the subject foreground [____] the sentence with a dependent clause, in both cases a clause indicating time. "Sundays too my father got up early" achieves two things through its syntax. The opening of the sentence with "Sundays too" emphasizes the time—highlights it, by putting it first—that the father *even* did this on Sundays, which implies that he did this every other day as well: there was no respite from labor. And by opening with time, the sentence contextualizes the father within time, he is in a sense subordinate, in terms of where he appears in the sentence, to time itself, a subtle way of pointing to the fact of mortality, of the father's especially. A similar subordination to time comes at the second stanza, "When the rooms were warm, he'd call." Again, time comes first; this syntactical arrangement also speaks to a tenderness or care on the father's part: lest anyone be cold, he only calls out when it's warm for others. So, on one hand, the syntax in both instances speaks to the father's character—ever-working, tender—and, on the other hand, the subordination of the father, syntactically, besides positioning him within time, enacts and mirrors the family's indifference to him; he's an afterthought, of sorts.

Stanza one also speaks to this indifference—and enacts it—via sentence length and via sound. Note that this stanza consists of only two sentences. The first one is four and a half lines long and is the one that describes the father's labors. It's immediately followed by a half-line-long sentence whose brevity is thrown into stark relief, after the longer, more detailed sentence with which the stanza opened. It's also the sentence that announces

indifference—thanklessness—in response to the father's labors. At the sentence level, we see everything the father puts into the household side by side with the next-to-nothing he gets back. To put it another way, the ratio of labor to gratitude is played out via sentence length.

This is reinforced sonically as well. Look at the music of the opening sentence. We have the string of rhymes: "clothes" and "cold"; "blueblack," "cracked," "hands"; "ached," "labor," "weekday," "blaze." We have alliteration: "blueblack," "cracked," "ached," "week"; "weekday weather"; "banked," "blazed," "blueblack." There is none of this in the sentence that follows. No rhyme or alliteration. The word "thanked" sounds briefly musical, but that has entirely to do with its rhyming with "banked" from the previous sentence. What music it has depends on the father, on the sentence by which the father is represented.

And yet, if this poem were merely about indifference to the father's work—it if were merely a narrative of that—I don't think the poem would have resonance. It's the poem's final two lines that shift everything. That's where the speaker moves from statements about his role within the situation ("I'd wake and hear," "I would rise and dress") to a question about what he understood of the situation. The poem shifts to a space of vulnerability—the speaker seems to say "my indifference came from ignorance, therefore I'm not to blame," or "I'm not to blame, yet I feel guilty," or "why should I feel guilty, if I'm not to blame"—any, and all, of these. It's not clear. What is, is that we've moved from the declarative mood to the interrogative, from stability to open-endedness, un-answeredness. We also encounter here the poem's only instance of anaphora, the repetition of the phrase "what did I know," a repetition that connotes, variously, pleading, defensiveness, despair. The combination of the grammatical shift and the sudden appearance of

a nowhere-else-seen rhetorical device (anaphora), pitched against the steady declarative mood of the rest of the poem, is the catalyst for what again feels visceral at the poem's end; the emotional register changes, from meditative examination of the exterior to a haunted interrogation of the self's interior. It feels like stumbling into unexpected regret, which is to say, this is *also* what the poem is about.

Why don't we talk about poems in this way more often? As living things made by living beings, as assemblages of parts working in various combination to convey both thought and feeling? As bodies, with a body's ability to betray the feeling beneath language, even as we will tell a friend sometimes that we're doing fine, but what the friend sees is that our hands are shaking, or our eyes are watering, as if we've either just stopped crying or we're about to. So the shifts toward the end of Bishop's poem show an emotion that belies the speaker's otherwise calm. So the changes in Hayden's poem reveal a sense of personal culpability that the detached delivery elsewhere had seemed to suppress.

Not that it's always about betrayal. Another thing that prosody does is confirm or reinforce—just as, say, blood pressure can show that we aren't as calm as we seem on the surface, but it can also confirm our outward calmness. My sense is that it's this prosodic interplay that in almost every case gives feeling—physicality—to what would otherwise just be statement. The sense of imbalance, when it comes to the father's work in "Those Winter Sundays," versus the thanks he got for it isn't apparent in the statements themselves—*how* this is stated makes us feel the imbalance, and engage with it ourselves; we spend much more time—and pleasure—inside the first sentence; the second sentence all but disappears beside it. To read that first stanza is to have experienced, through feeling, the poem's opening argument.

Lest it seem that this approach only works with poems prior to the twenty-first century, here's an excerpt from Tommy Pico's book-length poem, *IRL*:

> *I'm scared*
> *of watching movies*
> *under a down comforter*
> *in the summertime,*
> *w/the undercurrent of AC* 5
> *Being squeezed every now*
> *n again so good*
> *by Muse who breathes*
> *deep, but barely knows me.*
> *Don't fall in love Don't fall* 10
> *in love Don't fall in love*
> *with Muse, duh! Muse is*
> *embodiment of abstract*
> *concept: Art, dance,*
> *astronomy, drama, heroic* 15
> *poetry, security, good/god, edible*
> *underwear, pepperoni pizza, Jim*
> *Beam. You touch*
> *his shoulder and he*
> *scoops. Stab. You can't hold* 20
> *Muse because yr*
> *the side piece. Art is Muse's*
> *main squeeze. It's hard*
> *enough just not being*
> *muserable I had a* 25
> *vision of love You can't*
> *own Muse. Muse pwns*
> *you Surrender implicit*
> *in yr relationship. When Muse*
> *is done, Muse leaves. You* 30

are in a shawl by the fire-
place, rocking alone
again.
It's important to be alone
again. 35
Just what is so scary abt
the cave? I . . . I can hear
my heart beating in there
and I don't like it.

Pico's poem is written as an extended text message, as the title might suggest. So phrasing is likely to be clipped and to employ abbreviations where possible; at times punctuation is missing, or the system changes. For example, a period occurs at the end of most sentences here, but in a few cases the occurrence of a sudden capitalized word means a new sentence has begun, though no period suggests an earlier sentence has ended.

This excerpt concerns the unbalanced relationship the speaker has with Muse, his code name for his latest romantic crush. The speaker fears getting intimate with Muse because he knows Muse is only loyal to art, not to the speaker. This doesn't stop the speaker from falling in love anyway, then having to experience the usual abandonment, which leaves him to another fear—of being alone with himself.

That's what the poem says. For me, though, it's Pico's manipulation of line breaks that makes me feel it. Most of the lines are enjambed, but how they're broken changes across the poem. The first five lines are broken in such a way that each line contains a grammatical unit intact—each makes sense on its own. "I'm scared" gives us the state of mind, then each subsequent line (of these five) is a prepositional phrase that fills in the context or conditions of the speaker's fear. The lines are broken so that each line is an easily parsed piece of the sentence's overall information.

Look how this changes at line six. First of all, we're in a fragment—already less stable than a sentence—and, secondly, each line ends in such a way that we can't linger; we're forced, grammatically, to go to the next line for grammar to resolve itself. This adds both momentum—speed—and instability, compared to the opening sentence. What that sentence's prosody suggests to me is that stability is required to offset the fear. What the following fragment tells me is that instability enters any scene hand in hand with Muse. The speaker exhorts himself not to fall in love, but the poem just then tumbles into steady enjambment, almost every line broken at a point that requires immediate descent to the next line for grammatical closure—we fall, as it were, down the page. Our reading is the enactment of the experience being described. To accentuate our inability to pause at a line break, the poem begins, at the exclamatory "duh!" of line twelve, to employ increasingly a full stop in the middle of the line:

> underwear, pepperoni pizza, Jim
> Beam. You touch
> his shoulder and he
> scoops. Stab. You can't hold
> Muse because yr
> the side piece. Art is Muse's
> main squeeze. It's hard
> enough just not being
> muserable I had a
> vision of love You can't
> own Muse. Muse pwns
> you Surrender implicit
> in yr relationship. When Muse
> is done, Muse leaves. You

This strategy is abruptly abandoned as soon as Muse exits the scene, and we return to stability—what sounds first like refrain with the quatrain whose lines end, not coincidentally: "alone," "again," "alone," "again." Then, in answer to the question "Just what is so scary abt/the cave?," we return to the kind of lineation that opened this excerpt—these last three lines all break where the grammar breaks. We're returned to stability of line—again, as if to offset fear, what the excerpt opens and closes with. We might say that fear is the frame that contains any contact with Muse. That's what the prosody says, *in addition to* what the poem says.

There's much that could be said here, too, about Pico's mashup of "high" and "low" diction, or about his frequent employment of chiasmus or near-chiasmus, each of the following lines containing frames:

Don't fall in love Don't fall	10
in love Don't fall in love	11
with Muse duh Muse is	12
own Muse Muse pwns	27

But enjambment is the main prosodic tool employed here in the service of conveying meaning that sometimes reinforces statement and sometimes contradicts it. Reinforcement and contradiction are forms of gesture. This is how gesture—which is muscular—works. This is also how the tone with which we say a thing works. Tone, too, is muscular.

———

For many years I've spoken of an erotics of syntax without writing it down anywhere, apparently, what I meant by it. Here's what I mean.

We recognize pattern only after having been conditioned to it long enough to see it as pattern, a comfort, which we miss when we're abruptly released from it. A poem is a system of patterns by which information gets delivered in a manner specific to each poem. Another way to say it is that pattern is a system of restraint and release: we're held by pattern, then periodically released from it. Via the poem, the poet controls our passage down the page both in terms of what we get to know and how we know it. To this extent, poetry is not just a bodily thing but an erotic one. As with eros, the first aim is to get another's attention; after that, there's the business of sustaining attention, which can mean providing enough mystery to arouse curiosity, but not so much mystery that curiosity gets displaced, instead, by frustration. Of all the elements that a poem comprises, syntax is the most erotic, for syntax is precisely what allows information to be withheld and unexpectedly delivered; grammar lacks this flexibility—this athleticism—this power of manipulation.

I suppose the idea of syntax as erotic originated from my thinking that a sentence can be very straightforward or it can take us on a bit of a journey—and for whatever reason, the analogy of extended foreplay came to mind, with the sentence's eventual resolution as a form of climax. But perhaps that narrows or limits what I mean about syntax. In its ability to determine when and where information gets delivered, syntax is a system of privilege or engages in such a system, i.e., it privileges one piece of information over another piece, ideally in service of how we are meant to understand and experience (the two are different) a poem's content. But in this ability to create hierarchies of information, syntax is concerned with power (as is eros, of course), which is to say at some level syntax is always more than just erotic; it's by definition political.

Of course, the chief role of this manipulation of syntax is to serve the poem's artistic purposes and whatever argument it might have.

Here's Shakespeare's Sonnet 73:

> *That time of year thou mayst in me behold,*
> *When yellow leaves, or none, or few do hang*
> *Upon those boughs which shake against the cold,*
> *Bare ruined choirs where late the sweet birds sang;*
> *In me thou seest the twilight of such day*
> *As after sunset fadeth in the west,*
> *Which by and by black night doth take away,*
> *Death's second self that seals up all in rest;*
> *In me thou seest the glowing of such fire*
> *That on the ashes of his youth doth lie,*
> *As the deathbed, whereon it must expire,*
> *Consumed with that which it was nourished by;*
> *This thou perceiv'st, which makes thy love more strong,*
> *To love that well, which thou must leave ere long.*

The first line could have been phrased in at least three other ways:

> *Thou mayst in me behold that time of year*
> *In me thou mayst behold that time of year*
> *In me thou mayst that time of year behold*

All that's required, grammatically, is for the phrases "that time of year," "in me," and "thou mayst" to remain intact; but they can be arranged, via syntax, in various ways. So why *this* way? Shakespeare's arrangement makes time the entry point—not the lovers. And when we get to the lovers, the thou comes first, then the

speaker. Paradoxically, the thou has priority over the speaker be-cause of youth; presumably, the speaker is closer to death, will soon be no longer—and this is because of the fact of time, with which the line began. Syntax here establishes for us the hierarchy of the poem: time triumphs over human life; youth triumphs over age by having more time left with which to resist mortality.

Line two makes similar use of syntax. Why not—meter aside—have said simply, "when yellow leaves do hang," and have omitted "yellow leaves, or none," and have gotten more quickly to the verb upon which the line's meaning literally hangs? One reason is that that space within which the verb gets withheld shows the speaker thinking: he at first aims for a period when leaves still have some color and are on the tree; then a moment of self-correction: no, when *no* leaves are on the tree. Then there's the realization that what's meant is an in-between time—the tree neither in full leaf nor bare, but a few leaves left. This juggling among subjects—the order in which information gets delivered—enacts the mind figur-ing out exactly what it means. Meanwhile, the syntax, by present-ing this information at a distance from what it modifies ("That time of year")—as opposed to

> *That time of year when yellow leaves, or none,*
> *Or few do hang, thou mayst in me behold*

gives the moment its own line, highlights it enough for us to see the idea of in-betweenness, a theme that structures all the rest of the poem: in quatrain two, we get the in-betweenness of twilight, between sunset and black night; in quatrain three, the in-betweenness of a glowing ember—not fire anymore, not ash, either.

Syntax doesn't have to mean inflected word order, though, or

dependent clauses. Look at this sentence that opens Hemingway's novel *A Farewell to Arms*:

> In the late summer of that year we lived in a house in a village that looked across the river and the plain to the mountains.

Like the Shakespeare sonnet, this sentence begins with time; in this case, time is a container, i.e., it contains all of the action of the rest of the sentence. Living occurs in a very specific concrete place (a house in a village, etc.), all of it contained by the abstraction of time. So time gets privileged, thanks to syntax. But syntax also determines the order of the rest of the sentence. Hemingway could have written "we lived in a house in a village that looked to the mountains across the river and the plain," for example. Or "in a village that looked across the river and the plain to the mountains we lived in a house." But the syntactical arrangement he lands on creates the cinematic effect of panning out: the house is contained by the village, the river hems in the village, the plain contains the river, the mountains mark where plain falls away.

So the vision keeps opening outward. And somewhere here it's implied that human life is small—lived individually within two things that are indifferent to human existence: time, and the natural world/landscape. "We lived" is the crux of the sentence—its action—but it's all but lost between time and a landscape that continues, literally, long past the fact of human life. A very simple sentence, but the syntax allows the novel to open with some implications that will resonate for the next nearly three hundred pages.

So syntax doesn't have to be overly complex or involve an especially long sentence. Greater length does, however, increase the sentence's opportunities for muscularity, as in the second sentence

of Sharon Olds's "Of All the Dead That Have Come to Me, This Once." Here are the first two sentences:

> *I have never written against the dead. I would*
> *open my*
> *shirt to them and say yes, the white*
> *cones still making sugary milk,*
>
> *but when Grandfather's gold pocketwatch*
> *came in by air over the Rockies,*
> *over the dark yellow of the fields*
> *and the black rivers, with Grandmother's blank*
> *face pressed against his name in the back,*
>
> *I thought of how he put the empty*
> *plate in front of my sister, turned out*
> *the lights after supper, sat in the black*
> *room with the fire, the light of the flames*
> *flashing in his glass eye*
> *in that cabin where he taught my father*
> *how to do what he did to me, and I said*
>
> *No.*

Olds's stanza breaks alone highlight the musculature's turns: "but when" . . . "I thought" . . . and then the final turn of "I said//No." But muscularity is also at work in how Olds extends the material of each of the stanzas. Essentially, the second sentence says: when the watch arrived, I thought of the behavior of the grandfather it once belonged to, and I refused all of it. But the extended second stanza gives strange agency to an inanimate

object and charts its pilgrimage and provenance; meanwhile, the extended third stanza adds layer upon layer of disturbing memories of the grandfather—the syntax of listing, the movement from the flames to the eye to the cabin to the subordinate clause that speaks to abuse without ever mentioning it—all of this creates suspense, yes, but also seems to enact the emotional buildup toward refusal, anger: the speaker finds an agency that had once been lost to her.

Syntactic work can be brief, though, as well, and not associated with emotion, necessarily. In Ed Skoog's "Waves," syntax creates an arrangement of information that becomes itself an implied meditation:

> I combed my mother's hair
> when she could no longer speak.
> My son, almost helpless,
> drifting out of the sky
> into sleep's tall waves,
> reaches out and combs
> my hair. I don't speak
> by his low bed, a lamb
> with batteries stirring
> an ocean between us.

It could have opened this way:

> I combed my mother's hair
> when she could no longer speak.
> My son reaches out and combs
> my hair. He's almost helpless, etc.

This arrangement immediately would have brought to the fore a parallel: just as I combed my mother's hair, so my son combs mine. Which would be perfectly fine, but it's a little easy, to my mind, and risks seeming sentimental. In the poem as actually written, the information works like this:

$$I \rightarrow mother \rightarrow helpless/no\ speech$$
$$\downarrow me \leftarrow helpless \leftarrow son(not\ speaking)$$

Via the act of combing, we are directed from the speaker to the speaker's mother, who is associated with the inability to speak, a form of helplessness here. This leads straight to the speaker's son, immediately associated with helplessness, combing the hair of the speaker, who is associated with not speaking, recalling the mother who doesn't speak—but because she can't, not because she chooses not to. Yes, in this arrangement, son and speaker (the son's parent) are paralleled. But so are the speaker and the speaker's mother. And so are the grandson and grandmother. They are genetically related, but it's also helplessness that binds them. Meanwhile, the syntax that allows for the son to be so removed from the act of combing, in the second sentence, is where we get the information that seems to set up a conceit of the poem henceforward—drifting, which leads to waves of sleep, which will get reinforced by and echoed in the "ocean between us" with which the poem ends.

We might say that, in that second sentence, the syntax distances the combing from the son so as to prevent too easy an equation with the speaker's gestures; and it creates space within which the poem's governing image—the act of combing hair—gets balanced by marine imagery, which also allows us to think of hair in terms of

waves, of certain ocean waves known as combers, also of combing as something that people do, combing the beach, and that sea creatures do, combing the ocean floor.

Can syntax be relevant to a poet who works largely in fragments? Yes. But because fragments are grammatical units lacking one of two things required for a sentence—a verb and a subject noun—the fragments tend to be dependent on an understood subject noun or verb, which is the work not of syntax, but of grammar. Fragments require grammatical context; this they borrow—almost always—from the nearest preceding complete sentence. Here's Linda Gregg's "We Manage Most When We Manage Small," for example, which consists of six sentences and nine fragments:

> *What things are steadfast? Not the birds.*
> *Not the bride and groom who hurry*
> *in their brevity to reach one another.*
> *The stars do not blow away as we do.*
> *The heavenly things ignite and freeze.*
> *But not as my hair falls before you.*
> *Fragile and momentary, we continue.*
> *Fearing madness in all things huge*
> *and their requiring. Managing as thin light*
> *on water. Managing only greetings*
> *and farewells. We love a little, as the mice*
> *huddle, as the goat leans against my hand.*
> *As the lovers quickening, riding time.*
> *Making safety in the moment. This touching*
> *home goes far. This fishing in the air.*

We know that, in the first fragment, what Gregg means is "the birds are not steadfast," and likewise, "the bride and groom are

not steadfast either"—that is, we carry the verb and adjective of the initial sentence over to the two fragments, which themselves would have no clear meaning otherwise. Later, when we encounter "But not as my hair falls before you," we understand Gregg to mean "The heavenly things ignite and freeze, but not as my hair, etc." In this case, we simply see the fragment as an extension of the sentence, prevented only by punctuation from being an actual part of that sentence. This particular kind of fragment governs the rest of the poem.

But syntax can still be useful, even crucial, within the fragments. Perhaps the most striking instance here is in lines 2–3:

> Not the bride and groom who hurry
> in their brevity to reach one another.

Gregg could have placed "in their brevity" after "to reach another," emphasizing, by having it end the line, the brevity of the lovers. In the actual arrangement, though, the union of the lovers is literally interrupted by brevity—the syntax has a narrative of its own, then. The sentence doesn't speak to how love is thwarted by mortality, but the syntax does.

Notice the muscularity, apart from syntax, that manifests itself here as the steady but unpredictable interchange of complete sentence and fragment, an interchange that contributes to the poem's meaning. For me, the narrative at the level of sentence and fragment is that we are forever striving for a completeness that routinely breaks down; union, in the form of marriage in particular (and the end of a marriage is a large part of the subject of *Too Bright to See*, which opens with this poem), is one idea we have of completeness. The poem opens with the completeness—stability—of a sentence and immediately succumbs to fragment—instability. And it closes

in the same way. As if to say that this is the inevitable trajectory, no matter how hard the patterning within the poem tries to resist this trajectory, enacting our human refusal to believe we can't find, and hold on to, something like stability within union with another person.

Syntax accounts for the startling opening of francine j. harris's "suicide note #10: wet condoms." Note how the first line, syntactically, could have appeared at the end of the opening sentence:

> *Dear Blank,*
>> *If I start this off by saying he takes his wet condom when he*
>>> *leaves*
>> *then it's more about him, less about the desire for evidence,*
>>> *more about*
>> *trust, less about the edge of the mattress and the falling sky.*
>>> *less about*
>> *the moment the litany turns to shatter inside the overhead*
>>> *light. Or*
>> *the last time I saw my mother. more about a zygote in the*
>>> *toilet*
>> *or an infant he and I might have held. less about the neighbor*
>> *taking out the trash under my window, less about the burn*
>> *in my stomach.*

Notice, by the way, that the grammar of the first sentence goes on to govern almost all of the rest of the stanza, which is all fragments. So, for example, when we get to the first fragment, "less about the moment the litany turns," we understand that "it's" precedes it. In the case of "Or the last time I saw my mother," we plug in "it's" and "less about" from the preceding sentence. Again, this is the work of grammar.

But syntax accounts for arrangement; it's why the first sentence's material is arranged thus: it's more about A, less about B, more about C, less about D—a rocking between more and less, back and forth, is established: a parallelism. In its way, the sentence's regularity is comforting, because it's predictable. Here's where a meaningful disruption of pattern occurs. Tracking the instances of more and less down the page, we get the following:

A	B	C
more	about him	concrete
less	about desire	abstract
more	about trust	abstract
less	about mattress and sky	concrete/abstract
less	about the moment	abstract
less	about the last time	abstract
more	about zygote (or imagined infant)	abstract?
less	about neighbor	concrete
less	about burn in stomach	abstract/concrete

Going down column A, the drift is toward less-ness, with moreness rallying briefly, then succumbing. One translation is that there's a downward trajectory in terms of what things mean to this speaker (and/or what she seems to want to make them mean), i.e., things seem increasingly meaningless.

Part of how things mean, for human beings, is through sensory proof. What's concrete is clear; much blurrier, abstraction. When I look at column B, I find another pattern, a shuffling between concrete and abstract. In the first four instances, it's as if the desire is to contain

the abstract within the concrete (thanks to the particular syntactic arrangement of chiasmus, which creates a double frame of information); then abstraction takes over for two moments. At the zygote, it's hard to tell—is that concrete? The infant seems to be, until it's modified by "he and I might have held"—so it's hypothetical, abstract. One more instance of the concrete (neighbor/trash) and, finally, the containment of abstraction within the concreteness of the stomach. We might say, then, that the shuttling between what's knowable and what isn't is only resolved, for this speaker, by the containment of what's unknown within what is known. But—and—isn't that what it is to be a human being, with both the burden and boon of self-consciousness? Which is to say, harris's poem speaks both from an individual sensibility in an individual situation, but toward a larger, more shared experience.

Patterns like these—the sorts of patterns I've been thinking about throughout this essay—are always there to be found, but I don't want to suggest that this is how I read poetry. I read it for how it makes me feel, physically. I only started noticing certain patterns, and departures from them, when I wanted to understand *why* I felt as I did. Consciousness of these patterns isn't required to appreciate a poem. Any more than I need to understand that it's a particular chord change or combination that makes me want to cry at one part of a favorite song. But if I *did* understand, it would be a way to appreciate the musician's artistry.

And yet . . .

Is artistry the right word? At one level, I suppose it has to be, but artistry suggests to me a consciousness of what one is doing. But that isn't, in my experience, how poems get written. Rather, I just write my poems—and sure, there's revision, I might rearrange words to avoid redundant sound patterns or revise unneeded language away. But I don't consciously think about all the things I've discussed here.

I mentioned earlier the difference between what we say and how we say it—the how variously reinforcing or arguing with the what. As Solmaz Sharif has said, "It matters what you call a thing," since a word can imprison, can erase otherness, can also grant power. It matters, too, how the calling happens, *how* we say a thing—and most important, perhaps, is the priority we give to a thing, where we locate it, within a sentence. Those choices are the work of syntax, but of course the writer chooses how syntax will be used. I think it's fair to say poetry is always, at the level of prosody, confessional. It's a record of our method of saying a thing, and that method is governed by individual sensibility, by choices we may not consciously make, but we do make them. Possibly the most disturbing thing about prosody—but about syntax especially, because it involves choice—is its utter fidelity to our innermost—truer?—selves. We sing—and we are betrayed.

Originally published in At Length, 2018.

Going Back

—

Plot and Revision

Plotting the Plot

ELIZABETH NUNEZ

During the COVID-19 pandemic, like many of us forced to stay indoors, meeting family, friends, and colleagues almost exclusively virtually, I eventually became bored, and looking around for something to do one particularly dismal afternoon, I flicked on the TV. It was one p.m. Before COVID shut me in my home, it had never occurred to me to watch TV in the early afternoon. At that hour I was either teaching, planning what I was going to teach, reading, or writing. But there I was, nodding, considering taking a nap, and absentmindedly turning on the TV to lull me to sleep. *Lauren Lake's Paternity Court* was in session. I glanced at it, fully expecting that in a few minutes I would turn it off. A few minutes turned into half an hour and I found myself totally captivated by a TV show that in "normal" times I never would have watched. With every break for a commercial, I grew impatient, anxious to see the next segment. And when the show ended, I felt the satisfaction that the audience too must have felt that justice had been delivered in Lauren Lake's court. Of course, I told myself that that first afternoon was an aberration, that by the next day I would be back to my usual occupations. But the next day Judge Lake and her court pulled me in and I was unable to resist the siren call. For a whole week, it was so. No

one and nothing could pull me away from the TV at one in the afternoon. Eventually, happily, the sirens retreated and I was released.

What had kept me so engrossed? The answer is plot, the same technique in storytelling that had made it impossible for me to put down Shakespeare's great plays that I would reread through the years, eventually writing three novels inspired by them: *Prospero's Daughter*, for which I was beholden to *The Tempest*; *Even in Paradise*, inspired by *King Lear*; and more recently, *An Honorable Murderer, A Love Story*, to which I am indebted to *Othello*.

Anathema! my reader will say when I dare make comparisons between *Lauren Lake's Paternity Court* and Shakespeare's masterpieces. Anathema! The main medium of storytelling is language, and few have used language more poetically than Shakespeare. Yet for a week, I was enthralled, consumed by *Lauren Lake's Paternity Court*. How did Judge Lake do it? For starters, at the beginning of each episode, she informs the viewing audience of the problem to be resolved. It is always the same. A woman (mostly it is a woman) accuses a man of not providing financial support for her child. The man claims the child is not his. Who is telling the truth? We want to know. Lauren Lake has us in her hands and we keep on looking at the show to find out.

Let's compare Lauren Lake's technique to the unfolding of the plots of three of Shakespeare's great tragedies. How does *Macbeth* begin? Three witches are on the heath in Scotland near a battlefield. Soon Macbeth and his men come upon them. One witch greets Macbeth: "All hail, Macbeth! Hail to thee, Thane of Glamis!" The second witch says: "All hail, Macbeth! Hail to thee, Thane of Cawdor!" The third witch says: "All hail, Macbeth, that shalt be King hereafter!"

Well, there is nothing surprising in what the first witch said. Macbeth is the Thane of Glamis. But the second witch? Macbeth

isn't the Thane of Cawdor. But before Macbeth could dismiss the witches' prophecies as nonsense, here comes Ross galloping toward him. The Thane of Cawdor was killed in battle, Ross says, and the king plans to name Macbeth Thane of Cawdor. Now imagine what Macbeth is thinking. One out of two, predictions? Perhaps the third? His brain is spinning.

Soon King Duncan appears. He declares he plans to spend the night at Macbeth's castle. Now Macbeth's brain is spinning even faster. But will he actually do what we can guess he may be thinking? Will he find a way to get rid of the king so that he will become king and the third witch's prophecy will turn out to be true? We have to read on, go to the next scene and the scene after that to find out.

Let's look at *Hamlet*. The guards are patrolling the castle. There is word that Fortinbras, the prince of Norway, is coming to Denmark with his army to avenge the death of Fortinbras' father at the hands of King Hamlet. Fortinbras believes Denmark is vulnerable because King Hamlet has recently died. But the ghost of King Hamlet, dressed in full armor, appears and tells his son, Prince Hamlet, that he was murdered. "The serpent that did sting thy father's life / Now wears his crown," he says. The father commands his son to avenge his foul murder. What will Hamlet do? We have to read on, go to the next scene and the scene after that to find out.

Shall I give a third example? My novel *Even in Paradise* is based on Shakespeare's *King Lear*. Within minutes of the opening of Shakespeare's play, King Lear puts down his marker to his three daughters: "Which of you shall we say doth love us most, / That we our largest bounty may extend / Where nature doth with merit challenge." We have to read on, go to the next scene and the scene after that to find out what his daughters will do.

Anathema it may be to find any similarity between *Lauren Lake's*

Paternity Court and these three great plays by Shakespeare, but what is clear is that they all begin by giving the audience the problem and the characters who will be affected by the problem. In other words, they all provide the first important element of a good plot.

Plot, as we know, is not the same as story. I would be rich if I got a dollar for each time someone came up to me and claimed that they had an incredible story to tell that would make a bestseller. Unfortunately, time is against them, they say. Their lives are too busy, but if they had the time to sit down and write the story, well. . . .

Story is not the same as plot. Story is the event. My best friend murdered her husband. That is a story, but it would not make a bestseller if the teller does not know how to plot it.

Plot is the arrangement of events in a story to achieve a desired effect. A well-plotted story piques the reader's curiosity to find out what will happen next. *Pacing* is important. The writer will use transitions to move seamlessly from scene to scene, and, if necessary, from back story to present story. She will use *triggers* to prod the reader into wanting to know *why* the character acts the way she does. What are the character's *motives*?

When I was a young girl in Trinidad, my aunt used to take me and my siblings to the movies on Saturday afternoons. I am one of eleven children, and though not all of us were yet born or of the age to go to the movies, at least six of us were. My aunt, though generous, was not rich. She could not afford to pay for herself and eight children, two of whom were her own, to seat us in the main area of the cinema or in the balcony, but she could pay for us to sit in the pit. The pit was not unlike the area in the theatres of Shakespeare's time. We would sit on long wood benches, among the hoi polloi and the unwashed. Like Shakespeare's audience in the pit, we demanded to be entertained and if we were not, we would show our dissatisfaction. There were no live actors on our stage; ours

was a celluloid screen. It did not matter. We screamed warnings to the hero or heroine of the dangers that could befall him or her; we yelled at the villain and threw balled paper at him. We were merciless in our criticism if the motives of the hero and the villain were not abundantly clear, if we did not know what caused them to do what they did. And we were particularly angry if the ending did not conform to our expectations or to our prepubescent logic.

Shakespeare's actors, unfortunately, did not have the luck to be protected by a celluloid screen. They had to bear the insults of a dissatisfied audience that would sometimes throw rotten fruit at them in disgust. The audience wanted a play with identifiable heroes and villains who would engage them *emotionally*; they wanted conflicts, suspense, and, in the end, they wanted resolution, hopefully a bloody stage. They got all that and more with Shakespeare's tragedies.

Did I get similar thrills when I watched *Lauren Lake's Paternity Court*? Clearly there was nothing new about the cases to be adjudicated in Judge Lake's court. The problem was one that had tormented men throughout the ages, who, if uncertain of the fidelity of their female partners, were riddled with doubts about the paternity of their offspring. In medieval times before the knights went off to the Crusades, they demanded that their womenfolk wear a chastity belt. Yet here we are in the twenty-first century still enthralled by the same question, though certainly we, the audience, know that the "mystery" of the child's paternity can be solved in a matter of minutes. One swab of the cheeks of both the man and the child and, Abracadabra, DNA will give us 99 percent proof of paternity. Why, then, does the audience (there is a live audience for the TV show) not throw tomatoes at Lauren Lake? Why was I, a sophisticated reader of literature, not willing to turn off the TV? The answer? Because though we know the problem and the likelihood of the

ending, we want to know *how* the problem was solved. *Why* does
the mother think the man is the father of her child? *Why* does the
man think it is impossible for him to have fathered the child? What
are their *motives*? There will be evidence: photographs, witnesses to
collaborate the assertions of the defendant and the plaintiff, more
conflicts, and maybe downright lies. The audience will choose sides
and in the end Judge Lake will issue her verdict.

But, for all my curiosity, I soon got bored with *Lauren Lake Pa-
ternity Court* and by the end of a week, I was no longer interested in
the show. I had ceased to care for the characters. They were one-
dimensional, their lives reduced to the single focus on the paternity
of a child. Here is where I part with the similarities between the
plot of *Lauren Lake's Paternity Court* and Shakespeare's tragedies.

Plot is not simply about the clever arrangement of events in a
story. It is about how these events affect the character. It is about the
character's journey through these events. I reread *Macbeth*, *Hamlet*
and *King Lear* because Shakespeare engages my interest both emo-
tionally and intellectually with the characters. I care about them.
When I read *Macbeth* or see the play performed, I sympathize with
Macbeth for the temptations he confronts. Who has not been
tempted to break the rules for a chance for a dazzling future? So we
wonder: Will Macbeth be tempted to believe that the witches could
correctly predict his future? Will he act on that temptation? And
what about Hamlet? Why should I care for him? But Shakespeare
has given us a character who engages our empathy. Hamlet's mother
has remarried the very man the ghost, his father, has accused of
killing him. Will Hamlet do as his father asked? Will he avenge his
murder? And what of King Lear? We recognize, along with Lear's
advisers, the folly of Lear's decision. But we care about him because
he is old and he loves his daughters. But will his daughters take ad-
vantage of him? We read the rest of the play to find out.

This takes me to the other essential elements of plot, now that we know the problem to be solved and we care for the characters who will be most affected by the outcome. These elements are tension, conflict and resolution. Tension in the plot is what garners the reader's attention and conflict makes that possible as the fortunes of the character swing between hope and despair.

Let's take the children's story, *Cinderella*. I know that story by heart. It was told to me when I was a child; I read it when I learned to read; I told it to my son when he was a child and I told it to my granddaughters, and yet, when the play came to Broadway, I was as eager as my eight-year-old granddaughter to see it. At first when I entered the theater, I pretended I was there just for the sake of my granddaughter, certainly not for mine, but when I looked around at the audience, I saw there were many couples and groups of friends, all adults and none accompanying children. What makes *Cinderella* a perennial attraction to so many people regardless of their ages? Why do we continue to root for this girl though we already know how the story will end? The answer is the writer's (or the storyteller's) use of tension and conflict as she/he unfolds the plot.

As with any good plot, when *Cinderella* begins we are immediately presented with the situation confronting the main character. We see Cinderella poking the cinders of a dying fire in the fireplace. We can assume it is cold outside, but Cinderella is barely clothed; indeed, she is in rags. And who do we see standing behind her? The two stepsisters and stepmother, all nicely coiffed, dressed to the nines. Our emotions are immediately engaged. We feel sorry for Cinderella. We care about what could happen to the poor girl.

The storyteller is now ready to unwind a plot that will leave the listener/reader asking for more. What is going happen next? If we are reading the book, we eagerly turn the page so we can find out.

First, the town crier arrives. The prince is having a ball, he announces, and all the young ladies in the kingdom are invited. *Tension*: Will Cinderella's stepmother allow Cinderella to go? After all, she is a young lady who lives in the prince's kingdom. *Conflict*: Yes, it is true, based on what the town crier said, Cinderella is invited, but how can she go? She has no fancy clothes to wear to a ball. *Conflict resolved*. *Hope*: Cinderella's fairy godmother appears. She will give Cinderella fancy clothes. Not only that, she will give her a coach with footmen to drive her to the ball. *Tension*. *Hope in peril*: The fairy godmother gives Cinderella a warning. She must leave the ball by midnight or her fancy clothes will turn to rags, the coach to a pumpkin, the footmen to mice. The audience is captivated; we cannot turn away now. Will Cinderella return home before midnight? What could possibly prevent her?

More tension and conflict: We are feeling happy for Cinderella, hopeful that she will triumph over the malicious intentions of her stepmother and stepsisters. She has managed to get to the ball. More than that, the prince has fallen in love with her, but will he find out that she is not a princess but, rather, a poor village girl? *Tension*: The clock begins to strike the hour. With each strike we hold our collective breaths. The prince and Cinderella are dancing. Will Cinderella get away before the clock strikes midnight? *Conflict*: Cinderella gets away but barely on time. Her glass slipper falls off as she is running down the steps. *More tension*: The prince finds her glass slipper, but can he find her? What he sees when he comes to the door of the palace is a pumpkin and some mice and a girl in rags running away. *More conflict*: The prince sends the town crier to go from house to house with Cinderella's glass slipper to see whose foot it will fit. The town crier comes to Cinderella's house. Cinderella is there. But will the stepmother allow him to try the slipper on Cinderella's foot? *More tension*: Cinderella is in the kitchen, stirring

the cinders in the fireplace to make a fire. Will the town crier know she is there?

More tension: There's noise in the kitchen. The town crier hears it.

Climax or Crisis that begs for resolution: The town crier finds Cinderella. He puts the shoe on her foot. It fits.

Resolution: Cinderella achieves her desire. She is no longer poor. She marries the prince and they live happily ever after.

So there we have an engaging plot. First, the writer (teller) of the story gives us the situation confronting the main character. It helps that the character's name, Cinderella, provides a clue to her situation. She is stoking the cinders. Importantly, the writer (teller) engages us *emotionally*. The main character wants something, that is, the main character has a *desire*. We read the story because we want to find out whether the main character will achieve her desire. The writer holds our attention through tension and conflict until conflict rises to *crisis* that demands *resolution*. You will note that there is nothing unique about the story *Cinderella*. It is a typical rags to riches story. What is unique about it is *how* it is told, how the teller engages us with the plight of the main character, in other words, how plot is unfolded.

The first few lines at the beginning of a work of fiction are crucially important for a good plot. Here is how Toni Morrison begins *Beloved*:

124 was spiteful. Full of a baby's venom. The women in the house knew it and so did the children. For years each put up with the spite in his own way, but by 1873 Sethe and her daughter Denver were its only victims. The grandmother, Baby Suggs, was dead, and the sons, Howard and Buglar, had run away by the time they were thirteen years old—as soon as merely looking in a mirror shattered it (that was the signal for Buglar); as soon as two tiny hand prints appeared in the cake (that was it for Howard).

In three words Morrison gives us the problem: "124 was spiteful." 124 is a number. It is the number of a house. Merriam-Webster's Dictionary defines spiteful as "having or showing the desire to cause harm to someone; given to, marked by, or arising from malice." Who wants to harm Sethe, the main character? It is a baby, but can we sympathize with a baby that is full of spite, malicious intentions, venom? Immediately we find ourselves caring for Sethe. She is alone with only her young daughter, who is also a victim of the baby's spite. The grandmother, who could have helped, is dead; Sethe's two sons have abandoned her. What does Sethe desire? She wants the spite to end. Will she get her desire? We must read the novel to find out.

Ultimately, though, the writer, the teller of the tale, can hold our attention through tension achieved by a series of conflicts that takes us on an emotional rollercoaster between hope and despair peaking to crisis, the plot must finally wind down. Finally, we need to know if the main character will achieve her desire. We need *resolution*.

I was surprised to discover that Toni Morrison liked watching the TV show *Law & Order*. I wondered if it was for the same reason I got hooked on spending my early afternoons watching *Lauren Lake's Paternity Court*. In an article by Hilton Als, "Ghosts in the House," published in the *New Yorker*, October 27, 2003, Morrison revealed that she liked watching *Law & Order* because it offered what she described as "mild engagement with a satisfying structure of redemption."

I like Morrison's qualification of "mild," for it relieves me of embarrassment with my learned colleagues when I tell them how I spent afternoons glued to the TV, watching *Lauren Lake's Paternity Court*. Yet mild or not, that TV show *engaged* my interest; it achieved an important goal of a good plot. I was emotionally invested in the plight of the defendant. And Morrison makes a good

point about the importance of a satisfying structure of redemption for the ending of a plot. Each of those words is significant. The ending of a novel should provide some satisfaction to the reader in the sense that the plot lines are addressed and resolved and the conclusion makes sense in terms of the logical or emotional outcomes of the plot. I think of redemption as reflecting both the main character's growth into becoming a better or more enlightened human being and also the righting of the wrongs the story addresses. But the emphasis for me in Morrison's statement is on structure rather than on redemption. Indeed, redemption does not always follow logically or organically in a novel. The original ending of my novel *Bruised Hibiscus* was very dark; the situations my characters encountered called for a dark ending. My editor urged me to reconsider. She wanted a less pessimistic ending. Readers, she said, want to be left with hope, even if tragic events occurred. I argued that life does not always end with redemption. She agreed but suggested that I consider the "structure" of the novel and whether, given the fictive world I had created, the ending did not lead more organically to a redemptive conclusion. I was glad to be given that advice, for in rethinking the novel, I realized I had imposed a more severe ending to my novel, one that conformed to my personal views rather than to the views of the characters in the novel. That, of course, is the error of authorial intrusion. So for at least one of the characters in *Bruised Hibiscus* there is redemption.

This brings me to my final point: To outline or not to outline.

Here are the notes E. M. Forster wrote in his diary more than two years before his masterpiece *Howard's End* was published.

Idea for another novel shaping, and may do well to write it down. In the prelude Helen goes to stop with the Wilcoxes, gets engaged to the son & breaks it off immediately, for her instinct sees the spiritual

cleavage between the families. Mrs. Wilcox dies, and some 2 years
later Margaret gets engaged to the widower, a man impeccable pub-
licly. They are accosted by a prostitute. M., because she understands
& is great, marries him. The wrong thing to do. He, because he is
little, cannot bear to be understood, & goes to the bad. He is frank,
kind, & attractive. But he dreads ideas. (Quoted in "Editor's Intro-
duction," *Howards End*, Abinger Edition, Vol.4 [London: Edward
Arnold, 1973], p. vii)

If you've read *Howards End*, you will realize how much is missing
in these notes from the events that occur in the finished novel. We
learn nothing about Mrs. Wilcox's will in the notes, a pivotal point
in the novel. And we learn nothing about Leonard Bass, who will
father Helen's child. We learn nothing about Helen's pregnancy and
how it affects the outcome of the story.

Indeed, a writer may have *an idea* for her story before she begins
to write, but it is by mostly following the journey of the character
that the writer eventually discovers the full story, particularly the
ending. Before he started writing *Howards End*, Forster knew Mrs.
Wilcox would die, but I think it was only as he wrote those scenes
leading to her death that he discovered the pivotal scene about her
will which led to the consequences of that will. It is that *discovery*
during the creation of the story that makes writing so fulfilling and
exciting for the writer.

Writers often refer to the metaphor of the car driving down a
dark winding road to explain how a plot develops. One starts with
an idea of where one wants to go (the story). However, getting there
is a matter of discovery; in fact, the destination may not be what
one had anticipated when one began the drive. Imagine it is late at
night, there are no street lights, the road is winding and possibly un-
paved for stretches. How does one find one's way in such darkness?

One has to drive forward, and when one does, the headlights on the car will illuminate the road in front of you. But you will have to keep on driving if you want to see more of the road. In other words, it is the writing, the character's movements, her decisions that will direct the plot. I am not suggesting that the writer must give up total control of her story to the character she is inventing. Perhaps another metaphor can explain this dance between knowing and unknowing, conscious decisions and unconscious ones. Take the relationship between the race horse and the jockey. If the jockey holds on to the reins too tightly, he may restrain the horse and the horse may not deliver what it is capable of giving. But if the jockey holds on to the reins too lightly, the horse can run astray and off course. The danger, then, of creating an outline before you begin to write your novel is that you may feel compelled to follow the outline regardless of where the character's story may be leading you, and by doing so you may end up in a ditch. You will still need a map to guide your plot, but I tend to map out my next scene after I have written the previous scene. So, if you choose to create an outline, you should allow yourself the possibility that your outline will change as your writing leads you in directions you had not previously considered.

I have focused on the character-driven plot, which involves the following elements: 1. early identification of the main topic/issue/ problem; 2. early creation of a main character who engages the emotions of the reader, a character who desires something; 3. tension, conflict; 4. crisis; 5. resolution. But there is something else that is very important to me in a well-developed plot: it is the references found in a good story that establish or advance the literary canon. In "The West Indian Novel: What is a Classic?," an essay I wrote for the Caribbean literary journal *BIM*, I pointed out the practice among English writers to mention the names and works

of English writers as part of the plots for their fiction. One cannot read Jane Austen, for example, without being reminded of Shelley, Scott, Cowper, Byron, Shakespeare, Pope, and many others. I notice that J. M. Coetzee, though a South African, asserts his claim to the English literary tradition, albeit inherited, by doing the same in his novels. In his famous novel, *Disgrace*, for example, the reader is treated to explications of Wordsworth and Byron, whose works are not incidental to the main themes of the novel.

In my own work, I am conscious of the importance of weaving into my narratives the works of writers, who, like me, come from the English-speaking Caribbean. I consciously mention writers such as George Lamming, Derek Walcott vs. Naipaul, Jamaica Kincaid, Merle Hodge, Michele Cliff, and Wilson Harris, among others. My intention is to solidify the inclusion of works by writers of color in the literary canon by making certain that these works remain in the public's eye. It seems that the people who made the movie *Marshall*, starring the late Chadwick Boseman, shared my concerns. I was delighted to see the almost casual insertion of a scene in a bar in Harlem where Billie Holiday sings on the stage and Langston Hughes and Zora Neale Hurston sit around a table having drinks.

I make another deliberate inclusion in the plots of my novels. I remind my readers of the enslavement of Africans in America and in the Caribbean. I do not always know where I will make that reference, but so far, in the ten novels I have written, there is always an occasion to recall that brutal time in Western history. I will never forget and I do not want my readers to forget.

So, plotting a plot can be deliberately contrived, but allowance should also be made for unanticipated changes. The writer must learn the craft as I have outlined in this essay and yet must be willing to go where her characters take her, sometimes unraveling a purposefully well-designed plot.

Re-Vision

MITCHELL S. JACKSON

Let me tell you how I got popped. Let me start with a couple of hours pre the arrest, when I was in medias res cooking dope in the house I shared—a blatant disregard of her wishes—with my then-girlfriend.

By an act of Arm & Hammer legerdemain—it was my first time too; how's that for irony?—I'd cooked up near double-digit extra grams of crack. Cooked it and cut it and bagged it and cleaned up and bounced out the house and stashed the sack of rocks under my seat and my pistol under the dash in my '86 Honda. Common sense says I should've headed straight for the suburban apartment where I housed my dope, but on the contrary my sense-deficient self rolled to play hoops with my boys at an indoor gym. We balled a couple hours and afterward, though at that point I fordamnsure should've drove to the suburbs, my sillyass instead went and picked up this pretty young thing. We weren't more than a few blocks from that pickup when the cops swooped behind me. They followed a block or so and hit me with flashers the first turn I made. "Don't worry, don't worry," I told myself first and my PYT second. Said it because I had a license and valid insurance and knew how to speak assimilated Negro English. Said it because I'd been pulled over riding dirty on occasion and had

gone free. So, I rolled my window down with that false peace, and no sooner than I said, "Officer, may I ask why you—" I heard his partner yell, "HE'S GOT A GUN!" from the passenger side.

Sidebar: The PYT is not the girlfriend and never is.

Now I'd made those sense-deficient sillyass moves, but I didn't so much as twitch before the white men with guns and badges barked, "EVERYONE PUT YOUR HANDS WHERE I CAN SEE THEM!" It was dark; it was raining; I was wearing an ever-obfuscating puffy black coat, and real talk, if those officers were having a bad day, had the wrong bias, or a nervous *digitus secundus manus*, I could've ended up the kind of headline that makes a mother weep eternal. They didn't shoot (hallelujah!), but what they did do was order me out my ride and handcuff me and my pretty young thing and stuff us in the backseat of their patrol car and proceed to seize my 9mm Smith & Wesson and, after an avid search, find the sandwich bag of packaged crack hidden under my seat.

Maybe what they mean by kismet is the fact that the baggie was laden with those extra grams I mentioned a second ago.

"Look . . . what . . . we . . . found . . . here," the cop said in slo-mo. He held the tumid baggie to twitching streetlight.

That was March. In June His Honor Henry Kantor sentenced me to Oregon state prison time. No doubt it was a sadface moment for me and mines, but on the other hand, if Judge Kantor, say, had one of those days, was overwhelmed with his caseload, or just wanted to send a message of less-than-zero tolerance, he could've turned over my case to the federal courts, in which case if I mattered enough, which I didn't, I could've ended up this superdupersadface headline:

Dope-Dealing Scholarship Student
Lands Ten-Year Prison Sentence

Instead, I spent sixteen months in first Mill Creek and then San-tiam prison. My last few months at Santiam, I scribbled on loose-leaf paper the first paragraphs of what became my novel. Puffed up off calisthenics (how cliché?), I paroled in the summer of 1998 and whether I realized it then or not—and for the most part I didn't—I began to revise.

Let me rap to you good folks about revision or, rather, let me rap to you about what revision ain't: editing or proofing. Editing is finding minor problems. It's addressing those minor problems with easy fixes such as deleting a word or sentence or copying and pasting a paragraph elsewhere. Proofing is seeing the work as static. Proofing is correction; it's fixing a comma splice or a misspelled word or faulty subject/verb agreement—a.k.a. applying the rules of convention.

Revision is a philosophy; revision is revolution.

But revision, now that's another thing. Revision might include editing or proofing but will always move beyond them. Revision is seeing the work in progress. Revision is seeing the work in con-text. Revision is recognizing the parts of a text and how they work to form a whole. Revision is seeing what could and should and shouldn't be there and conceiving of ways to make it so. Revision is discovering what's right and imagining how to make it more right; it's pursuing a new way of seeing and being. Revision is a philoso-phy; revision is revolution.

Thank God I have learned to revise my work. Thank God, the angels, the saints, and a few heathens I've been given chances to revise my life. The philosopher A. K. Coomaraswamy once said, "The artist is not a special kind of person; rather each person is a special kind of artist," and that premise leads to my nutgraf: You can, no you should, apply the tactics of revising for the page to

revising a life. And that revision or re-visioning could alter what might've felt like or may very well have been one's fate.

Second Gang Member Dies at Apartment 43

A gunman fired one shot and killed an 18-year-old man
Saturday afternoon at the Towne Plaza Apartments. Kevan Hai
Miller died at the scene with a gunshot wound to the chest.

Kev and me met freshman year during daily doubles football practice. That season he was a starting star safety and I was a frail second-string defensive back. Kev was the one who talked courage into me when I didn't want no part of our Heads Up drills. Kev was one of the first to slap my shoulder pads when I lucked up on an interception during our last game of the season. Off the field, Kev was a bona fide math savant who had an easy smile and one of those voices that made you lean in for a listen. Never knew what set Kev claimed, but most days the homie wore creased Dickeys, Nike Cortez, a figurative fitted cap with no bend in the brim, and beaucoup red, a get-up that let you know he was an aspiring or affiliated or wannabe Blood. No doubt he was down with gangster metaphor, though it never ceased seeming to me that he was playing dress-up.

Sidebar: He never even earned a handle, and it's a natural fact that a gangster with no nickname is one of negligent lore.

The last time I can remember seeing Kev alive was the summer after we graduated from high school. We were in my basement bedroom and I was showing off the low-grade weed I'd bought from whoknowswho when my might've-been-clairvoyant grandmother crept up on us. Me, I was stunned into a gap-mouthed stupor, but Kev copped to it swift: "It's mine, Mrs. Jackson. It's mine." My grandmother stabbed a finger toward the door and yelled, "You leave now. Leave now and don't ever come back!"

But Kev's banishment didn't much matter. He was murdered within a half year.

How to Revise: Step 1

These days I teach writing to undergrads. But what if, instead, I was in a classroom facing the young live versions of The Homies? Picture me in lecture mode, a PowerPoint beaming on a SMART board, my notes laid out on the lectern. I'd open with the etymology of the French word *essai*. How it translates to "to try" or "attempt." How the godfather of the form Michel "Mr. What-Do-I-Know?" de Montaigne named his grand collection *Essais* because he understood the primal need for revision. What more proof do we need than the fact that he wrote, published, and reworked them for over two decades? If I peeped even an inkling of affirmation, I'd try to persuade The Homies that whether they considered themselves artists or not, they should deem themselves essayists—always working to sharpen their ideas. And if that theory went over, I'd propose that furthermore they should consider themselves the essay itself—that they are, that we all are, in effect, trial runs.

No way I'd dismiss class without making the point that revision is a process, without explaining that the first stage of that process is assessing content. This is the stage where you ask questions, I'd tell them. When you ask, who's your audience? What's your purpose? What's your argument(s)? Who and/or what is supporting your claims?

One on one, I'd pitch to Kev that there's another way of seeing. I'd tell him about critic Edmund Wilson's claim that "Your wound is your bow." Whether Kev knew it or not, and it's a safe bet he didn't, his wound was his difference. Those of us who bothered looking could see it in the way he presented himself to the world, in the way he downplayed his superior brain, in the way he was

seldom vocal in a group. If I were plying him to see the strength in his difference, I'd tell Kev how the whole time he'd known me and years before, I was embarrassed to the hilt about my mother's drug habit, that it was my wound even before I knew to call it one. I'd tell him how when I got the mind to write forreal, I was petrified to speak honest about my life for fear that I'd be judged. I'd be sure to tell him how my work was weak as fuck because, among other flaws, there was much too much evading the hard truths. No way I'd let him leave without me telling him how, along the way, I realized that my harms were a resource, that exposing them on the page could make the work stronger, could make me stronger. The grown me wonders how things would've turned out for Kev if I'd persuaded him to embrace what set him apart rather than flee it, if he'd accepted the belief that things he was ashamed of might one day accrue him the most strength.

Man, 20, Fatally Shot outside Club

A 20-year-old Portland man was shot and killed early
Thursday after arguing with a man outside a
nude dance club in Northeast Portland.

Me and Lil Anthony knew each other from almost the womb. In fact, our mothers were so close we considered ourselves cousins. One of my earliest memories of Lil Anthony—my junior by a couple years—was when he and I were in grade school and staying over our auntie's house. Anthony had an outie belly button that we used to tease him about something vicious, and this particular day, I duped him into submitting to the crackpot theory—not sure where it came from—that we could "fix" his belly button by taping nickels over it. Poor boy, you should've seen his face when it didn't work.

The last time I saw my cousin alive was the day Judge Kan-

tor dropped the gavel on me. The bailiffs marched me out of the courtroom and onto an elevator and off the elevator and toward a holding cell on the upper floors of the Multnomah County Courthouse. My head was dropped and my eyes were wet—wasn't no fronting as a Man of Maraging Steel—but I perked up when I heard Anthony's familiar voice yelling, "Cousin, cousin, I heard you was comin'," from inside a cell. Lil Anthony, who I should mention, pledged allegiance to the Crips in his tweens, told me he was headed to court to seek bail on his case. "If they give me bail I'm gone," he said.

Sidebar: Lil Anthony's gang name was Lil Smurf. He was the proud deuce of a dude named Big Smurf. And boy oh boy, that boy was supercalifragilistic with his gangbanging. For evidence I offer exhibit A: There's a documentary about his life, titled *Killingsworth*, that alleges at one point Lil Anthony, a.k.a. Lil Smurf, was responsible for "half the gang shootings in the city, either as the shooter or the target."

The judge gave Lil Anthony, a.k.a. Lil Smurf, bail.

He was dead and gone six months from then.

How to Revise: Step 2

Revision is a process, I'd remind The Homies. And the second stage of that process is Organization. This is the stage where you ask yourself if you've found the right structure, if you've ordered your ideas and paragraphs to produce maximum effect. The second stage is when you judge whether you've created proper transitions.

If the grown me could pull the young living version of Lil Anthony aside, I'd ply him to believe in another way of being, would mention to him Barry Hannah's belief that you have to "Be a master such as you have." I'd segue from Hannah's advice into a con-

fession: I'd tell my cousin how I admired his resilience—his and my mom both had long-term drug habits—in dealing with his mom's addiction, how even though he was younger than me, I looked to him as a measure of what could be survived. For sure I'd tell my cousin how acute I have felt my literary dearths, would explain how minor I feel compared to writers who can claim childhoods as voracious readers, who learned Latin in grade school, studied abroad as biddy brainiacs, who earned a Rhodes scholarship, or fought as front-line soldiers, or spent post-doc time as a motherfucking African missionary. Before we parted, he'd know of one of my strongest fears—the dread that all I lack will be obvious in my work, that somewhere in me there exists the belief that I'm an insufficient scribe. But I'd also tell him how the kind of childhood he and I had can bestow gifts, how the preachers and pimps and hustlers I loved and loathed as a youngster have become the muses that inform my writing voice, and how that voice has given me reason to believe I belong.

Lil Anthony had much to master. He had a smile that made grown folks fawn. He was courageous enough to walk the streets (albeit wearing a bulletproof vest) while there was a rumored hit out on him. True story: the boy used to stack phone books in his seat to see over the wheel—if that ain't ambitious, you tell me what is—as he drove around the neighborhood in buckets on may-pop-at-any-time tires. With his resilience, his charm, his courage, his ambition, he could've been just about anything he wanted—CEO, comic, a damn good motivational speaker . . . and I wish I could've seeded him with that conviction, that I could've made him see that mastery might alter what might've felt foreordained.

Man Gets 17 Years in 1997 Ambush Killing.

_____ fails to get the judge to allow him to change his pleas.

Me and my boy Black—he was a grade above me—attended the same Catholic school. From the jump, I admired him because he was a Prison Ball braveheart—he'd catch a speedball toeing the line or blast you almost off your feet from a good distance—and he was the best basketball player in the school. As a matter of fact, Black was the guy who took me to join my first basketball team, and by that I mean walked me to the gym, introduced me to the coach, and waited to make sure I didn't punk out and jet before tryouts. He pulled the same big brother move when it came to me playing little league baseball. Black and I went to different middle schools but wound up attending the same magnet high school. My freshman year, I was an astonished fanboy cheering from the stands while Black as a sophomore lived out what in those days was my most coveted dream: He was starting and playing big minutes in the state basketball tournament. It was him squeaking across the Coliseum floor, stealing balls, hustling for steals, and scoring mid-range jumpers and dipsey-do layups, him who posed post-game with the championship trophy.

One of my last memories of Black and me as freedmen on the streets was when we were both in our twenties and dealing dope. He called me over one night and when his girlfriend let me in, I saw Black in his living room, shirtless in hoop shorts with scrapes everywhere. "Goddamn, bro, what happened to you?" I said. Black told me about an episode the night before where he'd had a bad trip on ecstasy, ran out of his clothes into the street, and after being tackled (hence the scrapes), ended up in detox. "Bro, I'm only telling you this because I love you," he said. "Don't ever fuck with that shit."

Black was damn near invincible to me back then. Not only had he won that state championship as a fearless guard, on the streets—Black was a Crip, a fact I'm mentioning since I mentioned what the

others claimed—he seemed afraid of no one. There were stories galore of Black's panache for doling natural ass whoopings to foes of all height and girth. Like the legend of him putting hands on Fat Fred (RIP), a guy who—no hype—was thrice Black's weight. The night in his apartment sticks with me because it was the first and only time he exposed a weakness to me. Memorable too because it was one time he admitted in word what he'd showed me in deed: that his care for me was beyond friend for friend.

How to Revise: Step 3

The third stage of revision is Expression, I'd tell The Homies. This is where you start to consider your voice or, in other words, the way you say what you need to say. This is the place to make more specific choices of style, where you choose diction, where you make conscious choices about how to effect the tone you want.

Sidebar: To date I've visited Black once since he's been locked down. And that one time was to film him in prison. Those facts make me no small part of irredeemable fraud.

Black and I have exchanged a few letters, which don't make up for my fraudulence but does present a chance for me to tell him about this philosophy I cribbed from a once-upon-a-time writing mentor of mine named Gordon Lish: "What comes next is always behind you." Lish calls the method recursion. What I plan to tell Black is how much of a boon it was in the late stages of editing my novel, how there was this scene—we could call it the climax— toward the end that I kept reading and reading and wanting to be right when I knew in my heart it was wrong. For days I read and reread the scenes that preceded it and asked myself, "what's next, what's next?" Then one day I recalled that idea of moving forward by looking back, and ended up writing a last scene—a

damn good one if you ask me—based on one of the first scenes in the book.

My big homie, no, my big brother comes home soon, and I hope takes a long look back as well. It might be tough. There's beaucoup benefits, especially when you're locked down, to disremembering, much profit in focusing on what's to come. But I hope Black at least tries recursion, that he conjures how brave he was, and that that courage might serve him if ever a job search protracts, if ever he needs to dismiss the lure of dope sack, if ever he needs to turn a cheek to an old foe. I hope Black can resurrect the grit it took to win it all, the feeling of being hero to us freshmen and JV plebes. Should my friend, no, my big brother find himself becoming too much of the self he'd rather not be, I pray he recalls the compassion that made him warn me from danger.

Beyond Revision?

It was old Nabokov who said his "pencils outlast their erasers," which was a clever way of hinting at the level of hope one needs to revise. Hope for more and for better is at the heart of revision. Now, I'm not trying to get all dour on you, but I have to say this: Revision don't work so well at preempting first trouble. In fact, it's liable only to work—you've got to endure some serious strife to have a real sense of its efficacy—on those who've been baptized by grave moral or mortal grief. And let me say this too: As much as I believe revision could've helped my homeboys, will help my homeboy, I know deep down that some dudes are beyond it. Some dudes, the best you can do is stay the fuck out their way. Where I'm from, these dudes got a raison d'être nada and a handle that lets you know what they're about: Pistol, Menace, Stitches, Killa. They anesthetize from wake-up and flaunt yield-colored sclera and

super-scorched lower lips. These dudes have kids they don't see and parents they don't love and mugshots galore and ain't worried about boxes—coffins nor cells. You can bet they own knife and/or bullet wounds and wear hats dipped low and sport tattoo tears on their cheeks and affiliations and RIPs on their necks and arms and bruised knuckles and don't bother with the grime under their jagged nails. But check it, you can most know them by how slow they move—hurry implies a kind of hope, and by how they negotiate the world, by which I mean how, no matter their size, they claim a preponderance of physical and psychic space; they claim it and damn near dare you to enter it. Double dare you so they can show you what they're made of. Or rather what they're made for, which is the crime that will make them most infamous. Trust me on this, please, these nefarious dudes live by credos that push them far outside peace and revision and prayer and any attempt to soften their slow-ticking atheist hearts. As evidence I offer exhibit B: I was once in a small crowd watching two guys argue, one who I knew to be the kind of guy I mentioned a second ago.

"You don't want it with me," he told his foe, with what seemed every fiber in him. "I will bring violence to your life."

Wannabe Novelist Seeks Benefactors

That was my actual headline. They ran it right before I moved to New York for grad school. This was a couple of years after I paroled, and I was ecstatic about the chances I had received to reenvision my life. At the time they ran this, though, I could still be seen bending corners in my money-green '94 Lexus, could still be seen decked in repeat-print Versace jeans, gleaming Air Force One Nikes, and spanking new white t-shirts never to be worn twice. Those days, no small part of my public self was based on the fact of me being a former dope dealer. This is why "seeking benefactors" made me feel

like a beggar or a lowlife or worse. Now that I look back, though, my actual headline was the genesis of me coming to realize another important aspect of revision: collaboration. At every stage of my development as a writer—shit, my development as a human—there have been folks urging me ahead: writing teachers, grad school professors, editors, first readers who never refuse a request for comments on my drafts.

Now here's the ask: Who are you going to collaborate with? I ask because what you've read thus far would be for damn near naught if you—yes, you—do nothing. Not asking you to save the world or stage some theatric intervention but to prosecute at least one meaningful action toward helping another human avoid a death sentence or a life sentence or a so-much-of-their-life-there's-not-much-life-left sentence. Here's the ask in other words: What physical act can you—yes, you—and me and we do to help the next Kevan or Lil Anthony or young Black see themselves in context, see their lives in progress, discover what's right about themselves and imagine ways to make it more right?

How to Revise: Step 4

Before I dismissed class, I'd tell The Homies about the last stage of revision—Mechanics and Format. This stage involves checking things like grammar and misspellings and punctuation errors and omitted words. It's also the stage where you format your work, and if need be, apply the rules of APA or MLA or *The Chicago Manual of Style*.

Near the end of class, I'd tell them one last story about revision—this one about handing in my novel at last, after eleven, twelve, thirteen—my heart had to stop counting—or more years of revising. Let me start with the week in mid-May when my

"final pass" draft was due, a week at the end of which I was booked to catch a flight to Atlanta to chaperone my daughter's Field Day. That week my life was no more than teaching all day and coming home to scarf a meal and edit and proof and, in some cases—more cases than affirm good sense—revise my "last pass" pages till right before the sun rose. Then I'd shower and dress and leave and teach and do it all again, once, twice . . . and so on.

Thursday rolled around and I was clinging to the wispy hope that I could meet what my editor confirmed to me was my Capital D drop-dead due date—a.k.a. the deadline that, if flouted, would mean the book would miss its publication date, along with a gang more fallout. Proactive me worked a deal to have my girlfriend messenger the pages to the publisher that Friday, which seemed well within the realm of mortal means. Seemed possible until I looked at the clock on my computer and at the stack of unread pages of my manuscript and understood, as if a prophet had whispered in my ear, that there was no way no how in the known world I'd finish before my flight. This truth prompted the email to my editor that asked if I perhaps—I never say perhaps in real life, so it was a synonym for perhaps—could deliver it to her on Monday. She, however, shot that idea down. She needed the manuscript by close of business Friday—5 p.m. and not a second past. This truth sent me in the wee hours huffing the few blocks from my girlfriend's apartment to a college where I teach. Once there, I convinced a wary security guard that I had to get into my office for an emergency and went upstairs and prayed the last thirty pages out of a dubious printer.

There was just enough time after that to grab my bag and head to the airport and, oh so delirious, board my flight. Maybe I edited a page or a paragraph on the flight. Maybe I didn't. What I can tell you is my brain wasn't broadcasting right. What I know is my daughter's mother picked me up and we zoomed over to my daugh-

ter's school where I was told my job was to man a Field Day station where kids tried to balance golf balls on spoons with a hand behind their back—Golf Ball Boxing. There I stood, the physical me at least, for what must've been eons in Southern spring heat, and when the games at last at last were done, I sprinted for the car, grabbed those last twenty or so pages and scratched what felt to me like the most important words I would ever write in this life or the next. To keep it 100, what I did was more editing and proofing than revising but, let the church say Amen, I finished my business just about the time Field Day finished and we—the we being my daughter, her mother, and dematerializing me—set out on a mission to find the nearest print/copy outpost. Per all available artificial intelligence, the closest one might as well have been in Timbuktu. We're talking serious miles, but we trekked to that joint and after the albatrosses of being coerced to purchase a zillion-dollar flash drive and submit to an impossible line of computer traffic and suffer a thwartrific log-on experience, after being forced to wait on the slowest copy center worker on planet Earth because the center's baby ENIAC computer couldn't find my thumb drive, after the ordeal of an Internet connection the speed of human evolution—this all happened; my word is my bond—I let my daughter hit send on my "final pass" pages seconds before the fall-out-and-die deadline.

The princess and I walked out—her smiling and me feeling my tight chest loosen.

"We did it," I said.

"Yes, we did, Dad," she said, and looped her arm in mine. "Does this mean you're done?"

Originally published with the Center for Fiction.

The Art of Revision

Most of What You Write Should Be Cut

CHARLES JOHNSON

In fiction there must be a theoretical basis to the most minute details. Even a single glove must have its theory.

—Prosper Mérimée

It is in self-limitation that a master first shows himself.

—Goethe

A classic is a book that doesn't have to be written again.

—Carl Van Doren

The late John Gardner, my writing mentor more than thirty years ago, once told a story about revision that has stuck with me. He said he gave a reading, and during the Q&A a woman raised her hand and said, "You know, I think I like your writing, but I don't think I like *you*." His reply was memorable. "That's all right," he said, "be-

cause I'm a better person when I'm writing. Standing here, talking to you now, I can't revise my words. If I say something wrong or not quite right, or maybe offensive and it hurts someone, the words are out there, public, and I can't take them back. I have to rely on you to revise or fix them for me. But when I'm writing, I can go over and over what I think and say until it's right."

I think Gardner captured the heart of the creative process. We often hear that 90 percent of good writing is rewriting. We also know that writing well is the same thing as thinking well, and that means we want our final literary product—story, novel, or essay—to exhibit our best thought, best feeling, and best technique.

When I compose a first draft, I just let everything I feel and think spill out raw and chaotically on the page. I let it be a mess. I trust my instincts. I just let my ideas and feelings flow until I run out of words. It's fine for an early draft to be a disaster area. I don't censor myself. When I have this raw copy, I can then decide if this idea is worth putting more effort into. If so, then with the second draft, I clean up spelling and grammar. I add anything I forgot to include in the first draft and take out whatever isn't working.

Then the real fun begins with the third draft. (Despite its importance, art should always be a form of play.) That's where I work on what I know are my creative weaknesses. There are many, but let me focus on just one—poetic description, achieving what Gerard Manley Hopkins called *inscape*, and a granularity of specifics and detail. As a cartoonist and illustrator, I think visually first. Like most writers, my images overwhelmingly represent *sight*, what I see. We do have a built-in bias for visual imagery. We say we "see" (or hear) the truth. Never do we say we touch or feel it. So, in that third draft, I work consciously to include, whenever possible, imagery for the other senses—taste, smell, touch. If need be, I'll resort to synaesthesia, or describing the experience of one of our senses using

the language of another. Or onomatopoeia. With taste and smell, for example, my goal would be to describe odor as well as Upton Sinclair did in the "Stockyards" section of *The Jungle* and sound as well as Lafcadio Hearn handles it. A book in my library that helped me much with this when I first started writing was *The Art of Description* by Marjorie H. Nicolson.

Another problem I often have, personally, is at the idea stage. I sometimes start out with too many ideas. Before I begin to write, my thoughts are bursting with possibilities for the stories, multiple layers of meaning, things I'd love to include, all of which I jot down as quickly as they come to me. But then at some point I realize that less *is* more when one is plotting a story, if one wants it to be an economical, efficient, and coherent aesthetic object. Inevitably, I always have to scale things back, to search for and find the simple action and structure that creates suspense, causation that feels logical and inexorable, and a clean, uncluttered emotional through line, i.e., what to emphasize and what to mute. With that decided, I then know how to place the discarded idea in a new way in the composition.

In that third draft, I begin to polish sentences and paragraphs for style. I always need a minimum of *three* drafts before I have anything worthy of showing to others, and that's only if I'm lucky. (Don't get me wrong: my drafts are not separate entities completed from start to finish. They flow into each other. I'm constantly rethinking a story's beginning as I work on the middle and end.) Sometimes my ratio of throwaway to keep pages is 20:1. From the third draft forward, I work at varying sentence length (long, short) in every paragraph and also varying sentence forms (simple, compound, complex, loose, periodic). I see each sentence as being a unit of energy. The music and meaning of each sentence and paragraph must carry into the next and contribute to a larger rhythmic design.

I try to make sure each paragraph can justify its being on the page. That is, each paragraph should have at least *one* good idea in it. Or do *something* to advance the story. Or enrich the details of the world in which the story is taking place or the characterizations of its people. I work at being as artistically generous as possible. I work to amplify a strong narrative voice. I want intellectual and imagistic density. And I want to achieve, of course, the feeling of organic story flow. I rewrite and edit until the piece has no waste or unnecessary sentences whatsoever. Nothing that slows down the pace of the story. Any sentence that *can* come out *should* come out. ("Kill your babies," as the saying goes, unless, of course, you absolutely love that sentence.) There should be no *remplissage* (literary padding) or *longueur* (long and boring passages). No irrelevant postcard details in background descriptions. I want every detail to be "significant," i.e., revealing in terms of character, place, or event. I work to get music—rhythm, meter—between sentences and paragraphs, as if the prose composition is actually a musical work, one pleasing to the ear. The way to test this is to read it out loud. If I stumble when reading the piece, I know those sentences that tripped me up (that were hard to say or recite) need to be rewritten. Also, I try to be generous with concrete language and to write always with specificity. (The devil is always in the details.)

I try, as I rework and revise, to remember a note I made to myself in my writer's notebooks: "In great fiction the main element of importance is the fusion of *character* and *event*, their interplay, the way the latter reveals the former, and the way the former leads inevitably to the latter. One must also see how event transforms character even as it is produced by character."

Character, then, is the engine of plot, and over the years I've come at the creation of characters from a few different angles: (1) basing them on an idea or principle; (2) drawing them from real

people, specific individuals (or several) as my model for a character; (3) basing them on myself; and (4) basing them on the biography of a historical figure. Quite often, my characters combine all those approaches. So for me, revision is a combination of cutting away (like sculpting the sentence from stone) and also a constant layering of the language (like working with the sentence as you would clay). The palimpsestic layering part of the process often leads to sudden surprises—puns, oracles, and revelations—that I'm always looking for. And these discoveries often redirect the story away from my original idea or conception. Back and forth, adding and subtracting, like that. You know when a piece is finished because you can't pull out a single sentence or change a word or syllable. If you do extract that heavily polished sentence, you create a hole in the space *between* the sentences before and after it, since you have altered not only the sense but the sound that links those sentences. (It's like ripping an arm off a human body, an act that affects everything else in the organism you're creating.) Achieving this requires (for me) lots of thrown-away pages: 1,200 for *Faith and the Good Thing*, 2,400 for *Oxherding Tale*, 3,000 for *Middle Passage*, and more than 3,000 for *Dreamer*. I use this same method for short stories. I guess I don't so much write stories as sculpt them. I love the sustained focus this requires, for it is so much like the first stage in formal meditation, called *dharana* (or concentration).

I started keeping a diary when I was twelve; my mother suggested the idea, mainly so she could read it and learn what feelings and secrets I was keeping from her. I remember her asking once at dinner, "Why don't you like your uncle So-and-so?" and I thought, Dang! She must be a mind reader. Then I realized she'd been reading the diary, and from that point on I had to hide it from her. In college the diary transformed into a journal in which I wrote poetry and brief essays to myself and (as with a diary) tried to make

sense of daily events. (These old journals fill up one filing cabinet in my study.) When I started writing fiction, the journals moved in the direction of being a writing tool and memory aide.

I use cheap, unlined spiral notebooks, each page like a blank canvas. Into them go notes on literally *every*thing I experience or think worth remembering during the day; I jot down images, phrases used by my friends, fragments of thoughts, overheard dialogue, anything I flag in something I've read that strikes me for its sentence form or memorable qualities, its beauty or truth. These writing notebooks kept since 1972 sit on one of my bookshelves thirty inches deep, along with notebooks I kept from college classes. (I save everything; it's shameless.) After forty-three years of accumulation, the notebooks contain notes on just about every subject under the sun. When I have a decent third draft, I begin going carefully through my notebooks, page after page, hunting for thoughts, images I've had, or ideas about characters (observations I've made of people around me), carefully selecting from my notebooks details like someone arranging a Japanese rock garden. Although it can sometimes take five days (eight hours a day), and even two weeks, to go through all these notebooks and folders (since I add something new to the current one every day), I can always count on finding *some* sentence, phrase, or idea I had, say, twenty or thirty years ago that is perfect for a novel or story in progress. The literary journal *Zyzzyva* used to publish a feature called "The Writer's Notebook." If you look at the fall 1992 issue (pages 124–43), you'll see reproductions of my revised pages and an early outline for *Middle Passage*, as well as character notes for Captain Ebenezer Falcon that I wrote on hotel stationery (the Sheraton-Palace Hotel in San Francisco) when I was on the road.

When I tell students the anecdote about Gardner, I emphasize his feeling that the result of this painstaking revision process is that for

at least *once* in their lives, here on the page, they can achieve perfection or something close to that, if they are willing to revise and reenvision their work long enough. And then I say: Where else in life do we get the chance—the privilege and blessing—to lovingly, selflessly go over something again and again until it finally embodies exactly what we think and feel, our best expression, our vision at its clearest, and our best techne?

Or, as Jeffery Allen said in an interview about his novel *Song of the Shank*, "I really tried hard to get it right. Art may be the only form of perfection available to humans, and creating a work of art might be the only thing in life that we have full control over. So we might ask, How is great measured? Craft is certainly one thing. I would also like to think that certain works of art transform the artist."

Originally published in *LitHub*, December 20, 2016. Excerpted from *The Way of the Writer: Reflections on the Art and Craft of Storytelling* by Charles Johnson.

Afterword

This project began as do many projects that are a function of Black folks pooling their meager resources to make incredible things happen. At every turn, the writers' workshops the Hurston/Wright Foundation hosts have as a critical aim helping workshop participants understand the craft of writing. How does good writing, regardless of content work, work? What are the literary devices and techniques writers use to tell stories, from language and structure to scene and characterization? In the essay "Salvation Is the Issue," Toni Cade Bambara declared her near exclusive interest in telling stories that save lives. She saw little point in storytelling otherwise. In "Rootedness: The Ancestor as Foundation," Toni Morrison suggested that the written word was the only viable replacement for the ritual of passing down stories orally to help communities understand myth and tradition. It is the writer, she noted, in *Playing in the Dark*, whose work is the lasting result case when official historical records and national narratives fail in their consideration and portrayal of an Africanist present. *How We Do It* was born out of an impulse that believes wholly in these sentiments—that literature written by Black authors does unique work and does so uniquely. Providing writers the space to help us understand better how it do what it do has been sheer joy.

The relationship between Howard University and the Hurston/ Wright Foundation is a long, winding road. Over the years, the

university has been the site of the Legacy Awards. For almost a decade, the Department of English specifically has been a champion of the Foundation, hosting the summer and weekend workshops at no cost. The benefit of having bestselling and aspiring writers alike on the campus, having their present-day creative energy meet that of the persistent creative spirit energy of Zora Neale Hurston, Lucille Clifton, Amiri Baraka, Toni Morrison, and Greg Tate is priceless. This work, *How We Do It: Black Writers on Craft, Practice, and Skill,* grows from a belief in the power of that kind of connection and the Foundation and Howard's (and so many HBCUs') shared vision of preparing the next generation of Black writers.

In this time of reflection on the stories that cover racism, violence, acceptance, empowerment, heritage, and the uniqueness of the African diaspora experience, Black writers and their stories are more important than ever. And because the Hurston/Wright Foundation's workshops have long been a source of connection for Black writers about writing in every major genre, we believed in documenting the achievements of Black writers and the strategies that help them bring a story to the page. Acclaimed poet Jericho Brown agreed to join us in this effort as the editor, and as we celebrate the Zora Neale Hurston/Richard Wright Foundation on its thirtieth anniversary.

The writers who joined this project as contributors are a collective in the ongoing struggle to give voice to the ways we find joy, the ways we resist, the ways we declare our will to be free (of uncertain and imposed identities and of oppression alike). For readers and writers, we want this book to be a tool in their hands. While we know that the techniques of fiction, nonfiction, and poetry might not change, these pages offer cultured visions of the way Black writers gather, remember, and talk it out. This

anthology creates an important exchange, a gift from one writer to another. It is a gift that begins with an understanding of the demands good writing makes of a writer and an understanding of the ongoing engagement between the writer and the page. This is how we do it.

Darlene R. Taylor
Dana A. Williams
Howard University | Washington, DC
May 2022

Contributors

Daniel Omotosho Black is an award-winning novelist, professor, and activist. He has published six works, including his most recent novel, *Don't Cry for Me*. Black is a professor of African American studies and creative writing at Clark Atlanta University and lives in Atlanta, Georgia.

Breena Clarke is author of three novels, the most recent of which is *Angels Make Their Hope Here*. Clarke lives in New Jersey and is on the faculty of Stonecoast creative writing at the University of Southern Maine.

Rita Dove, 1987 Pulitzer Prize winner in poetry and former US poet laureate, received the 1996 National Humanities Medal from President Clinton and the 2011 National Medal of Arts from President Obama. Among her more recent honors are the Hurston/Wright Legacy Award, Harvard University's W. E. B. Du Bois Medal, the American Academy of Arts and Letters Gold Medal, the Wallace Stevens Award, and the Ruth Lilly Prize. Her latest book is *Playlist for the Apocalypse*.

Michael Dumanis is the author of the poetry collections *Creature* and *My Soviet Union*. He teaches at Bennington College, where he serves as the director of Poetry at Bennington and editor of the *Bennington Review*.

Camille T. Dungy is an award-winning poet and recipient of a Guggenheim Fellowship. Her poetry collection *Suck on the Marrow* won the American Book Award in 2011. Dungy is currently a professor in the English department at Colorado State University and lives in Fort Collins, Colorado.

W. Ralph Eubanks is the author of *A Place Like Mississippi*. He is a faculty fellow and writer-in-residence at the Center for the Study of Southern Culture at the University of Mississippi and lives in Oxford, Mississippi, and Washington, DC.

Angela Flournoy is the author of *The Turner House,* which was a finalist for the 2015 National Book Award and a *New York Times* notable book of the year. She is a faculty member in the low-residency MFA Program for Writers at Warren Wilson College.

Curdella Forbes is the author of five books of fiction, including *A Tall History of Sugar,* which won the 2020 Hurston/Wright Legacy Award for Fiction. She is a professor at Howard University and lives in Silver Spring, Maryland.

Ernest J. Gaines was an award-winning novelist who served as a writer-in-residence emeritus at the University of Louisiana. He received a MacArthur Fellowship and the 2016 Hurston/Wright North Star Legacy Award. He died in 2019 at his home in Oscar, Louisiana.

Nikki Giovanni is an award-winning poet. She has been awarded seven NAACP Image Awards and the 2014 Hurston/Wright North Star Legacy Award. She is a distinguished professor at Virginia Tech and lives in Blacksburg, Virginia.

Marita Golden is the co-founder and president emerita of the Hurston/Wright Foundation. She is the author of numerous works of fiction and nonfiction. Her most recent nonfiction book is *The Strong Black Woman: How a Myth Endangers the Physical and Mental Health of Black Women.*

Terrance Hayes is an award-winning poet. His collection *Amer-*

ican Sonnets for My Past and Future Assassin won the 2019 Hurston/ Wright Legacy Award for Poetry. Hayes is a professor of English at New York University.

Ravi Howard is the winner of an Ernest J. Gaines Award for Literary Excellence and was one of the first novelists to win the Hurston/Wright Foundation Award for College Writers. His most recent novel is *Driving the King.*

Mitchell S. Jackson is the recipient of the 2014 Hurston/Wright Legacy Award for Fiction for his debut novel *The Residue Years.* His most recent novel is *Survival Math: Notes on an All-American Family.* Jackson also received the Ernest J. Gaines Award for Literary Excellence. Jackson teaches creative writing at the University of Chicago.

Barry Jenkins is a writer, director, and producer. His acclaimed film *Moonlight* won Best Picture at the 2016 Academy Awards and Golden Globes. His most recent television project is the adaptation of Colson Whitehead's novel *The Underground Railroad.* Jenkins is a curator at the Telluride Film Festival and a United States Artists Smith Fellow and lives in Los Angeles, California.

Morgan Jerkins is the author of the New York Times bestseller *This Will Be My Undoing, Wandering in Strange Lands*, and *Caul Baby.* She holds a bachelor's in comparative literature from Princeton University and an MFA from the Bennington Writing Seminars.

Charles Johnson is a novelist, essayist, literary scholar, philosopher, cartoonist, screenwriter, and professor emeritus at the University of Washington in Seattle. He is the winner of a MacArthur fellowship and a National Book Award. He lives in Seattle, Washington.

Tayari Jones is the award-winning author of four novels. Her most recent book, *An American Marriage,* won an Aspen Words Literary Prize and an NAACP Image Award in 2019. Jones is also a recipient of the 2003 Hurston/Wright Legacy Award for her debut novel

Leaving Atlanta. She is an Andrew D. White Professor-at-Large at Cornell University and the Charles Howard Candler Professor of Creative Writing at Emory University. She lives in Atlanta, Georgia.

Jamaica Kincaid is an award-winning novelist and essayist. Her most recent book is *See Now Then*. She teaches at Harvard as the Professor of African and American Studies in Residence and lives in Vermont.

Tony Medina is an author/editor of twenty-four books for adults and young readers, including *I Am Alfonso Jones*. Twice awarded the Paterson Prize for Books for Young People, Medina is a professor of creative writing at Howard University and received a 2022 Audie Award.

E. Ethelbert Miller is an award-winning poet based in Washington, DC. He is the winner of the Barnes & Noble Writers for Writers Award given by *Poets & Writers* and a PEN Oakland Josephine Miles Award. The author of poetry collections and memoirs, his most recent book is *How I Found Love behind the Catcher's Mask: Poems*.

Elizabeth Nunez is the award-winning author of a memoir and ten novels. Her most recent novel is *Now Lila Knows*. She received the 2015 Hurston/Wright Legacy Award for nonfiction for *Not for Everyday Use* and the 2001 American Book Award for *Bruised Hibiscus*. She is a distinguished professor at Hunter College, the City University of New York.

Carl Phillips is an acclaimed poet and author of more than a dozen books of poetry and criticism. His 2009 collection *Speak Low* was a finalist for the National Book Award for Poetry; in 2011, *Double Shadow* won the *Los Angeles Times* Book Prize for Poetry and was a finalist for the National Book Award for Poetry. His most recent published collection is *Then the War: And Selected Poems*.

Jewell Parker Rhodes is an award-winning and *New York Times* bestselling author and educator of both youth and adults. Her novel

Paradise on Fire was published in 2021. She is a narrative studies professor and Virginia G. Piper Endowed Chair at Arizona State University. She lives in Seattle, Washington.

Charles H. Rowell is the founder and editor of *Callaloo*. He is the recipient of the 2018 Hurston/Wright Foundation's Madam C. J. Walker Legacy Award for dedication to Black literature. Founded in 1976, *Callaloo* is one of today's premier literary journals.

Rion Amilcar Scott is the author of the story collection *The World Doesn't Require You*, which was a finalist for the PEN/Jean Stein Book Award. His debut collection, *Insurrections*, won the 2017 PEN/Robert W. Bingham Prize for Debut Fiction. He teaches creative writing at the University of Maryland.

Evie Shockley is the author of several poetry collections, including *semiautomatic* and *the new black*, both winners of the Hurston/Wright Legacy Award in poetry. She received the Lannan Literary Award for Poetry in 2019. Shockley is the Zora Neale Hurston Distinguished Professor of English at Rutgers University.

Darlene R. Taylor is a multidisciplinary artist, fiction writer, and lecturer in the first-year writing program at Howard University. She lives in Washington, DC.

Natasha Trethewey is a Pulitzer Prize–winning poet who served two terms as the nineteenth poet laureate of the United States. Her most recent book is *Memorial Drive: A Daughter's Memoir*, an instant *New York Times* bestseller and winner of the Anisfield-Wolf Award for nonfiction. She is the winner of the 2013 Hurston/Wright North Star Legacy Award for poetry and the Rebekah Johnson Bobbitt National Prize for Lifetime Achievement in Poetry from the Library of Congress. She serves as a Board of Trustees Professor of English in the Weinberg College of Arts and Sciences at Northwestern University.

Frank X Walker is an award-winning poet with numerous col-

lections of poetry and honors. He was awarded an NAACP Image Award for Poetry and the Black Caucus American Library Association Honor Award for Poetry. His most recent collection is *Masked Man, Black: Pandemic & Protest Poems*. Walker is the director of the MFA program in creative writing and a professor of English and African American and Africana Studies at the University of Kentucky.

Tricia Elam Walker is an award-winning author and educator. Her children's book *Nana Akua Goes to School* is the winner of the Ezra Jack Keats New Writer Award. *Dream Street* was named one of the *New York Times* best children's books of the year. She is an assistant professor of creative writing at Howard University and resides in Takoma Park, Maryland.

Afaa Michael Weaver (尉雅風) has published fifteen books of poetry, the most recent of which is *Spirit Boxing*. He was named the first Elder of the Cave Canem Foundation; he is also the recipient of 2015 Phyllis Wheatley Award and the St. Botolph Club Foundation's National Medal in Art & Literature. He is professor emeritus at Simmons University and now teaches in the MFA program at Sarah Lawrence College.

Crystal Wilkinson is Kentucky's poet laureate and an award-winning poet and novelist. The author of three works of fiction, her most recent work is *Perfect Black,* a collection of poems. She is the recipient of numerous awards including an O. Henry Prize and Ernest J. Gaines Award for Literary Excellence. She teaches at the University of Kentucky, where she is a professor of English in the MFA in Creative Writing Program.

Dana A. Williams is a professor of African American literature and dean of the graduate school at Howard University. She serves on the Hurston/Wright Foundation Advisory Board.

Jacqueline Woodson is the author of dozens of award-winning books for young people and adults. She is the recipient of the 2014

National Book Award for Young People's Literature for her memoir *Brown Girl Dreaming*, the 2021 Coretta Scott King Book Award for *Before the Ever After*, multiple NAACP Image Awards, and a MacArthur Fellowship. She has also served as the Library of Congress National Ambassador for Young People's Literature. She lives in New York.

Tiphanie Yanique is a novelist, poet, essayist, and short story writer. Her most recent book is *Monster in the Middle: Fictions*. She is associate professor of English and creative writing at Emory University. She lives in Georgia.

Credits & Permissions

About the Editor

Jericho Brown is author of *The Tradition*, for which he won the Pulitzer Prize. He is the director of the Creative Writing Program and a professor at Emory University. He lives in Atlanta, Georgia.